Thomas MacGreevy and the
Rise of the Irish Avant-Garde

First published in 2019 by
Cork University Press
Boole Library
University College Cork
Cork T12 ND89
Ireland

Library of Congress Control Number: 2019946258

ISBN 978-1-78205-356-9
Printed by Hussar Books in Poland
Typeset by Alison Burns at Studio 10 Design, Cork

Thomas MacGreevy and the Rise of the Irish Avant-Garde

FRANCIS HUTTON-WILLIAMS

CORK UNIVERSITY PRESS

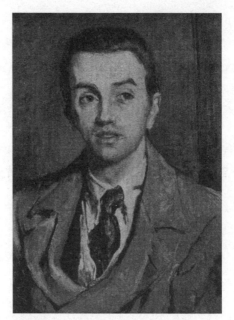

Portrait of Thomas MacGreevy (c. 1921)
Sarah Purser (1848–1943; first woman elected
to the RHA, in 1925)

CONTENTS

LIST OF PLATES

PLATE 1: Detail (initial letters *S* and *U*) from page folio 116v of the *Book of Kells* (c. 800)
Hand ink on stretched calfskin (vellum), 33 x 25 cm
Illuminated manuscript
Medieval and Renaissance Latin Manuscripts, IE TCD MS 58
© The Board of Trinity College Dublin
Photo © Dublin, Trinity College Library

PLATE 2: *Green Abstract* (1927)
Mainie Jellett (1897–1944)
Oil on canvas, 84 x 67.3 cm, NGI 2007.75
National Gallery of Ireland Collection
Photo © National Gallery of Ireland

PLATE 3: The opening of the Retrospective Exhibition of Paintings and Drawings by Mainie Jellett at the Municipal Gallery of Modern Art, Dublin (26 July 1962)
Photo © The Estate of Thomas MacGreevy

PLATE 4: *Arrangement in Grey and Black: Portrait of the painter's mother* (1871)
James Abbot McNeill Whistler (1834–1903)
Oil on canvas, 144.3 cm x 162.4 cm
© Musée d'Orsay, Paris, France / Bridgeman Images

PLATE 5: *Dinner Hour at the Docks* (1928)
Jack Yeats (1871–1957)
Oil on panel, 23.5 x 36.5 cm
Presented by Mrs Smyllie, in memory of the late Mr R. Smyllie (1966), NGI 1791
© Estate of Jack B Yeats. All rights reserved, DACS 2019
National Gallery of Ireland Collection
Photo © National Gallery of Ireland

PLATE 6: *Judith with the Head of Holofernes* (c. 1495)
Andrea Mantegna (1431–1506)
Tempura with gold and silver on panel, 30.8 x 19.7 cm
© Czartoryski Museum, Cracow, Poland / Bridgeman Images

PLATE 7: *Judith with the Head of Holofernes* **(1530)**
Lucas Cranach the Elder (c. 1472–1553)
Oil on beech wood, 74.9 x 56 cm
GKI 1182 / DE_SPSG_GKI1182
© Jagdschloss Grunewald, Berlin, Germany

PLATE 8: *Judith* **(c. 1504)**
Giorgione Barbarelli (c.1477–1510)
Oil on canvas transferred from panel, 144 x 68 cm
© State Hermitage Museum, St Petersburg, Russia / Bridgeman Images

PLATE 9: *Humanity's Alibi* **(1947)**
Jack Yeats (1871–1957)
Oil on canvas, 60 x 92.5 cm
Gift from Dr John A. Falk (1973)
Bristol Museum & Art Gallery, K4195
© Estate of Jack B Yeats. All rights reserved, DACS 2019
Photo © Bridgeman Images

PLATE 10: *Bachelor's Walk – In Memory* **(1915)**
Jack Yeats (1871–1957)
Oil on canvas, 45.7 x 61 cm
On loan to the NGI from a private collection, L 2009.1
© Estate of Jack B Yeats. All rights reserved, DACS 2019
Private Collection
Photo © National Gallery of Ireland

ACKNOWLEDGEMENTS

Since embarking upon this study, I have been fortunate to receive advice from many inspiring educators. Above all, I am indebted to Tara Stubbs, whose guidance has been present throughout. My thanks extend to Gerald Dawe and Nicholas Grene, founders of the Oscar Wilde Centre at Trinity College, Dublin; to John Kelly, who introduced me to Oxford; and to Laura Marcus, Finn Fordham and Michael Whitworth, whose feedback has been especially instructive. I gratefully acknowledge Fiona Stafford for her recommendation of my research and her sage words on beginning a book project; Maria O'Donovan, who generously took on the project with enthusiasm as editor of Cork University Press; my anonymous readers, whose suggestions helped to turn basic research into a publishable study; and Aonghus Meaney, whose copy-editing saved me a number of embarrassments.

Several grants allowed me to complete this study: my thanks go to the Fellows and Rector of Exeter College, Oxford, who awarded me the Amelia Jackson senior scholarship to fund my DPhil and grants from the Exeter College Academic Trust; to the Fellows of St Catherine's College, Oxford, who provided me with teaching in Irish literature; to the board of directors of Trinity College, Dublin, who awarded me the A.J. Leventhal scholarship to carry out research in Paris; to the executive committee of the Trinity Association and Trust, which awarded me grants from the Trinity Trust Travel Award; and to the award committee of the Maxwell and Meyerstein Fund at the English Faculty, Oxford, who supported me on multiple occasions with travel expenses and with the costs of reproductions.

I am much beholden to Robert Ryan and Margaret Farrington, co-executors of the Estate of Thomas MacGreevy, for their permission to quote from the author's archives and unpublished works, to quote at length from individual poems, and to reproduce photographic material of the opening of the Retrospective Exhibition of Paintings and Drawings by Mainie Jellett at the Municipal Gallery of Modern Art, Dublin (26 July 1962). Additional thanks are due to DACS and Bridgeman Images for their permission to reproduce Jack Yeats' *Humanity's Alibi* (1947); to DACS and the NGI for their permission to reproduce Jack Yeats' *Dinner Hour at the Docks* (1928); to DACS, the NGI and the private owner of Jack Yeats' *Bachelor's Walk – In Memory* (1915) for their permission to reproduce this

painting; to the NGI for its permission to reproduce Mainie Jellett's *Green Abstract* (1927); to the Board of Trinity College Dublin for its permission to reproduce detail (initial letters S and U) from page folio 116v of the *Book of Kells* (*c.* 800); and to Bridgeman Images for permission to reproduce James Whistler's *Arrangement in Grey and Black: Portrait of the painter's mother* (1871), Andrea Mantegna's *Judith with the Head of Holofernes* (*c.* 1495), and Giorgione Barbarelli's *Judith* (1504). Any information relating to the image or current rights holder for Sarah Purser's portrait of Thomas MacGreevy, which is in the public domain in its country of origin, will be gratefully received and incorporated in future editions.

I am deeply indebted to Aisling Jane Mary O'Brien and Sharon Sutton, who aided me with the conversion of hundreds of sources stored at the Manuscripts and Archives Research Library at Trinity College, Dublin into digital format; to Sheila Pratschke, director of the Centre Culturel Irlandais, who granted me access to the libraries of the École Nationale Supérieure; to the rights and reproductions assistants at the National Gallery of Ireland, who advised me on several image requests; to Cathryn Setz, who shared with me the digital content of *transition*; and to Ian Rawes, who directed my listening sessions at the British Library. Susan Schreibman has created the excellent online resource on Thomas MacGreevy, and I would like to reserve special mention for her. Parts of this book rest on source materials that she has made available. For a full acknowledgement of Susan Schreibman's invaluable editorial and recuperative work, please see the 'Digital sources' section of the bibliography.

Many others have inspired ideas and discussion without which this study and its author would certainly have been the poorer: Alexander Bubb, Rosie Lavan, Stephen J. Ross, Masud Ally, Peter Schwartzstein, Andreas Mogensen, Max Edwards and Nick Wakeling among them. My thanks to Claire Stahly for her love and support. To my parents, I owe everything else.

CHRONOLOGY

This book refers to post-revolutionary conditions in the twenty-six-county Irish Free State (Saorstát Éireann), which was established in 1922 as a dominion of the British Commonwealth of Nations. Much debate continues to surround the use of the terms 'state' and 'nation' in relation to the Irish Free State, whose gradual path to sovereignty and separation from the British Empire involved two constitutional changes: the first, in 1937, involving the abolition of the oath of allegiance to the British monarchy and the creation of Éire; and the second, in 1949, involving the official declaration of the Irish Republic. The following chronology charts MacGreevy's life and work within the developing strands of revolutionary nationalism.

1893 Born the seventh of eight children in Tarbert, County Kerry.

1909 Sat the boy-clerk examination for the British civil service.

1910 Moved to Dublin to take up a post with the Irish Land Commission.

1914 Worked for the Charity Commissioners of England and Wales in London. Start of the First World War. Transferred to the Intelligence Division of the Admiralty. On 26 July, a patrol of the King's Own Scottish Borderers opens fire at a large crowd on Bachelor's Walk in Dublin, killing three civilians and injuring thirty-two more.

1915 Jack Yeats paints *Bachelor's Walk – In Memory*.

1916 The Easter Rising started by Irish republicans. 485 killed.

1918 Served as a second lieutenant in the Royal Field Artillery with the 148th Brigade in Flanders. Seriously wounded at Messines. Sinn Féin sweeps to power in the Irish general election, defeating the Irish Parliamentary Party. End of the First World War.

1919 Offered a demobilisation scholarship to Trinity College, Dublin (TCD) to read history and political science. First Dáil Éireann forms a breakaway government from the United Kingdom and proclaims an Irish Republic. War of Independence started by the Irish Republican Army.

1920 Graduated from TCD. Co-founded the Irish Central Library for Students with Christina Keogh and Lennox Robinson. The Fourth Government of Ireland Act implements home rule while partitioning the island into 'Northern Ireland' and 'Southern Ireland'. The Auxiliaries, a

counter-insurgency unit consisting of 2,215 former British army officers, arrive in Ireland. The Black and Tans also arrive in Ireland to aid the Auxiliaries and the Royal Irish Constabulary (RIC). Kevin Barry is hanged in Mountjoy Gaol. On Bloody Sunday, British soldiers raid Dublin after the Irish Republican Army (IRA) assassinates thirteen British intelligence officers. Members of the Auxiliary Division and RIC carry out a retaliatory killing of civilians in Croke Park.

1921 On 6 December 1921, the Anglo-Irish Treaty is signed by representatives of both the Irish and British governments.

1922 The twenty-six-county Irish Free State (Saorstát Éireann) is established as a dominion of the British Commonwealth of Nations. The Four Courts is occupied by anti-Treaty IRA militants. Start of the Irish Civil War. Having pledged his loyalty to King and country on the Western Front, MacGreevy supports the anti-Treaty side of Sinn Féin during the party's split over the oath of allegiance to the British monarchy, though he condemns the resulting civil war.

1923 The pro-Treaty forces win the civil war. Mainie Jellett exhibits her first cubist compositions with the Society of Dublin Painters. 'Picasso, Mamie [*sic*] Jellett and Dublin Criticism' is published in *The Klaxon: An Irish international quarterly*.

1924 First trip to France as a civilian. Introduced to James Joyce.

1925 Moved to London and worked for T.S. Eliot.

1927 Appointed *lecteur d'anglais* at the École Normale Supérieure (ENS). Moved from London to Paris. Assisted James Joyce with *Work in Progress*.

1928 'A Note on *Work in Progress*' is published in *transition* 14. Renewed ENS position for two more years. Met Richard Aldington at Joyce's apartment. Met intended successor at the ENS, Samuel Beckett. Introduced Beckett to George Reavey and Joyce. Stayed with W.B. Yeats in Rapallo.

1929 The Censorship of Publications Act is passed in Ireland. Translated Paul Valéry's *Introduction à la méthode de Léonard de Vinci* into English.

1930 Acted as best man to Giorgio Joyce at his wedding to Helen Fleischman. Appointed secretary of the English edition of the arts magazine *Formes*.

1931 *T.S. Eliot: A study* and *Richard Aldington: An Englishman* are published by Chatto & Windus in London.

1932 Start of the Anglo-Irish Trade War.

1933 Left Paris for London.

1934 *Poems* is published by Heinemann in London and reprinted by Viking Press in New York. Delivered a lecture to the Irish Society at Oxford entitled 'A Cultural Irish Republic'. Beckett's 'Recent Irish Poetry' is printed under pseudonym in *The Bookman*'s special 'Irish Number'.

1937 The new constitution of Ireland (*Bunreacht na hÉireann*) is approved, resulting in the creation of Éire.

1938 Chief art critic for *The Studio*. Delivered a lecture to the NUI Club in London entitled the 'Cultural Dilemma for Irishmen: Nationalism or provincialism?'. End of the Anglo-Irish Trade War.

1939 Permanent lecturer at the National Gallery (London). Start of the Second World War. Evacuated pictures from London to caves in Wales for safekeeping.

1941 Returned to Ireland in October. Changed his surname from McGreevy to MacGreevy by inserting the Gaelic prefix 'Mac' before his anglicised surname. Appointed art critic for *The Irish Times*.

1943 First Irish Exhibition of Living Art is opened in Dublin.

1945 *Jack B. Yeats: An appreciation and an interpretation* is published by Victor Waddington in London, and *Pictures in the Irish National Gallery* by Mercier Press. End of the Second World War.

1948 Received the Chevalier de la Légion d'Honneur from the French Ministry of Culture. Began correspondence with Wallace Stevens.

1949 Ireland is formally established as a republic.

1950 Appointed director of the National Gallery of Ireland (NGI).

1951 Appointed to the first Arts Council in Ireland (An Chomhairle Ealaíon). *Illustrations of the Paintings* is published by the NGI.

1955 Received the Ufficiale al Merito della Repubblica Italiana from the Italian Ministry of Foreign Affairs.

1962 Received the Officier de la Légion d'Honneur from the French Ministry of Culture. Organised the Irish section of the Venice Biennial.

1963 Received the Silver Cultural Medal of the Direzione Generale delle Relazioni Culturali from the Italian Ministry of Foreign Affairs. Forced to retire from directorship of the NGI following a succession of heart problems.

1967 Died from heart failure following an operation.

INTRODUCTION

T homas MacGreevy (1893–1967) was a central figure in the intellectual culture of early twentieth-century Ireland. Vita Sackville-West likened him to 'a wind of freshness and of freedom through the over-lush coppices of poetry'.[1] W.B. Yeats declared him 'the most promising of all our younger men'.[2] Samuel Beckett described his verse as 'probably the most important contribution to post-war Irish poetry'.[3] The praise that MacGreevy received from some of the most distinguished writers of the twentieth century contrasts sharply with his fitful reception today. How might we explain the arrival of Ireland's first experimental poet? An existential outsider who later became head of Ireland's most famous cultural institution? MacGreevy became director of the National Gallery of Ireland during the 1950s, by which date his role within the pre-war Irish and European avant-garde went largely unnoticed. Today, he remains better known as an art historian than as a poet. The mention of a slim literary corpus can attract some surprise.

Recognition of his value as a poet might be said to have been rekindled by Michael Smith and Trevor Joyce's publication of his work by their New Writers Press in 1971 and by the championing of his poetry in the pages of the press' journal, *The Lace Curtain*, in the early 1970s. Several writers, editors and critics have since endorsed his poetic achievement, which still commands respect long after his collection of *Poems* (1934) first impressed Marianne Moore and Wallace Stevens.[4] In a letter to *The Irish Times* in July 1982, Derek Mahon broke rank with the Belfast poets of the Heaney generation by rating the experimental work of MacGreevy and its poetics of migration, fragmentation, collage and discontinuous narrative as 'higher than any "Movement" poet' of the 1950s and '60s, such as Philip Larkin or Thom Gunn.[5] MacGreevy is one of twenty-nine poets now featured in *The Cambridge Companion to Irish Poets*, a collection edited by the Northern Irish poet and academic Gerald Dawe that eschews the divisions motivated by geography, politics and entrenched areas of expertise to engage more widely with the languages, literatures and cultures common to poets writing in English and Irish from the seventeenth century to the beginning of the twenty-first.[6]

Though his stature is finally being acknowledged alongside a broader resurgence of interest in Irish poetic experiment, no study has examined MacGreevy's central role in the development of Irish culture.[7] From the arrival of national independence in 1922 to the moment of programmatic modernisation in the early 1960s, MacGreevy was pivotal to the Irish avant-garde both in his personal connections and in his work. He is frequently recounted in literary histories as the man who introduced Samuel Beckett to James Joyce, though he was also a vital companion of Wallace Stevens (who had no comparable friend across the Atlantic) and of the Yeats brothers (who both entrusted him to serve as executor of their estates).[8] MacGreevy's correspondences with scholars and government leaders, including art historian Lionello Venturi and former Taoiseach Éamon de Valera, are preserved in public and private collections around the world. Most significantly, his highly active role as art critic and, eventually, as director of the National Gallery gave him a position of influence that few of his contemporaries could match or seek to emulate.

This book is not only interested in the unrivalled range of MacGreevy's contacts and associations but in the extent of his commitment to public affairs both before and after the Irish revolution. From the age of seventeen, he worked as a civil servant for the British government, taking up a post with the Irish Land Commission before working in London for the Charity Commissioners of England and Wales.[9] Upon the outbreak of the First World War, he was assigned to the Intelligence Division of the Admiralty, probably as a second-division clerk. In 1918, he served as a second lieutenant with the 148th Brigade in Flanders, where he was twice wounded before being forced to return to England after his second injury for medical treatment.[10] Having served the British government for nine years until his demobilisation from the Royal Field Artillery in 1919, MacGreevy then entered Trinity College, Dublin to read history and political science on a scholarship programme for former combatants. There, he participated fully in the university's social, intellectual and artistic life; acting, translating and directing plays; reviewing stage productions and art exhibitions; and writing poetry.

MacGreevy returned injured from the Western Front to an Ireland still at war. The Anglo-Irish War of Independence (1919–21) coincides almost exactly with his tertiary education. At no point was he a member of the British or Irish forces during this conflict. The dialogues in the unpublished

'Autobiographical Fragments' at Trinity College, Dublin between the nar-
rator and other private personas reveal the fraught tensions of these loyalties:

> – Was the [First World] war your reality?
> – No, it wasn't. But it became, it has become, the only reality in my
> existence. It has put me on the wrong track and I've got to stay on it. The
> war has given me a sense of identity with Englishmen that I have not got
> at all with the men who are fighting for Sinn Féin.[11]

MacGreevy's 'sense of identity' was tested by the ongoing clash between
British and Irish forces. On the most violent day of the Anglo-Irish War
(Bloody Sunday, 21 November 1920), he found himself unexpectedly in
the same room as the fugitive Ernie O'Malley. British soldiers were raiding
Dublin and, earlier that day, had carried out the Croke Park massacre of
civilians after the IRA had assassinated thirteen British intelligence officers
(members of the so-called 'Cairo Gang'). MacGreevy kept lookout from the
window after his friend, Lennox Robinson, had agreed to let the unknown
rebel hide in his apartment for the night at 1 Clare Street, where he and
Robinson were stranded during the searches. At first sight, few points of
convergence might be thought to exist between a former British gunner
and an active IRA officer. But their direct experience of military conflict
and common interest in art and literature would lead to an unlikely friend-
ship between them, motivated in part by MacGreevy's growing disillusion-
ment with the British security forces in Ireland and with the Irish Free State
that followed.

By 1925 MacGreevy had left Ireland once more.[12] Back in the British
capital, he met T.S. Eliot (through a letter of introduction from W.B. Yeats)
and started to write for *The Criterion* and the *Times Literary Supplement*.[13] While
completing the editorial assignments that Eliot gave him, MacGreevy lived
in a house in Chelsea occupied by Hester Dowden and her daughter, Dolly
Travers Smith. The affluent setting of 15 Cheyne Gardens is clearly on
display in the poem 'The Other Dublin' (previously entitled 'Living with
Hester'), which is one of several poems by MacGreevy that started to
receive acclaim from 1925 onwards.[14] 'Dysert' (later retitled 'Homage to
Jack B. Yeats') was published in *The Criterion*'s January 1926 edition.[15] On
26 March Marianne Moore wrote to MacGreevy confirming her inclusion
of his work in *The Dial*.[16] 'Did Tosti Raise His Bowler Hat?' is also marked

'London 1926' and coincides with drafts of 'Recessional' and 'Gloria de Carlos V' from the same period.[17] MacGreevy's most anthologised and successful Irish-nationalist poem, 'Aodh Ruadh Ó Domhnaill', was also written at this time in London.[18]

It was in Paris, however, that MacGreevy established himself alongside some of the most innovative writers of the period. He was appointed *lecteur d'anglais* at the École Normale Supérieure (ENS) in January 1927 (a position for which T.S. Eliot acted in support) and immediately announced his presence to James Joyce upon arrival, whom he had met during his first trip to France as a civilian in 1924. As part of Joyce's inner circle of scribes and supporters, MacGreevy assisted with *Work in Progress* and was the first to write a defence of the then unnamed composition. He also met *transition* editor Eugene Jolas, *Ulysses* publisher Sylvia Beach, the career diplomat Denis Devlin, and the man who would join him as *lecteur d'anglais* at the ENS, Samuel Beckett.[19] MacGreevy continued to work as a member of the Parisian literati after his position at the ENS had expired. In 1929, he translated Paul Valéry's *Introduction à la méthode de Léonard de Vinci* into English.[20] In 1930, he was appointed secretary of the English edition of the arts magazine *Formes*. In 1931, he wrote two monographs for the Chatto & Windus Dolphin series on T.S. Eliot and Richard Aldington and translated Spanish poems by the *Generación del 27* for an ambitious anthology project entitled *The European Caravan*.

After nearly seven years spent mostly in Paris from January 1927 to December 1933, MacGreevy returned for a third sojourn in London, where his collection of *Poems* was published by William Heinemann during the summer of 1934. A further edition was released by Viking Press in New York that November. After *Poems* was published in Britain and America, MacGreevy would not write any further verse until the 1960s.[21] Instead, he began to turn his eye exclusively to painting. In 1938, he became chief art critic for *The Studio* in London and, from February 1939 onwards, a permanent lecturer at the National Gallery. MacGreevy's position at the gallery was cut short after the inevitability of the declaration of war forced it to remove all its paintings from the premises in late August. With widespread bombing predicted to rage over London, MacGreevy helped to evacuate hundreds of pictures to caves in Wales for safekeeping.

One of the unintentional consequences of the war in Europe was the creation of a flourishing art scene in Dublin. Irish artists, as well as British and European artists who had taken refuge in Ireland due to its neutrality

during the war, exhibited there frequently. Ernie O'Malley spoke enthusiastically to MacGreevy, who in 1940 was still resident in London, about the showings of contemporary Irish art in Dublin. He sent news of Jack Yeats, who had enjoyed his first solo exhibition in Dublin for nine years at the Jack Longford Contemporary Pictures Galleries that had recently opened on South Leinster Street. He mentioned Nano Reid, who had received her first solo exhibition that same month at 7 St Stephen's Green. And he updated MacGreevy on the activities of Mainie Jellett, who had lectured in Dublin on a range of Fauvist and postimpressionist paintings by André Derain, Maurice de Vlaminck, Raoul Dufy, Pierre Bonnard, Georges Braque, André Lhote, Juan Gris and Albert Gleizes.[22]

The prospect of joining a reinvigorated art scene, combined with the difficulty of continuing his activities in London, convinced MacGreevy to return to Ireland in October 1941. Back in Dublin, he became art critic for *The Irish Times*, lectured widely on art history, and continued to make the case for the inclusion of living artists in Ireland's top galleries and institutions. He was crucial in framing the public's response to the first Irish Exhibition of Living Art, which opened in Dublin in September 1943, and he became a renowned figure on the lecture circuit, delivering plenary talks at several Irish institutions on the history of European painting. On 1 July 1950, MacGreevy was appointed director of the National Gallery of Ireland. Under his leadership, the gallery's rooms and exhibits were completely overhauled, collections rehung, a new public lecture series established, and an in-house conservation facility installed. After thirteen years of relentless exertion to realise his vision for the gallery, a succession of heart attacks forced him to retire. By 1962, MacGreevy had received several awards for cultural service, including the Officier de la Légion d'Honneur from the French Ministry of Culture and the Cavaliere Ufficiale al Merito della Repubblica from the Italian Ministry of Foreign Affairs.

The unusual range and combination of MacGreevy's pursuits is testament to how active and resourceful he was when bringing together writers and artists, challenging approaches to style and technique, working with different audiences and educating public taste. Over forty years, MacGreevy wrote nearly five hundred articles and reviews on art and literature, contributed to over fifty periodicals and newspapers, and produced thirteen books and pamphlets. These include the first monographs on T.S. Eliot, Richard Aldington and Jack B. Yeats; the first defence of James Joyce's *Work in Progress*; the second book publication on Nicolas Poussin; and a catalogue

of the National Gallery of Ireland's oil paintings.[23] Through the various trajectories of his published work and wider career, it is possible to trace some of the most powerful alternative routes of Irish culture – routes that broaden our understanding of how Irish identity has been developed outside of Ireland in dialogue with larger social, literary and art-historical influences.

In her critical reappraisal of the Kerry-born writer, Susan Schreibman remarks that 'MacGreevy had no trouble aligning newly-independent Ireland on the periphery of the continent with many of Europe's most influential cultural and artistic movements'.[24] Rhiannon Moss has also highlighted MacGreevy as one of a trio of 1930s Irish writers who, together with Samuel Beckett and Sean O'Faolain, worked consistently within what she calls a 'transnational' framework of cultural reference.[25] In *Ireland: A social and cultural history, 1922–2002*, Terence Brown considers MacGreevy among a cohort of poets who saw no contradiction between their European and Irish identities:

> Apart from Beckett, their literary work, that of the poets Denis Devlin, Brian Coffey, and the slightly older Thomas MacGreevy, has received limited critical attention in Ireland or elsewhere. Its intellectual, often theological concerns, its unselfconsciously urban pre-occupations, its assured familiarity with European civilisation, set their work apart from what most Irish men and women had come to expect from their contemporary writers. For these writers, Ireland could be most herself not through a self-absorbed antiquarianism but through acceptance of her position as a European nation with links to the intellectual and artistic concerns of the Continent.[26]

How do these dissident figures challenge orthodox strains within Irish culture? What European styles and techniques do they bring to bear upon the native scene? In recent years, the publication of the letters of Samuel Beckett (a four-volume epistolary resource which is the result of decades of careful editing by Martha Dow Fehsenfeld and Lois More Overbeck) has uncovered a vital network of relationships formative to Irish writing and art of the 1930s. These letters, many of which are addressed to MacGreevy, provide us with a more precise indication of relevant social, literary and art-historical influences through the exchange of typescripts, the references that they make to painting and literature, and the attitudes that they sustain in relation to Ireland as a cultural and ideological territory.

AVANT-GARDISM

Before the French term passed into international currency and acquired a secondary figurative meaning (which is now the dominant sense), the *avant-garde générale*, *avant-garde stratégique* or *avant-garde d'armée* referred to the advanced division of soldiers ('the fore-guard') who marched out in front to engage the enemy wherever they might be found. Matei Calinescu has argued that

> etymologically, two conditions are basic to the existence and meaningful activity of any properly named avant-garde (social, political, or cultural): (1) the possibility that its representatives be conceived of, or conceive of themselves, as being in advance of their time; and (2) the idea that there is a bitter struggle to be fought against an enemy symbolising the forces of stagnation[27]

I take these two points as central to avant-gardism in both its historical and psychological forms, which always has a trenchant social or political edge. The avant-garde typically introduces something new and unfamiliar in opposition to a prevailing custom, usage or style. It also remains acutely aware of the need for invention, regardless of whether it is successful in overcoming the pressures of mainstream values. By introducing the concept of the 'Irish avant-garde', this book recognises an adversarial stance that is bitterly opposed to the status quo and that rests upon the expectation of having to take sides – often in resistance to a middle-class audience, government ideology, utilitarian preference or restrictive convention. The history of the concept is useful in two senses: first, for considering the impact of literary and artistic invention; and second, for understanding the centrality of Paris to the development of new social, cultural and artistic outlooks.

There are several reasons why critics have tended to overlook – and in some cases dismiss – the vitality of Irish culture after 1922. Many have argued that the golden years of the Irish Renaissance, which gathered momentum during the late 1880s, provided too rich a world of cultural achievement for the post-revolutionary generation to follow. Others have contended that the prolonged effects of trauma after seven years of paramilitary conflict (1916–23) saw off any possibility for the nation's art and culture to thrive. Still others have maintained that the practical work of nation-building had to take precedence over thoughts about cultural advancement. A common

premise underlies these different positions: all seek to explain, or excuse, an apparent decline in Ireland's cultural activity. Despite its social significance, with regard to Irish culture the opening decades of independence are frequently characterised as a quiet period of stagnation, uncertainty and retreat.[28] Responses to the period's cultural production have been largely constrained by the view that the arts themselves, though instrumental to political resistance during the giddy backdrop of the pre-revolutionary years, no longer had a significant role to play in advancing the nation. And yet some of Ireland's most daring creative activity emerged during the aftermath of the revolution from those who refused to accept the imposition of censorship, who challenged derivative modes of expression, and who brought the nation forward into a new age of politics, thought and feeling.

It is worth reiterating how little time MacGreevy spent in Ireland during the opening decades of state formation. He left Ireland in 1925 just three years after the Free State's establishment and returned only intermittently to the country until 1941, when he relocated to Dublin on a permanent basis. This book contains five chapters that extend from the foundation of the Free State in 1922 to the date of MacGreevy's eventual return to Ireland and to his later work as director of the National Gallery (1950–63). Together, these chapters examine MacGreevy's passage by way of Paris back to Dublin; they consistently relate his life and work to the Parisian coteries, public discourses, government policies, galleries, museums, exhibiting societies and art schools that shaped new kinds of creative experiment; and they highlight his position at the centre of several points of cultural tension between commitment and detachment, inheritance and discovery, imitation and invention, fidelity and betrayal then crucial to debates about Irish life.

The first chapter, entitled 'Becoming a Poet: MacGreevy and the aftermath of the Irish revolution', considers what the Irish mainstream had come to represent during the 1930s. It examines the restrictions that had been placed on certain styles and subjects, and introduces the forums in which critical interventions were first made against dominant social, cultural and psychological forces. In so doing, the chapter provides an immediate sense of the historical context within which MacGreevy and others sought to chronicle and drive aesthetic changes. The second half of the chapter discusses the growth of new forms of poetic experiment. It reads MacGreevy's *Poems* (1934) alongside Beckett's 'Recent Irish Poetry' (1934) and *Echo's Bones and Other Precipitates* (1935) and Devlin's *Intercessions* (1937),

uncovering a network of avant-garde activity between these poets and their creative ambitions.

The second chapter, entitled 'MacGreevy as Parisian *Littérateur*, 1927–33', examines MacGreevy's literary activities in Paris. The first section documents his publishing in the international quarterly *transition* (the largest avant-garde journal in Europe, with each issue running to around three hundred pages). The second section discusses his involvement with the composition and serial publication of Joyce's *Work in Progress*. The third section analyses both his part in *The European Caravan* (an ambitious anthology project that George Reavey, founder of the Europa Press and literary agent to Beckett and Devlin, co-edited with Samuel Putnam) and his association with Paul Valéry, then member of the Permanent Committee for Arts and Letters for the League of Nations and of the International Committee on Intellectual Cooperation. In so doing, the chapter examines MacGreevy's commitments to international journals, anthologies and appeals in Paris, and interrogates the conflicted balance of his relationship with ideological standards in Ireland.

The third chapter, entitled 'MacGreevy and Postimpressionism', shows how MacGreevy worked to transform Irish culture through a sustained engagement with one of France's most radical artistic movements. It begins with the conservative media reaction that erupted after Mainie Jellett exhibited her first Cubist compositions with the Society of Dublin Painters in 1923 before discussing MacGreevy's defence of her work and the Retrospective Exhibition of Paintings and Drawings opened by President Éamon de Valera at the Municipal Gallery of Modern Art in 1962. By analysing the twists and turns of public controversy and official recognition, the chapter shows how an interest in postimpressionism enabled MacGreevy and his fellow Irish avant-gardists to challenge multiple preconceptions about art and Irish identity and to redirect ideas about national commitment.

Like its precursor, the fourth chapter, entitled 'Reconstructing the National Painter', inspects MacGreevy's engagements with modern art. It starts with Daniel Corkery's personal attack on MacGreevy in *Synge and Anglo-Irish Literature* (1931) before analysing MacGreevy's own pursuit of national identity through various civic institutions, public exhibitions and artworks. As part of its coverage, the chapter interrogates MacGreevy's 1945 monograph on Jack Yeats (the first to be completed on the artist) as well as several essays and newspaper articles that he wrote during the

1920s, '30s and '40s. By scrutinising the language and assumptions behind MacGreevy's art criticism, the chapter explains how he positions art and the artist as topics of national significance. It also discusses Beckett's quite contrary take on the question of art and nationality in his 1945 review of Jack Yeats, which was prompted by the publication of MacGreevy's monograph on Jack Yeats earlier that year.

The closing chapter, entitled 'The National Gallery Revisited, 1950–63', brings this study forward into the post-war period. The chapter considers how and why, after repeated controversy and marginalisation, MacGreevy was able to carry on with his earlier innovations and to impact Irish culture more broadly. It discusses the radical reforms that he enacted as head of this institution: most notably, to rehang famous portraits in less prominent positions; to circumvent the gallery's exclusion of living artists; and to secure the legacy of female artists skilled in postimpressionist styles. The first part of the chapter theorises the gallery as the space for a more democratic and inclusive ideal. The second part considers MacGreevy's attempts to establish the National Gallery as a place not only for exhibitions but also for living art, teaching, research and conservation. Both parts address MacGreevy's transformation, after the Second World War, into an educator of the public.

Over the course of five chapters, this book examines MacGreevy's efforts to remould 'A Cultural Irish Republic': the title of his 1934 lecture to the Irish Society at Oxford. From his early work as a poet and critic to his directorship of the NGI when he was best known and most publicly influential, I show how he changed nationalist sentiment to make it serve rather than master the people. In the first half of the book, I analyse his attempts to replace the reactionary demand to be 'once again' with the future-oriented 'yet to be'. In the second half of the book, I analyse his attempts to reconstruct new versions of national identity and to enhance the image of art in the national body politic. In the final chapter of the study, I consider the importance of his later work as director of the National Gallery to bring the 'wider essentials of living' to Ireland's leading cultural institution.

For several decades, the forty-year period that separates the arrival of national independence in 1922 from the moment of programmatic modernisation during the early 1960s has been viewed as culturally conservative and inward-looking. Without entirely displacing that view, this book demonstrates the vital nature of another persistent strand of Irish culture.

Examining the ways in which the Irish avant-garde breaks with tradition allows me to consider the broader implications of a shift in attitude and to inspect the relations between competing forms of political and cultural self-apprehension. A reimagining of the past and future is evident in the use of the dawn and evening song (Chapter 1), Joyce's portmanteau inventions (Chapter 2), and the promotion of postimpressionist techniques (Chapter 3). Later chapters focus on MacGreevy's attempts to improve the cultural and political agency of the artist (Chapter 4) and his efforts to revitalise Ireland's most famous cultural institution as a centre of energising force and learning (Chapter 5). Together, these five chapters trace the rise of the Irish avant-garde: an informal expatriate group whose apparent 'aesthetic extremism' counters a prevailing ethos of political and economic self-sufficiency (Chapter 1), pursues new forms of self-expression (Chapters 1, 2 and 3), and develops alternative relationships with the public (Chapters 4 and 5).

1

Becoming a Poet: MacGreevy and the aftermath of the Irish revolution

· ·

MacGreevy's 1931 monograph entitled *Richard Aldington: An Englishman*, which was written while he was living in Paris, contains vital reflections on a fellow veteran of war trying to come to terms with a violent political inheritance. As 'a student of history and of civilisation as well as of the arts', he contends,

> [Aldington] knew, even in the hundred-odd years since the French Revolution, that the tradition was threadbare, that revolutionary ideals had, at long last, taken possession of aesthetic, had impregnated it and made it fruitful, and that the greatest art of the future, much more than the art of the nineteenth century, would be the expression of revolutionary humanity. And he knew that much of that expression would inevitably be discordant.[1]

That single word – 'discordant' – is deeply revealing of the attitudes borne by a new generation of Irish avant-gardists impatient with the innocent airs of Irish melody. If we take the 'hundred-odd years since the French Revolution' to the Third Republic to be indicative of the time lag that MacGreevy envisages before revolutionary ambitions are seen to have 'impregnated' the artistic realm and made it 'fruitful', then it is possible to see why the Irish revolution of 1916–23 had so far failed to produce a new cultural counterpart.

In a paper delivered in 1934 to the Irish Society at Oxford, MacGreevy notes ironically with the benefit of eleven years of hindsight how a desire

to impress Britain on narrowly tactical grounds has resulted in derivative modes of expression. 'The change of regime in Ireland', MacGreevy argues, 'has given us licensing laws modelled on those of England and a non-sectarian censorship, the Griffith-Collins-O'Higgins plaster memorial in Leinster Lawn, new banknotes, a new coinage and new postage stamps.'[2] The official overprinting at independence of King George VI philatelic products with 'Saorstát Éireann' as a revenue strategy serves as a befitting emblem for the cultural situation that MacGreevy describes, which had resulted in a series of superficial alterations.[3] The VR, ER and GR cast-iron pillar and wall boxes had not been replaced but repainted green.[4] Without securing an independent basis on which to deepen its self-expression, the new regime was destined to regurgitate formerly authoritative symbols as part of what MacGreevy fears in the conclusion of his speech may be no more than an 'Anglo-Irish-cum-London-Irish cultural province'.[5]

MacGreevy's lecture to the Irish Society at Oxford was one of a rising number of public pronouncements that highlighted the dangers of entrenched idealism and insular thinking. In a lecture delivered to the Munster Fine Arts Club in Cork, Mainie Jellett also forecasts the likely outcome of turning inwards. 'If we keep our heads like ostriches buried in the sand', she argues, 'and imagine by so doing we are guarding our own nationality and racial characteristics from profanation by outsiders, we will find ourselves continuing to live, or more truly, die, under the influence of a so-called tradition adopted by us from England, a tradition which England herself is now trying to cast off.'[6] Even those who would go on to promote a very different vision of Irish culture to that favoured by MacGreevy and Jellett's pro-European stance could support this emphasis. James Devane urged his readers to understand in an article for *Ireland To-Day* that '[u]ntil we create within that English medium a native periodic and cultural press, native readers, we shall be a Yorkshire, a Lancashire, a few isolated counties within a British culture'.[7]

Some strenuous intellectual efforts were made to remain open while promoting an independent culture. In its inaugural editorial in 1923, *An Gaodhal* vowed to avoid using Irish to insulate the country from foreign influences and 'to endeavour to assimilate and mould to the Gaelic idea what we find best in the development of the world at large. It will be no part of our aim', the editors promised, 'to take any course which will tend to shut out this country from the eyes of the world.'[8] *An Gaodhal* enjoyed a

credible base in Irish Gaelic culture; however, its nuanced editorial position, which favoured a global self-fashioning of Irish identity, failed to gain traction in the belligerently partisan climate of the new Irish Free State. By the late 1920s, a prevailing ethos of patriotic one-upmanship and economic and ideological self-sufficiency, as characterised by the 'Irish-Ireland' movement, had become the dominant force in consolidating the nation's drive for cultural distinctiveness. As the appeal of 'Irish-Ireland' ideology spread, a cohort of right-wing activists inspired by D.P. Moran, Daniel Corkery and others sought to purify the nation by reducing the range of its cultural sympathies to the landscape of the west. In a 1926 'Editorial' for *The Dublin Magazine*, Seumas O'Sullivan criticises this 'longing for fusion' with a recreated ancestry:

> Our very longing for fusion tends towards making us false to ourselves. For in our eagerness to think of ourselves as belonging to the civilisation that our historians and scholars have created for us, we run the risk of mistaking the outward forms for the inner life. This is the great danger of our conscious preoccupation with tradition. We become obsessed by the external forms of the past. We set them up like Molochs in the present, and stuff them with living victims. Ireland to-day is full of preconceived ideas to which we all either sacrifice or are sacrificed.[9]

In this outspoken passage, O'Sullivan treats the 'conscious preoccupation with tradition' like a taxidermy exhibition. Having no real connection with 'Ireland to-day', the fossilised remnants of 'preconceived ideas' are seen to have turned present members of Irish society into 'living victims'. In the Old Testament, the Ammonite god 'Moloch', which means 'king' in Hebrew, is an idolatrous figure of worship for the people of Israel.[10] Here, however, it is intended to critique the course taken by some of Ireland's more conservative representatives, who had set about rebuilding a lost or phantom homeland with paranoiac determination. A primal need to ensure the security, purity and goodness of the 'in-group' had encouraged nationalist hardliners to throw a cordon sanitaire about Irish society to prevent the importation of harmful or counter-doctrinal ideas.

It is in this developing climate of religious and cultural orthodoxy that MacGreevy campaigns for a new edifice of the mind. As evidenced by his numerous references to the currency and insignia of the new regime when

addressing the Irish Society at Oxford in 1934, MacGreevy expresses dismay at the divisive and in many ways incoherent attempts to forge a sense of Irish cultural and political identity in the aftermath of the turmoil of 1916–23. His ironic reference to 'a non-sectarian censorship' refers to the official basis for cultural suppression that had been introduced to Ireland after the Censorship of Publications Act was passed in July 1929. The lack of dissent surrounding its imposition had a significant impact on Irish culture, effectively splitting apart the intelligentsia from the state's 'protection' of the people. By 30 September 1935, 618 books and eleven periodicals had been listed as banned by the Free State Register.[11]

Even before the attempt to broaden the interpretation of obscenity in existing legislation had been brought before the Oireachtas (the Free State's legislative body) in the summer of 1928, a level of unofficial assent to censorship by the publishing industry meant that the leaders of literary periodicals had to twice face down strikes from printers who refused to work on the contents of modernist texts. O'Sullivan himself decided to reject an essay by 'Con' Leventhal on James Joyce's *Ulysses* after the Dollard print house had threatened strike action, and the editors of the short-lived magazine *To-Morrow* had to turn to a printing house in Manchester after Irish printers (the Talbot Press) refused to work on an anonymous essay by W.B. Yeats that ridiculed contemporary bishops.[12] Further examples of the ways in which the censorship Act was popularly and imaginatively enforced are contained in Brendan Behan's 'Letters from Ireland', which were published by the Parisian magazine that Sindbad Vail edited, *Points*. Referring to the outlook of one prudish bookseller, Behan acknowledges to the Parisian editor that

> I got a Penguin *Plato's Symposium*. With difficulty: The Censorship can hardly get after him at this time of day, but as one bookman (saving your presence) said to me: 'We saw a slight run on it, and the same sort of people looking for it, so we just took it out of circulation ourselves. After all, we don't have to be made decent minded by [an] Act of the Dáil. We have our own way of detecting smut, no matter how ancient.'[13]

Looking back on the Free State's rule from the 1970s, the civil servant and writer Mervyn Wall perceived that the state coordination of the 'masses' had been deep and effective and that its censorious legislation had been

imposed 'with the will of the entire people' – an observation that is corroborated by several other writers who lived through the 1930s.[14] What is most disturbing about these testimonial accounts of the period, though often exaggerated by the extremity of their palpable disillusionment, is the apparent disappearance of a middle audience between the Irish Free State and the general public. Even the Oireachtas festival (an event that now found an unfortunate namesake in the Free State's legislative body), which had been operating since 1897 as Ireland's first annual festival for the literary and performing arts, was cancelled from 1924 to 1939 due to a lack of public interest.

Perhaps the strongest evidence of what the Irish mainstream had come to represent at this time is to be found in the dramaturgy of the Abbey Theatre. The venue, otherwise known as the National Theatre of Ireland (Amharclann Náisiúnta na hÉireann), became the first state-subsidised playhouse in Europe after receiving an official subsidy from the Free State government in 1925. This was an arena in which the previous concerns of the Irish Literary Revival, which W.B. Yeats and Douglas Hyde had helped to shape with their 1888 collection *Fairy and Folk Tales of the Irish Peasantry*, continued to express themselves largely in romance, folklore, heroic narrative and in heavily idealised renditions of peasant life. Thomas Cornelius Murray's theatrical studies of the peasant class in *Birthright* (1910), *Maurice Harte* (1912) and *Autumn Fire* (1924) had made this an attractive subject for the national drama, the recurrent success of which would become known as 'the peasant treadmill'.[15]

Once packaged into a commercialised formula, the dominance of peasant themes on the national stage had become oppressively normative and prescriptive. On 5 October 1930, Beckett wrote to MacGreevy comparing Eileen Crowe's performance as Dervorgilla in Lady Gregory's play of that name to 'Frau Lot petrified into a symbolic condemnation of free trade', noting how the abducted wife of Tiernán O'Rourke had been recast as passive justification for the nation's increasingly isolationist social and economic policies.[16] The vested interests that now attached themselves to the maintenance of a rural and folk aesthetic were by no means representative of the original force with which the Irish Literary Revival had been conceived by Irish poets prior to the revolution, the seeds of which lie, as Roy Foster has shown, in 'the literary societies of the mid 1880s, when the Young Ireland ethos was revived …'.[17] While the Irish Literary

Revival's mythopoetic repertoire had provided an important framework for revolutionary politics within the oral tradition of song, the movement appears to have lost its force once it moved away from nationalist ballads towards state-subsidised melodramas.

Several independent channels sought to chronicle and drive aesthetic changes, with varying degrees of success. O'Sullivan's *The Dublin Magazine* (1923–58) provided a reliable platform for Irish writers to develop and sustain alternatives to the Abbey Theatre's nostalgic nativism. A pragmatic operator, O'Sullivan ensured the survival of the magazine by sidestepping controversial disputes and the worst excesses of censorship. Less durable outlets for the distribution of new writing included *The Klaxon: An Irish international quarterly* (which made only one appearance in the winter of 1923), *To-Morrow* (1924; *To-Morrow*'s third issue never arrived), and the later *Ireland To-Day* (1936–38; eventually boycotted by Irish newsagents). It is no accident that the future and the everyday feature in many of the titles of these short-lived journals. Their fleeting capacity to break with past traditions and to present international material to the public was essential to the refinement and pursuit of broader social and artistic possibilities. Sean O'Faolain's 'Commentary on the Foregoing', which was published in the fifth number of *Ireland To-Day*, marks a decisive break from the idealisation and myth-making in the mainstream media.[18] Here, O'Faolain directs his critique at the exponents of a 'hidden Ireland'. Its pertinence is such that it is quoted at length:

> Dr. Devane, like Prof. Tierney [a member of the Evil Literature Committee], Prof. Corkery and many others who share his inferiority complex with regards to the actuality of the Ireland in which we live – fearing to *see* what is before their eyes to see, wishful to cover it over and gild it over – are misled by one simple act of non-recognition. They will not recognise the court. And the court which will, in time, judge them is Ireland as it is – Ireland as the novelists and dramatists and poets have a dozen times revealed to them. O'Casey, Yeats, Joyce, O'Flaherty, O'Connor, McNamara, Somerville and Ross, Colum, Synge – not any one alone, but all together, have presented a picture of Ireland to the world. These men and women have no axe to grind. They look at Irish life and they present it, recreated with integrity in its essential truth. Dr. Devane and the rest of the yearners say: 'No, Ireland is not like that.'

They are exactly like the audiences who hissed Synge and attacked O'Casey. They hate the truth because they have not enough personal courage to be what we all are – the descendants, English-speaking, in European dress, affected by European thought, part of the European economy, of the rags and tatters who rose with O'Connell to win under Mick Collins – in a word, this modern Anglo-Ireland.

One myth after another these yearners invent to cover up the fact of Anglo-Ireland – to cover up the simple historical fact that we are what history made us. The Gaelic Revival, the new Puritanism, the yarn of the 'Hidden' Ireland, the Censorship, the howls about a 'National' literature, the menial tariff on Joyce and Yeats, the attempt to prevent the Abbey from playing Synge in America – they are all the opiates to drug the seeing eyes; dream-clothes to cover those who cannot simply be Irishmen, thinking, living, behaving, as free individuals in their own right, on their own feet, in their own time. It is not possible to argue with such people. They live in a fog of fear – utterly confused by their efforts to find a 'noble' ancestry. They are simply ashamed of the cabins and the lanes out of which we have all come.[19]

O'Faolain wrote this passage not long after his second novel *Bird Alone* (1936) had been banned by the Irish government. In this audacious attack on the censorious mindset, he traces an unhealthy obsession with identity politics and group membership back to the 'inferiority complex': a psychoanalytic term coined in the 1920s by the Austrian psychologist Alfred Adler. Most revealingly, O'Faolain's choice of vocabulary – 'yearners' – illustrates how sexual taboo and puritanical ardour have enkindled the factions of national chauvinism. Not all authors agreed that a fiercely realist approach was necessary for moving past colonial subjugation. A former high-ranking IRA Volunteer and explosives expert attacked the disenchanted present by beginning the first unsigned editorial of *Ireland To-Day* with a reference to the image of the phoenix rising from the flames on the magazine's cover. With a triumphant sense of hope and optimism undergirding his ongoing faith in the revolutionary process, Jim O'Donovan predicted that a culture truly worthy of the left-wing republicanism that had preceded it would now arise from 'the smouldering ashes'.[20]

From diatribes condemning the spread of psychological delusion to laments for a bygone heroism, the cultural debate that was conducted in

these short-lived journals appears to have been deeply conflicted about the truthfulness of Ireland's hidden core. No plan of intervention, however, was more emphatic in its response to current historical pressures than that of Beckett's August 1934 review of 'Recent Irish Poetry', which was printed in *The Bookman*'s special 'Irish Number' just before it stopped publication:

> It is agreeable, if unreasonable, to connect ... the entire drill of Celtic extraversion, with Mr Higgins's blackthorn stick, thus addressed:
>
>> And here, as in green days you were the perch,
>> You're now the prop of song ...
>>
>> – ('Arable Holdings')[21]

'Recent Irish Poetry' presents a devastating caricature of literary society in Dublin, many of whose members viewed themselves as custodians of a blossoming Revival tradition. At the end of August 1934, Devlin wrote to MacGreevy characterising the fallout from the review as a *succès de scandale*: 'It appears [that W.B.] Yeats was furious, it appears that Austin Clarke is vindictive by nature and will pursue Sam to his grave; it appears Seumas O'Sullivan thought he might have been mentioned at least; and my domestic bull [F.R.] Higgins voyez-moi ce type amazed me by being glad he got off lightly.'[22] Written under a pseudonym, Beckett's chosen nom de plume ('Andrew Belis') provides insight into the avant-garde network that surrounds this published text. Beckett and MacGreevy are likely to have been introduced to 'Andrey Bely' (Boris Nikolayevich Bugayev) by their Russian-born friend George Reavey, whose enterprising literary agency the Bureau Littéraire Européen, which he started with the Russian émigré Marc Slonim in 1932, represented writers from all over Europe.[23] Devlin (whose poetry was published under Reavey's Europa Press imprint) and MacGreevy are also included in 'Recent Irish Poetry' as examples of new work by Irish poets.

From the outset of 'Recent Irish Poetry', Beckett divides the 'Irish scene' into that of 'antiquarians and others', though he in fact qualifies this initial distinction by affirming that 'the issue between the conventional and the actual never lapses' and 'is not peculiar to Ireland or anywhere else'.[24] If it is, as Beckett concedes, 'especially acute' in Ireland, it is only so because of recent acolytes of the Revival tradition. The 'younger antiquarian' to whom Beckett refers in this article draws attention to a specific type of

conservatism – one that has replaced a Protestant, post-Arnoldian Celticism with the Catholic, bourgeois, newly governing spirit of 'Irish Ireland'.[25] Beckett places James Stephens' 'Theme and Variation' (1930) and 'Strict Joy' (1931) in the annexe of a tradition 'where the poet appears as beauty expert', identifying further examples of overly-crafted and fetishised sentiment where an elicited feeling is idealised without any thought given to its actual application.[26] In one particularly acerbic passage (given above), Beckett connects 'the entire drill of Celtic extraversion' with the 'blackthorn stick' that features in F.R. Higgins' *Arable Holdings* (1933): the support mechanism, no less, for a lyric that is dead on its feet.[27]

The 'others', by contrast, who are bracketed in Beckett's review refer to a small group of Irish poets – Thomas MacGreevy, Denis Devlin and George Reavey among them – who had worked in Paris and whose direct influences extended only so far as the modern French line of poetry from Arthur Rimbaud, Jules Laforgue, Paul Éluard and the surrealists to T.S. Eliot. Their 'otherness' is united chiefly in opposition to the derivative literary credentials that Beckett traces from the verse of James Stephens, F.R. Higgins and the early Austin Clarke. Opposition of this sort appears to have required no uniformity in poetic approach or in political and ideological standards. Nevertheless, their break with latter-day practitioners of the Irish Literary Revival is judged sufficient to constitute 'the nucleus of a *living* poetic'.[28] Beckett is aware that the distinction he is making between past and present is neither definitive nor wholly accurate, despite the provocation that is contained in the review's acronym (read 'RIP' for 'Recent Irish Poetry'). 'RIP' has a double meaning, since it refers both to the work of neo-Revivalists that is quite literally *passéist* and to the 'gasping' of new poets struggling to move under W.B. Yeats' burdensome shadow.

While this purposefully exacerbated analysis shows little hesitation in its desire to abandon dominant poetic stereotypes, Beckett's taciturn note of respect while searching for a living poetic beyond the self-inventing genius of his precursor has been overlooked by critics. If he associates himself with the rest of 'the fish that lie gasping on the shore', it is because Yeats, whose poetry was published by the press and embroidery workshop of his sisters, 'wove the best embroideries, so he is more alive than any of his contemporaries or scholars to the superannuation of these …'.[29] Beckett's unusual description of Yeats' craft proceeds from two earlier passages that depict contemporary Irish poetry labouring under its misapprehension as one of the decorative arts:

The device common to the poets of the Revival and after, in the use of which even beyond the jewels of language they are at one, is that of flight from self-awareness, and as such might perhaps be described as a convenience. At the centre there is no theme. Why not? Because the centre is simply not that kind of girl, and no more about it. What further interest can attach to such assumptions as those on which the convention has for so long taken its ease; namely, that the first condition of any poem is an accredited theme, and that in self-perception there is no theme, but at best sufficient *vis à tergo* to land the practitioner into the correct scenery, where the self is either most happily obliterated or else so improved and enlarged that it can be mistaken for part of the *décor*?[30]

An overall lack of self-perception is held to be common in Revivalist poetry, which demands a perfect synchronicity between place and poet. Beckett criticises a style in which attention is lavished solely upon the poet's capacity to situate the self in a prearranged landscape without interrogating the self that utters its object or speaks it into existence. Central to this strategy of instant arrival 'into the correct scenery' is 'an accredited theme' that precludes a sense of historical relevance or individual consciousness and precipitates a wholly evasive and affected posture. For Beckett, the immediate insertion of the practitioner into a familiar locale means that the poet is encouraged to act out his lines without making any real contact with the surroundings of which they are part. One can see how the performative loop that is attached to this convention might have fallen oppressively short of the poet who wanted to imagine creatively within contemporary culture and to address its live social and historical pressures. Accordingly, much of Beckett's critique is preoccupied with the deconstruction of the Revival's ahistorical tropes and figures and with the insertion of the self at the centre of the creative act.

Though Beckett is vague in this review about what, exactly, the admission of a 'deeper need' entails, his public support for Denis Devlin in 1937 three years after the publication of 'Recent Irish Poetry' helps to clarify the role that he wishes to assign instead to the creative act. When defending his compatriot in the 'Commentaries' section of *transition* from a negative review by the *Times Literary Supplement*, Beckett highlights the integrity with which the poet has allowed his consciousness of the image to emerge: 'a mind aware of its own luminaries'.[31] Beckett cites examples of profounder

self-awareness from 'Communication from the Eiffel Tower', 'Bacchanal' and the final stanza of 'The Statue & Perturbed Burghers'.[32] An untranslated and unpublished French article written by Beckett in the same year as his defence of Devlin is entitled 'Les Deux Besoins' ('The Two Needs').[33] It is clear from the existence of both of these documents that Beckett was still working out what the admission of a 'deeper need' might look like in relation to Devlin's new collection of poetry.

Beckett's attempts to detach the experimental verse of his contemporaries from the Irish Revival's nativist outlook and linguistic programme are most securely grounded in debates about poetic technique. In 'Recent Irish Poetry', he queries the role of rhyme and metre in relation to several 'antiquarian' poets and castigates the early poems of Austin Clarke for metrical operations that 'remove ... the clapper from the bell of rhyme'.[34] As W.J. McCormack has shown, Beckett's description of Clarke's verse, which is written in English but based on the adoption of Gaelic verse forms, is taken directly from the technical annotations that Clarke himself had provided for *Pilgrimage and Other Poems* in 1929.[35] Apparently undeterred by Beckett's reference to his verse, Clarke had remained convinced of the need to look for metrical forms of equivalent intricacy and reliability in the Irish vernacular tradition.[36] Beckett would again confront Austin 'Ticklepenny' (a name fictitious enough to cover the accusation of libel) in his 1938 novel *Murphy*, during which he sends up the poet with a comic aside:

> This view of the matter will not seem strange to anyone familiar with the class of pentameter that Ticklepenny felt it his duty to Erin to compose, as free as a canary in the fifth foot (a cruel sacrifice, for Ticklepenny hiccupped [*sic*] in end rimes) and at the caesura as hard and fast as his own divine flatus and otherwise bulging with as many minor beauties from the gaelic prosodoturfy as could be sucked out of a mug of Beamish's porter.[37]

Here, we have a context for the objection in 'Recent Irish Poetry' to 'the tics of mere form' that pare away 'segment after segment of cut-and-dried sanctity and loveliness' from 'an iridescence of themes'.[38] Beckett's cartoon sketch of Clarke's *Gaeilgeoir* tendencies and of the organising principles that he had developed for patterning Irish verse is worth comparing with MacGreevy's humanist defence of Richard Aldington, which is equally

inclined to treat prosodic inquiry as a method of self-evasion. In the following passage, MacGreevy is wary of how an obsessive concern with metre might prevent the poet from finding 'his own personal way':

> … though Aldington writes lyrically he makes no attempt to recapture the cheap virtuosity of the recent past. Rhymed poetry is part of that past. And he makes no attempt to rhyme. Simplicity of expression and sincerity are the most important things, and rhyme − already as long ago as Tennyson's and Swinburne's time − had become a serious danger to both, had become mere mechanism … For the future the musician or the poet had to make his own personal, unmechanical music, his own rhythm, in his own personal way, and stand or fall by it. Rhyme was a mere adventitious aid in hypnotising the insensitive reader into continuing. If you wanted to say what you had to say personally and with the perfect economy which is style, you had to shed every borrowed trick.[39]

Though one reading is parodic and the other sincere, the parallels between these two critical judgements are significant. Both Beckett and MacGreevy reject any ambition to establish a rule in advance for determining the play of verse. In the modern age, rhymed poetry is seen to produce only intoxication and trickery. For MacGreevy, such organising principles can carry none of the 'revolutionary humanity' that he cites in his monograph on Richard Aldington, the expression of which must be 'discordant' rather than 'harmonious'.[40]

It is no accident that the Irish Literary Revival provides the backdrop for MacGreevy's reading of Aldington's early poems. When reading 'Au Vieux Jardin' (1912), MacGreevy points to the 'Hellenic transformation of the so-called "Celtic" twilight, which Mr. Yeats, in a moment of aberration, under the influence of the Scottish Fiona Macleod and his Antrim disciple A.E., first introduced into good Irish poetry'.[41] MacGreevy remains adamant in his refusal to associate 'twilight poetry' with 'Celtic' identity. In the same passage, he adds in parenthesis that '(It is nonsense incidentally to talk of twilight poetry being specifically "Celtic" […])'.[42] MacGreevy is deeply sceptical about whether a line of influence can in fact be drawn between 'twilight poetry' and Yeats' own peculiar version of the Celtic, which Yeats had developed out of his interests in the occult two or three decades earlier.[43]

What Beckett and MacGreevy seek, in mutual opposition to the cultural programme that Yeats, Lady Gregory and their literary confederates had originally espoused to the public in a bid to regain contact with an ancient Celtic spirituality, is a new poetry that works without reference to romantic fantasy, stereotyped invention, or the wishful lilt of language. Both strive for an unadorned medium that, shot through with personal statements, can act as an antidote to the 'uninjurable', 'incorruptible' 'stuff of song'.[44] Whether motivated by the experience of war or simply out of radical aesthetic opposition to previous literary movements, 'the cheap virtuosity of the recent past' unites their approach to the lyric and underpins their desire to challenge many of its controlling assumptions.

'SHEDDING EVERY BORROWED TRICK'

This section offers a comparison of three collections that rewrite the map of Irish poetry during the 1930s. MacGreevy's *Poems* (1934), Beckett's *Echo's Bones and Other Precipitates* (1935) and Devlin's *Intercessions* (1937) represent some of the most innovative attempts by Irish poets to dismantle existing mythological archetypes and divest them of their idealist accretions. A reading of poems from these collections will highlight their new approaches to the lyric through their extensive use of parataxis, collage and discontinuous narrative. As Devlin writes in 'Now':

Hail to the Holy Adjective!
Three-score and ten.
What's beauty, truth, life, love, what's me?
Can we get there?
Don't know, don't know, don't know.
By candle-light?
Pull down that gilded rubbish. We
Candle-light.
In metaphysic, apotheo –
How many miles is it?
– sise Adjective. Hail Sitwell. We
How many?
Feed on our own decrease.[45]

Here, the temporal coordinates of the 'I' no longer suffice as markers of a centralising or utopian force. Even the stability of the subject that would give voice to the lyric is questioned: 'what's me?' In the Romantic period, the lyric had answered to the conception of the national landscape as fulfilment, the idea of the world as an extension of the self's desires, and the location of the 'I'/'eye' as the demonstrative source of origin. For the poet operating comfortably within this tradition, the outer world is recovered by a contemplative attitude that sustains both the position of the speaking subject and its desires, mirroring them perfectly as the absolute locus of visionary experience. In 'Now', the demands of national revolution have irrevocably altered the landscape of lyric poetry. The association of national fulfilment with song clearly belongs to an outstripped poetic tradition.

For a new generation looking back at the recent literary past, MacGreevy, Beckett and Devlin's approaches to the lyric bear all the hallmarks usually associated with the avant-garde: the problem of disintegrating subjectivity in modernity; the absence of unity between the self and the social world; and a self-conscious pastiche of literary form. However, the ways in which they introduce political tensions to the lyric are complex and are not simply motivated by an impulse towards satire. Undergoing substantial revisions over the course of six years, Devlin's euphemistically renamed 'Bacchanal', originally entitled 'News of Revolution', anticipates the march of future citizens through a series of jumbling and discordant registers:

> Forerunners run naked as sharks through water,
> nose to their prey, have message by heart
> Only envy learnt in feeding the shutfist pistoned
> right machines
> Canaille, canaille, what red horizons of anger
> for humbled lives lie
> Tumbled up in the old times, the long-ferment-
> ing now, canaille![46]

Without developing any single image, the passage proceeds through indent-ed lines of deferral that lend a mocking sense of repetition to the word 'canaille', a French word for 'riff-raff' or 'rabble' derived from the Italian *canaglia*, 'pack of dogs'. The loss of spatial and temporal coordinates in this dystopian present allows for a mixture of pre- and post-revolutionary

perspectives that the poem refuses to distil from the appetites of raw, angular and malignant figures dispossessed of their conscious history. The mindless outrage and unstoppable motion of 'shutfist pistoned / right machines' incapable of doubt and reflection is reinforced by the passive constructions, dangling modifiers and shifting line lengths at the level of the poetic form ('Tumbled up in the old times, the long-ferment- / ing now').

Devlin was often conflicted about whether to publish his poems because of the position he held within the Irish Department of External Affairs.[47] As he writes to MacGreevy after he had sent him 'Bacchanal' on 22 January 1937: 'I'm not risking my job lightly especially as I have other responsibilities besides myself, but I must publish it.'[48] The powerlessness of poetry to effect significant change emerges as its own theme in *Intercessions*, which was published later that year. One of the most sublime examples of failed agitprop is that of 'Daphne Stillorgan', a poem very much written from the perspective of a diplomat. In this poem, the speaker anticipates the disturbance of a calm pastoral scene, voicing the expectation that the inert locale of a Dublin suburb will soon be blasted apart by the mobilisation of international forces (for which the approaching train in the poem serves as an allegory of 'Emergency' Ireland amid the advance of Nazi Germany). Heard along the rails (and here, Devlin emphasises the spatial dynamics of the poem as a verbal icon), the sound of the train's approach is likened to the

> thud
> Of thousand pink-soled apes, no humorous family god
> Southward, storm
> Smashes the flimsy sky.[49]

The poem weaves in and out of mythic and futurist modes of recognition, playing on the slow confusion of the passengers on the platform to comprehend the deafening apocalypse that is heralded by the train's oncoming:

> Scared faces lifted up,
> Is the menace bestial or a brusque pleiad
> Of gods of fire vagabond?
> Quick, just in time, quick, just in time; ah!
> Trees in light dryad dresses.[50]

The punctual arrival of the locomotive is marked by its rapid assimilation back into the mythological woodland-place spirit of the nymph and faun. The train is distinguished not by its shock tactics but by its failure to unsettle the sleepy indolence of the modest country station. Without alarming the native scene, the sound of the train's arrival signals ('ah!') a return to the anthropomorphosis of the parish pump. The questionable return of the Arcadian imagination ('Trees in light dryad dresses') for which the nymph Daphne serves as an obviously eroticised counterpart is undercut by the final stanza, and the image of the station suddenly evaporates – 'Birds (O unreal whitewashed station!) / Compose no more that invisible architecture' – which brings the poem to a sharp ending on that impulse to de-create.[51]

The first poem of *Echo's Bones and Other Precipitates* (though the last to be written) is much more resolute in its departure from the airs of Irish melody and is entitled 'The Vulture'. As is evident from Beckett's annotated copy of the collection, 'The Vulture' is based on the first five lines of Goethe's *Harzreise im Winter* (1777), which reads as follows:

> Dem Geier gleich,
> Der auf schweren Morgenwolken
> Mit sanftem Fittich ruhend
> Nach Beute schaut,
> Schwebe mein Leid.
>
> As a vulture would,
> That on heavy clouds of morning
> With gentle wings reposing
> Seeks for his prey –
> Hover, my song.[52]

The opening poem in *Echo's Bones* counters the restorative utterance of the original source by employing death as a metaphor for artistic creation. A disembodied 'skull shell of sky and earth' offsets the transcendent subject of the lyric.[53] Hovering above in the title, 'The Vulture' is desperate to insert itself into the main textual body, but is denied by a present participle on two separate occasions: 'dragging … // stooping …'[54] The predator waits in spite of these deferrals for the 'tissue' to break down before it can finally enter the carcass, just as the reader waits impatiently for a main verb that is

indefinitely withheld, and eventually replaced by the noun 'offal', meaning rubbish.[55]

Where the 'I' in *Intercessions* is invested in the outward phenomena it experiences (MacGreevy even compares Devlin to St Francis in his review of the collection), the speaker in *Echo's Bones* is cruelly divided from the outside world.[56] Repressed utterance and sexual impotence are the all-too-frequent counterparts of failed communication, which is registered with extreme irony in the lyric. In 'Alba', the pronominal address is suspended indefinitely to frustrate a sense of impending arrival ('before morning you shall be here').[57] The failure of the speaker to unite in this poem with the second person frustrates the erotic desires of the self, bringing them back to the point of origin: 'only I and then the sheet / and bulk dead'.[58] Beckett uses the lyric to characterise an empty awakening across the embroidered patterns of an absent lover's nightdress. 'Alba' first appeared in 1931 in the October–December edition of Seumas O'Sullivan's *The Dublin Magazine*. The poem 'Da Tagte Es' ('The Dawn Comes') was also submitted to O'Sullivan's magazine, but was not included in any edition.[59] Here, 'the sheet astream in your hand' is transposed from an erotic wipe into a handkerchief being waved from a death ship.[60] The title of this poem is directly influenced by the generic theme of loss and separation in Heinrich von Morungen's 'Tagelieder', a love song of the Middle High German period (medieval *Minnesänger*) based on Walther von der Vogelweide's 'Nemt, frowe, disen kranz' (*c.* 893) ('Take, lady, this wreath') that Beckett accessed during his reading of J.G. Robertson's *A History of German Literature*, each verse of which closes 'da tagte es'.[61] Beckett's 'Da Tagte Es' focuses on the moment of disillusionment towards the end of Morungen's poem when the poet's awakening from the raptures of love transforms the meditation.

Throughout *Echo's Bones*, Beckett undermines any strategy of personal deliverance that the speaker might derive from the natural world. At the beginning of 'Serena II', a number of Irish locations (the Pins, Clew Bay and Croagh Patrick) are recast in a twilight setting that resembles the convulsions of an ageing female dog.[62] In another evening song that Beckett sent to MacGreevy, entitled 'Serena III', the division of the speaker from the natural world falls back upon a landscape of sexual insistence: a 'brand-new carnation' of 'mammae', 'Butt Bridge' and 'cock up thy moon'.[63] In 'Sanies II', a poem in which a voluptuous Barfrau enchants her local audience, the lyrical act of apostrophe is reversed as a form of sexual pleading or

broken supplication: 'I break down quite in a titter of despite / hark'.[64] Even the line breaks of this poem are characterised as extorted utterance, the deliverance of which is synchronised with the flagellant strikes of the escort Madame de la Motte's 'cavaletto supplejacks'.[65] Alongside these playful treatments of dawn and evening settings, the prospect of sexual fulfilment allows Beckett to satirise the 'Celtic' twilight and to widen the discrepancy between pre- and post-lapsarian phases of vision. In 'Serena II', a series of disappointments are connected to the 'crapulent hush' of 'this damfool twilight'.[66] In 'Dortmunder', a poem that is set in a brothel, the 'long night phrase' culminates only in paralysis.[67] Rather than suppress the distance between self and other in an act of false sentiment or desired intuition, the poems in *Echo's Bones* estrange the subject from the object of utterance ('dragging … // stooping … // mocked …'), place the self at the centre, and redirect the perception of external phenomena towards a sexual need. The broader purpose of this strategy is to deny the climactic visions that the lyric once featured.

In *Poems*, MacGreevy plots the waning of the national body politic. As Brian Coffey writes in 'Nightfall, Midwinter, Missouri', which employs the 'you' of song to capture the lost public arena between the first-person speaker and the older Irish poet, 'Dear Tom, in Ireland / you have known / the pain between / its fruiting and the early dream / And you will hear me out'.[68] MacGreevy's five-part sequence poem 'Crón Tráth na nDéithe' – an Irish approximation of 'Götterdämmerung' ('Twilight of the Gods') – is one of the few poems to have been written about the Irish Civil War. Susan Schreibman has noted that 'Cróntráth' (dark time), which is usually one word, may have been separated by MacGreevy to emphasise the 'dark' element.

> When the Custom House took fire
> Hope slipped off her green petticoat
> The Four Courts went up in a spasm
> Moses felt for hope
>
> *Folge mir Frau*
> Come up to Valhalla
> To *Gile na gile*
> The brightness of brightness
> Towering in the sky over Dublin

The dark sloblands below in their glory
Wet glory
Dark night has come down on us, mother
And we
Do not look for a star
Or Valhalla

Our Siegfried was doped by the Gibichungs.[69]

Surveying the wreckage from which a new nation has arisen, the speaker questions what has survived and what has perished. *Folge mir Frau* (literally, 'follow me wife') is taken from the final scene of Wagner's *Das Rheingold*, where Wotan invites Fricka to 'Come up to Valhalla' (the home of the gods). With the visual citation of the Valhalla leitmotif, the poem extends Wotan's invitation to the mountaintop fortress to dissonant effect. As we follow this ambition to the Irish '*Gile na gile*' ('Brightness of brightness') that Beckett celebrates in his 1934 review in terms of a moment of 'pure perception',[70] the reader is interrupted by what is really 'towering in the sky', which is the smoke rising from the Four Courts, a building that had been occupied by republicans opposed to the 1921 Anglo-Irish Treaty.[71] Rather than echo the rise of the land into a triumphalist nation state, the poem marks the event that started the Irish Civil War.

Rhyme and melody are omitted from the poem the better to prise apart the association of national fulfilment with song. 'Wet glory' is a surprising, orgiastic image. The passage is strangely disconcerting in the way it deploys the standard images of female virtue to undercut the idea of heroic struggle, with the apostrophes to wives, goddesses and the vacant appeal to 'mother' forestalled until the end of the following line. What is generated here is an idea of political fulfilment that is predicated on Ireland's ability to rise out of mythological identification and her simultaneous inability to rise out of it. The reiteration of 'glory' as 'wet glory' on this 'Dark night' continues

the image of the fertility goddess that inhibits the historicity of self and world, echoing an earlier, more devious allusion to Robert Browning's 'Love Among The Ruins' (1855).[72] Though the passage subverts the idea of a romantic national heritage, the speaker is still determined to ask questions about where the people might be found and how to restore them to their usurped nationhood ('our Siegfried was doped by the Gibichungs').

Following the conceit between Wotan's fortress and the newly founded Irish Free State, the fifth and final section of the poem addresses the new home of the Free State parliament. A cenotaph commemorating the Free State's two founding fathers (Michael Collins and Arthur Griffith) had been erected on Leinster Lawn directly in front of the statues of Prince Albert and Queen Victoria on 12 August 1923.[73] Susan Schreibman explains that '[t]he Cenotaph was a plaster and timber construction with a stylised Celtic cross flanked by walls with medallions (one on each side of the cross) for the two founders of the state; an Irish inscription translated, "to the glory of God and the honour of Ireland", was on the cross shaft'.[74] Here, the speaker edits out the inscription when passing by Leinster Lawn on the final stage of the cab journey, highlighting the futility of the public tribute: 'This plaster riddle-me-riddle-me-rie / Backfiring on Albrecht der Jude, / Rotting rain-soaked wreaths against it'.[75] The present participle ('Backfiring') stresses the cenotaph's moulding as simply another moment of military reprisal rather than as a foundational gesture. Indeed, the construction of the 'Griffith-Collins-O'Higgins plaster memorial' – as MacGreevy refers to the cenotaph in his 1934 lecture 'A Cultural Irish Republic' following the addition of the O'Higgins plaque in 1927 – directly in front of the two British regal statues finds its place among the superficial insignia of what MacGreevy had feared in that speech might turn out to be no more than an 'Anglo-Irish-cum-London-Irish cultural province'.[76] 'Crón Tráth na nDéithe', which is date marked '*Easter Saturday 1923*', was completed shortly after MacGreevy's arrival in London in 1925; however, he chose to set it exactly seven years on from the day that the leaders of the Easter Rising had surrendered. '*Easter Saturday 1923*' connects this poem both to the fixed parameters of a single year and to the moveable feast of Easter, which can be sounded out across Christian time. The postscript suggests that this poem is very much a response to Yeats' 'Easter, 1916', even though MacGreevy passed the transcript to Eliot for consideration and, in his notes to the poem, credited Joyce openly.[77]

The legacy of another failed insurrection – the Siege of Kinsale (1601), which forced Red Hugh O'Donnell into exile – is the subject of MacGreevy's most celebrated nationalist poem. In 'Aodh Ruadh Ó Domhnaill', the speaker expands upon a staccato dialogue with a Spanish priest while rubbing at inscriptions in a foreign graveyard, trying to find the resting place of the Irish rebel who was buried in a now demolished chapter of the Franciscan monastery in Valladolid. Though the exact location of the tomb remains unknown ('asking where I might find it / And failing'), the speaker in the sixth stanza creates through the act of perception the very object he has failed to find: the 'blackening body / Here / To rest'.[78] As J.C.C. Mays notes, MacGreevy creates in a manner akin to Yeats' 'The Funeral of Harry Boland' (1922) 'the sense of glory he laments and establishes the sense of connection he has described as physically not there'.[79] Underlining this symbolic act of retrieval is a lengthy parenthesis that intercedes with the recent deaths of Ireland's political prisoners: 'Not as at home / Where heroes, hanged, are buried / With non-commissioned officers' bored maledictions / Quickly in the gaol yard ...'.[80] Here, the speaker's imaginative relationship with an assassinated rebel of the seventeenth century is suddenly juxtaposed with the ongoing horrors of the present moment that he cannot transcend.

A series of state-sanctioned executions, which MacGreevy witnessed on 14 March 1921, are recounted in 'The Six Who Were Hanged'. Formerly entitled 'Dublin Dawn I' in MacGreevy's 'Paris Notes – Walking to Mountjoy', 'The Six Who Were Hanged' is set outside Mountjoy Gaol, where six republican prisoners were executed: four on account of high treason, two in connection with the murders of British officers.[81] According to Dorothy Macardle's interpretation of this episode in *The Irish Republic: A documented chronicle of the Anglo-Irish conflict and the partitioning of Ireland* (a book that has 'official' status in republican accounts of the period), the bells tolled at each hour from six o'clock in the morning, marking three pairs of executions.[82] In 'The Six Who Were Hanged', MacGreevy aligns the breaks of the stanzas with the sounding of the chimes at each hour so that the timing of this historical event coincides directly with the dawn song. The poem ends with an appeal to the reader:

And still, I too say,
Pray for us.

Mountjoy, March, 1921[83]

Surrounded by hundreds of women and girls holding up crosses ('There are very few men. / Why am I here?'), the speaker merges his voice with the public through the condition of prayer.[84] The speaker's method in this scene of a papal Mass refuses personal disaffiliation from the appalling spectacle by insisting on the reader's active participation, so that the mirrored assent of an imagined audience marks the lyric's real 'epilogue'.[85] The 'I too' highlights the need for a (implicitly Catholic) community at precisely the moment that the personal and the public have reached a point of crisis: '*Morning Star, Pray for us!* / / What, these seven hundred years, / Has Ireland had to do / With the morning star?'[86] The altercation that is set up between the inner transcendence of lyric and the satire of reported speech is held together in counterpoint as the reader is invited to reassemble these fragments into a more coherent whole.

In 'Giorgionismo', the speaker falters again in a manner that recasts the alienation effect of horror as at root a shared experience. The poem is set in the cinema; indeed, 'Cinema' was the original title for the manuscript draft before it was published in the 1931 May–June–July edition of *The New Review*.[87] Though the experience of a violently uprooted world is this time mediated by the film screen, the speaker is faced with a comparable dilemma about whether to watch the appalling spectacle. Without resolving this ethical impasse, the 'I' proceeds with eyes wide shut:

> In the darkness
> I close my eyes
> To the German sadism on the screen
> And the recessionalist lovers
> Around me.
>
> I recede too,
> Alone.[88]

The speaker's refusal to watch the filmed violence is connected to 'recessionalist lovers / Around me', who are referred to for their human capacity to distance themselves from the spectacle. Just as lovers act alone together, oblivious to the film and the wider public, so, too, the speaker retreats from the screen into the darkness. As one of many 'I's / 'eyes' that recoil simultaneously from the motion picture, the final 'I' is at once 'Alone' and implicated ('too') in the space from which the film is being observed.

Whether faced with the hanging of republican revolutionaries or with a malevolent display of German sadism, the function of 'too' here, in relation to the 'I' of the lyric, prevents politics and the lyric from drifting apart. Without lessening the experience of individual alienation in the face of violence or implying a false collective identity that denies the separate feelings of each audience member, the poem applies the intensity of personal feelings to events that are collectively experienced.

When reviewing the 1934 Heinemann edition of *Poems* for the *New York Herald Tribune*, Eda Lou Walton found MacGreevy 'interesting because in thought he manages somehow – and it is difficult to understand this – to combine a revolutionary and a religious intensity'.[89] Stan Smith picks up on only half of this dynamic when he objects that the self is simply 'played-out', 'diminished', 'finished', and 'dwindl[es] into stasis' in MacGreevy's poetry.[90] According to Smith, the 'I' of the poet labours under the recessional features of 'exhausted indifference'.[91] Smith takes issue with the way the reader is compelled to observe the scene 'in purely aesthetic terms, as a spectacle, an event in nature, without human consequence'.[92] But this is not the way the poems record the violent realities with which they are encumbered. In 'The Six Who Were Hanged', the speaker reverses the ascensionist movement in relation to the 'epilogue pair' of republican prisoners:

The sun will have risen
And two will be hanging
In green, white and gold,
In a premature Easter.[93]

The 'purely aesthetic terms' that Smith cites are in fact the most heavily historically mediated. Much like Beckett's treatment of the dawn and evening song, an untimely occurrence ('a premature Easter') is used to undermine the perception of beauty or awakening. Political advantage is assigned to linguistic irony, as opposed to any overt message, which deepens in the faltering voice of the lyric. The formalist imperative of 'making strange' – of mimesis through the hardened and alienated – extends in MacGreevy's verse in a manner surprisingly consistent with his Catholic convictions. Wallace Stevens, whom Smith cites as the starting point for his essay on MacGreevy, had observed this tendency in detail when corresponding with the Irish poet during the late 1940s. In a letter to MacGreevy dated 6 May 1948, Stevens refers to MacGreevy's 'Homage to Hieronymus Bosch' to

demonstrate how the 'unearthly' has been reordered to fall back upon, and re-examine, the 'real':

> High above the Bank of Ireland
> Unearthly music sounded,
> Passing westwards

I thought about these lines of yours. Arranged as they are with the reality in the first line one's attention is focused on the reality. Had the order been reversed and had the lines read:

> Unearthly music sounded,
> Passing westwards
> High above the Bank of Ireland

the attention would have been focused on what was unreal. You pass in and out of things in your poems just as quickly as the meaning changes in the illustration that I have just used.[94]

Stevens recognised the mimetic charge that MacGreevy had left intact when experimenting with aesthetic effects. As is evident from the ordering of the lines, which proceed from the concrete to the spiritual, the metaphysical vision in this poem is neither escapist nor purely aesthetic but intended to heighten a sense of passionate contrast between the actual and the ideal.[95] While Stevens does not pursue the circumstances that gave rise to the poem, the political context that frames it challenges any prior conceptions we might have had about its fantastic dimensions.

'Homage to Hieronymus Bosch' is written in response to the fate of Kevin Barry. The eighteen-year-old IRA Volunteer had been captured by the British military and sentenced by court martial after an abortive ambush on a British army truck by republican militants had led to the deaths of three British soldiers (two of the British infantrymen who had been shot were of a similar age). MacGreevy later wrote in reply to the secretary of the Society of Authors that he was trying to capture the feeling of being an inhabitant in a nursery after the provost of Trinity College had turned down his appeal that Barry ought to receive only authorised legal handling, instructing him not to intervene: 'our appeal was that he should be reprieved only long enough for it to be verified that he had British justice and not

torture. Only two or three of the signatories were nationalists.'[96] As a former British officer, MacGreevy must have felt paralysed and infantilised by the provost's decision, knowing that Barry was likely to be violently interrogated for information. The poem opens with a surrealist fantasy of the 'boy' and the 'lipless' spirit of the nation he holds dear:

> A woman with no face walked into the light
> A boy, in a brown-tree Norfolk suit,
> Holding on
> Without hands
> To her seeming skirt.[97]

In a rough allusion to the central panel of Bosch's *The Garden of Earthly Delights* (*c.* 1500), the boy and the woman are accompanied by a 'nursery governor' who flies out of the well of St Patrick before receding back again into the underworld:

> [...] his head bent,
> Staring out over his spectacles,
> And scratching the gravel furiously,
> Hissed –
> The words went *pingg!* like bullets,
> Upwards past his spectacles –
> *Say nothing, I say, say nothing, say nothing!*[98]

A grotesque vocal performance dramatises the imperative to stay silent. Words are given a life of their own, ricocheting 'like bullets' in allusion to their suppressed subject matter: the formal resolution of British justice in response to republican violence. While following the flight of the words 'Upwards' past the governor's spectacles, the speaker is shocked by their patrician glare: '*Say nothing, I say, say nothing, say nothing!*' As the pressures of banned speech spread and multiply in contagion, utterances are severed from their speaker's intentions: 'I might have tittered / But my teeth chattered / And I saw that the words, as they fell / Lay, wriggling, on the ground'. 'Bowed obsequiously', the words turn and join in an irregular 'stomach dance' with 'brothers and sisters'.[99]

This chapter has been concerned with the difficulty of staging an authentic voice in the public sphere. As I have read from specific moments

at which the lyrical voice falters, an impassable tension is maintained in all three collections of verse between the need for detachment and the need for fulfilment. In Devlin's *Intercessions*, the speaker vacillates unpredictably between a sense of resistance and attraction to mythical archetypes that he cannot easily overcome. In Beckett's *Echo's Bones*, by contrast, the 'I' is split off entirely from the social world to produce a deviant poetic persona. In MacGreevy's *Poems*, however, the speaker uses a sense of division from society to imply a change in the way that the national landscape is rooted. Where Beckett recasts dawn and evening settings based on Provençal genres (the *serena* and the *aubade*), MacGreevy admits live historical pressures into his verse as *faits sociaux* of Ireland's political turmoil. These pressures are often appended to his poems with an exact time, date and location.

Beckett was aware that MacGreevy's comprehension of a fragmented world, while overlapping in some respects with his own aesthetic objectives, was by no means prototypical of the concerns that he had expressed in 'Recent Irish Poetry'. Theoretical constraints did not simply add up for the war veteran, who had no reason to believe that the world as he had experienced it could be stripped of empirical certainty or denied as inaccessible. Nor could MacGreevy share Beckett's enthusiasm to state the intervening space between the speaker and the surrounding landscape as 'no-man's land, Hellespont or vacuum', which he saw used more often by his contemporaries to justify attitudes of social and intellectual retrenchment.[100] MacGreevy's widening of the speaker's voice engenders the source of utterance differently from that of either Beckett or Devlin – providing the speaker with all the 'Thomistic' imperative to face the world head on. As he declares in a jotted notebook fragment:

> Platonism, Christian or Pagan, Florentine or English, is Puritanism, spiritual cowardice and inimical to healthy art while Thomism on the contrary encourages the individual to face everything and is bound to make for the objectifying of all that may be objectified.[101]

In this revealing excerpt, MacGreevy asserts that Thomism has not only a fundamental and necessary relationship with civic life but that it is essential to the 'healthy' positioning of art within that context. The statement corroborates with the poetic efforts we have seen that counter a 'Puritanical' sense of isolation with a 'Thomistic' sense of the indivisibility of one 'I' from another. As is evident from the collective orientation of the first-person

pronoun, MacGreevy stresses the authenticity of personal experience as a plural value where the 'I' that cannot join with others cannot know the meaning of 'I' in the singular. We have seen this process at work in the reactive principle ('I too') that returns the isolated individual to collective spaces in several poems. MacGreevy's dual emphasis on apartness and association can seem less like trying to have it both ways if we consider the opportunities afforded by defamiliarisation. Interestingly, the speaker's voice is far more direct in his unpublished poems. As Susan Schreibman has shown in 'The Unpublished Poems of Thomas MacGreevy: An exploration', MacGreevy deliberately impersonalised the 'I' during subsequent revisions.[102] An early typescript draft of a poem entitled 'Appearances' provides evidence of just how direct this voice can be. Here, the 'I' does not fall into silence, or realign itself within a Catholic collective, but addresses the reader directly through the security of its own achievements:

> It appears to you
> As a provincial-minded mentor
> That I have not kept faith.
>
> I understand
> And though cynics explain
> That one never explains
> I, not being a cynic,
> Shall explain
> Thus much:
>
> The concessions I have made
> Have been due, for the most part,
> To immaturity.
>
> Those I may make will be imposed
> But patently
> By material necessity.
> And – envoi –
> Though I may appear to have defaulted,
> I still hope –
> More – let me not be dishonest, I believe –

That, in time,
My name will serve as a rampart
To the integrity of an Ireland
Which appearances are always against.[103]

What we are confronted with here is not the singular spectacle of a self-fashioning subject but a comparatively unified 'I' responding to the external pressures that lay siege to it. The speaker voices itself apart from a backward audience, or *arrière publique*, as is apparent from the association of the apostrophised 'you' with 'a provincial-minded mentor'. Continuing the pronominal address to the second person, the speaker reverses the accusations of disloyalty with which he is presented, throwing in six concessive clauses ('And […] / I still hope […] / That […] / My name will serve as a rampart') that play on the idea of 'default[ing]' before finishing the original sentence impulse, which ends on the preposition 'against'. By distancing the self entirely from the accusative tense, the 'I' counters the conservative demand to be 'once again' with the future-oriented 'yet to be'. The 'concessions' that the speaker includes in the verse are not apologetic but aspirational, allowing the distance to pass – 'in time' – between the act of self-perception and the reformed or mediated concept of the nation that the 'I' intends to serve. Only through a prolonged, antagonistic loyalty to 'an Ireland / Which appearances are always against' can the speaker insert the autobiographical self at the heart of the poem. In its bare, unpublished, stripped-down form, the lyric registers the complexities of this dynamic as a sign of personal intent aimed at the Free State's jurisdiction. MacGreevy's refusal to accede to the demands of the existing culture in Ireland provides part of the context for his move to Paris in 1927 and is the subject of the next chapter.

2
MacGreevy as Parisian *Littérateur*, 1927–33

··

So you have got to your Hy Brasil, Paris. I imagine you will find distant mountains are not so blue as they appear to the traveller who sets out to walk them. Perhaps Ireland may appear quite blue so far away as Paris is.

George 'AE' Russell to MacGreevy: 08/03/1927; TCD MS 8117/23

I am genuinely pleased to have changed from London to Paris. I regard it as a step on the way home. I gave myself three years to work my passage around the grand tour so to speak and back.

MacGreevy to 'AE' Russell: 10/03/1927; TCD MS 8117/24

George Russell wrote with the pseudonym 'Æ'. From 1923 to 1930, he edited the weekly journal the *Irish Statesman*. An influential editor and poet, Russell occupied an important space in the small world of Dublin letters. These two messages appear to have crossed in the post. The dates are too close to constitute a reply. MacGreevy's desire to engage intermittently with artistic life in Paris is framed by his compatriot as an idealised escape – as an *exotic* departure from the immediate concerns of Irish culture. In a knowing jibe directed at MacGreevy's art-historical interests, Russell casts a blue-filtered lens over his compatriot's future engagements. In response, MacGreevy once again plays on the idea of defaulting, recasting his time abroad as *Wanderjahre* (journeyman years) that are entirely compatible with his beginnings ('a step on the way home'). Russell's jovial assertion that MacGreevy had merely

substituted the pressures of his native homeland for a lifestyle of exotic estrangement is clearly brushed off by his addressee's incoming letter, which articulates a backward projection of experimental tensions from a vantage point beyond the nation's borders. The dispute as to whether MacGreevy's engagements in Paris signal a journey 'from' or 'to' Irish identity offers a provocative angle into this chapter. By January 1927 (two months before Russell's letter, cited above), MacGreevy had arrived in Paris as *lecteur d'anglais* at the École Normale Supérieure. This chapter considers his literary activities in Paris, where he lived until December 1933.

WRITING IN *TRANSITION*

Unlike the short lifespans of *The Klaxon: An Irish international quarterly* (which made only one appearance, in the winter of 1923), *To-Morrow* (1924; *To-Morrow*'s third issue never arrived) and the later *Ireland To-Day* (1936–38; eventually boycotted by Irish newsagents), *transition: An international quarterly for creative experiment* (1927–38) served as a reliable platform for Irish avant-garde work and helped to create a synergy in international debates about politics, metaphysics and language innovation. MacGreevy's arrival in Paris in January 1927 coincides directly with the publication of the journal's first issue. More of his poems feature in this international quarterly than in any other publication.

MacGreevy's decision to publish with *transition* was not always borne out of a positive engagement with like-minded experimentalists. In his 'Autobiographical Fragments', the notion of 'living' in Paris 'for the best part of six years' is qualified as 'Living not in Montparnasse or among the kind of people who write for Transition [*sic*], but amongst French people, ordinary French people not necessarily writers …'.[1] In turn, some of *transition*'s chief contributors found MacGreevy's civic nationalism hard to take.[2] More often, the placement of his work in the international quarterly appears to have been generated by a lack of alternatives. Russell's extremely cautious editorial judgement had left MacGreevy frustrated with the *Irish Statesman*'s stance on intellectual liberty, which he viewed by the late 1920s as a lackey for the status quo. Though broadly a Romantic liberal, Russell was afraid to publish work that was likely to attract the attention of the censors.[3] In a letter sent to MacGreevy during the summer of 1929, Beckett reports trying to get the manuscript of 'Assumption' published in Ireland, which had been

turned down by the *Irish Statesman*: 'I would like to get rid of the damn thing anyhow, anywhere (with the notable exception of "transition"), but I have no acquaintance with the less squeamish literary garbage buckets.'[4] Beckett is ironising the available options here in full knowledge of the blasphemous nature of his composition. In the end, the prose fragment *was* published in *transition*.[5] Still more revealing, given his reservations about the French journal, is the author's decision to offer *transition* his 'cul de réserve' – the unpublished 'Censorship in the Saorstát' – which Beckett updated along with the new censorship-registry number that he had received for his short-story collection *More Pricks Than Kicks*.[6] By 9 April 1936, Beckett had granted permission (via his literary agent George Reavey) for *transition* to publish any of the poems it wanted from his 1935 collection *Echo's Bones*.[7]

Despite their reservations about *transition*, MacGreevy and Beckett depended on the journal not only for the distribution of their creative and critical material but also for aesthetic debates and programmes that could shape and inform their work.[8] In Ireland, there had been a revolution but no 'Revolution of the Word' edition, which was the title of *transition 16/17*. Both MacGreevy and Beckett's poems were featured in this issue and accompanied by a forceful credo, the co-authored June 1929 'Proclamation':

Point 3.

Pure poetry is a lyrical absolute that seeks an *a priori* reality within ourselves alone.

Point 9.

We are not concerned with the propagation of sociological ideas, except to emancipate the creative elements from the present ideology.

Point 11.

The writer expresses; he does not communicate.[9]

The points listed above anticipate many of the concerns that we have seen expressed in Beckett's 'Recent Irish Poetry'. The idea of 'communication' in this instance (see 'Point 11') is undercut by the writer's refusal to make his or her work convey a predictable message to the reader. 'Pure poetry' does not necessarily clarify anything, prove anything, render any verdict, or pardon anyone. Indeed, the effort to find 'an *a priori* reality within ourselves

alone' ('Point 3') seems to cast doubt upon whether the external existence of an object can be communicated. The privileging of the creative act as an inviolable necessity without an ulterior motive beyond its own realisation offers a secondary perspective for the rejection in 'Recent Irish Poetry' of 'accredited themes' that are seen to deny the self the integral force capable of challenging and reconstituting experience. In the 'Commentaries' section of *transition* 27, Beckett deploys the same categories that he uses in 'Recent Irish Poetry' to announce 'The relief of poetry free to be derided (or not) on its own terms and not in [*sic*] those of the politicians, antiquaries (Geleerte) and zealots'.[10] The articulation of an internal dimension necessary to genuine poetic discovery is stated in conscious opposition to 'the go-getters', 'the gerimandlers [*sic*]' and 'the great crossword public on all its planes' whose need to traduce the self to a familiar locale and to view culture inertly as a panacea for social problems is parodied by the anecdote that Beckett provides: 'He roasteth roast and is satisfied. Yea, he warmeth himself and saith, Aha, I am warm.'[11]

Stuart Gilbert, an advisory editor to *transition* and amanuensis to Joyce, was also one of the June 1929 Proclamation's main signatories. Like Beckett, Gilbert argues for the importance of preserving distance between the 'sincere creator' and the dominant view of social reality that is being perpetuated. The idea of 'expression' that Gilbert advances in 'The Creator Is Not a Public Servant' (in full view of 'Point 11') is by no means opposed to the goal of 'communication' but intended to liberate the writer from constantly deferring the creative impulse to that end during the early stages of composition so they are 'not playing to a gallery of angelic harpists or canvassing the celestial proletariat'.[12] Continuing to uphold the 'sincere creator' in terms that resist any prior ideological affiliation (in full view of 'Point 9'), Gilbert argues that any sociological pressures that do inform the writer's position should enter only accidentally into the creative medium if they are to avoid serving a propagandistic function. Beckett's review of Devlin's *Intercessions*, which was published in *transition* six months after MacGreevy's review of the same collection, offers a precise context within which to view these demands for artistic freedom:[13]

> Art has always been this – pure interrogation, rhetorical question less the rhetoric – whatever else it may have been obliged by the 'social reality' to appear, but never more freely so than now, when social reality (*pace* ex-comrade Radek) has severed the connexion.[14]

In this revealing excerpt, Beckett refers to the international communist leader Karl Radek, who at the 1934 Soviet Writers' Congress had dismissed James Joyce's *Ulysses* (1922) on account of its individualised, 'private language'.[15] The traditional Marxist explanation for the 'decadence' of *Ulysses* was that the aesthetic qualities of inner subjective states were irreconcilable with the truth of social life. Beckett's contention, in placing 'social reality' in quotation marks, is that art's diminishing obligation to appear as anything other than the irreducible complex in which we find ourselves foregrounds the impossible allegiance being made to such external standards. The freedom to present material irrespective of the demands of a particular public, tradition or social structure is deeply bound up with his understanding of art's capacity to inquire, remake and emancipate the expressive act from ideological pressures ('whatever else it may have been obliged by the "social reality" to appear'). Here, 'social reality' can provide no pre-established purpose for art to adhere to, explain or dissect (as Beckett is only too happy to admit in response to Radek). Rather, what is being advanced in this passage is an idea of creative expression that cannot be absorbed by rational use or justification, either as a conscious aim of the poet (who may be unaware of what she or he is communicating) or as an explanation for what their work might mean once it has been completed.

There are three points of importance that I wish to define in relation to *transition*, the very title of which signals a movement away from the rigid application of a priori ideas: the awareness of an instinctive condition of being; the refusal to crystallise a single viewpoint; and the insistence on the role of language for altering an *état-limite* or world conception. These definitions help to explain the journal's emphasis on 'reality' not as an external standard to be followed or adhered to but as a metamorphic space to be shaped by the individual subject. An earlier version of MacGreevy's 'Homage to Hieronymus Bosch' entitled 'Treason of St Laurence O'Toole' is published in *transition* 21 as part of a wider attempt to define a new form of dream poetry (hypnologue) and magic-realist narrative (paramyth).[16] A previous version of 'Crón Tráth na nDéithe' named 'School … of Easter Saturday Night (Free State)' is featured after a section in *transition* 18 entitled 'The Synthetist Universe and the Chthonian Mind'.[17] Both 'Treason of Saint Laurence O'Toole' and 'School … of Easter Saturday Night (Free State)' had their titles revised after their publication in *transition* to ones less obviously political. In MacGreevy's *Poems* (1934), they are revised as more

innocuous 'homages' to painters and composers (to Hieronymus Bosch and Wagner respectively). The allusions both to Bosch's panel painting *The Garden of Earthly Delights* (*c.* 1500) and to Wagner's *Götterdämmerung* (Twilight of the Gods) became the outright titles of these poems.

That MacGreevy took the Irish context out of the titles of his poems is fascinating. Though none of his works were earmarked for censorship (a fate that affected several of his immediate circle), the generative process of composition, rewriting and reception encouraged him to couch the political content of his work in rich art-historical allegories. MacGreevy's decision to publish more forthright earlier versions of his texts in Paris, rather than in Dublin, allowed him to address current political pressures in his poetry in ways that would almost certainly have brought him unwanted attention at home. Studying the original context of publication in the international quarterly *transition* allows us to appreciate how these political pressures are siphoned off and displaced. The future reception of 'Homage to Hieronymus Bosch' also illustrates this. As we saw from Stevens' reading of the text in the previous chapter, which finds a positive role in it for the imagination, a decontextualising force continues beyond the life of the published poem.[18]

DEFENDING *WORK IN PROGRESS*

The serial publication of *Work in Progress* over the course of sixteen issues of *transition* overshadowed in scale and inventiveness every other contribution. MacGreevy's 'A Note on Work in Progress' and Beckett's 'Dante... Bruno. Vico.. Joyce' are two of the nine essays explicitly dedicated to the text that first appeared in the French journal (in *transition* 14 and 16/17 respectively). Despite contributing actively to *Work in Progress* during his lectureship at the École Normale Supérieure, MacGreevy hardly refers to its textual detail in his autumn 1928 'Note' for *transition*, which was the first attempt to shape its critical reception. John Nash has argued that MacGreevy's 'Note' was in fact motivated by Shane Leslie's anonymous review of *Ulysses*.[19] Though Leslie is never referred to by name, Nash has identified a covert presence in MacGreevy's *transition* article that connects its exacerbated account of Catholic traditions to the political atmosphere in Ireland before the passing of the Censorship of Publications Act.[20] In an earlier article on *Ulysses* for the *Quarterly Review*, Leslie had expressed relief in the fact that 'the limited copies and their exaggerated cost will continue to prevent the vast majority

of the reading public from sampling even faintly such unpleasant ware'.[21] Clearly, the reprieve that Leslie felt for the reading public had left too much to chance. By the time of his *Dublin Review* article, which he chose to publish anonymously, Leslie had hardened his position in favour of restrictive controls being placed upon the text's circulation, calling for *Ulysses* to be added to the Index of Prohibited Books. It is in this developing context that Nash sees MacGreevy's autumn 1928 article as making a public intervention of sorts, though the erudite context of publication – both in *transition* and later in *Our Exagmination Round His Factification for Incamination of Work in Progress* (1929) – is likely to have prevented the essay from reaching a wider audience.

In 'A Note on "Work in Progress"', MacGreevy refers explicitly to the inception of a censorship committee:

> We are even now founding an Inquisition in Dublin though one may believe that it is not likely to be a very successful obstacle to the self-expression of a people who with fewer pretensions have a sense of a larger tradition than that of the half-educated suburbans who initiated the idea of a new censorship. These latter understand no more than enthusiastic converts who lay down the law to nobler men than themselves that Catholicism in literature has never been merely lady-like and that when a great Catholic writer sets out to create an inferno it will be an inferno.[22]

MacGreevy's defence of *Work in Progress* recasts the heretical author as the authentic Catholic. Compromised versions of the faith proliferate throughout this intervention on Joyce's behalf, as MacGreevy argues that it is the very qualities of Joyce's writing that have attracted condemnation. In opposition to those 'who initiated the idea of a new censorship', the article attempts to distil a 'true' Catholicism that embraces the very quality of obscenity and does not refrain from voicing 'the unsavoury element' under the 'surface beauties'.[23] As such, the article confronts the recommendation of censorship that Leslie had anonymously proposed, though the impassioned directness of this confrontation leads in turn to distortion as MacGreevy is compelled to differentiate between a Catholicism overwrought by enthusiastic converts ('temporary Romanizers') and that upheld by the insuperable 'Irish Catholic'.[24]

Both MacGreevy and Beckett identify Dante's *Divine Comedy* as a possible precursor for *Work in Progress*, though it is difficult to privilege a single line of influence in relation to the then unfinished composition. Giordano Bruno and Giambattista Vico – two of the three forerunners that Beckett mentions in his essay on *Work in Progress* – provided Joyce with a structural template onto which he could layer and fuse his narratives; however, neither the work of the sixteenth-century metaphysician nor that of the eighteenth-century political philosopher yield conclusive information about Joyce's technique. In anticipation of Beckett's future essay, which was published during the following summer, MacGreevy mentions in his autumn 1928 'Note' for *transition* that 'the working out of the parallel between the Vico conception and the reconstruction of it in regarding Dublin's life history in *Work in Progress* must wait till the complete work has appeared'.[25] MacGreevy's comments are wise given the general hurry among Joyce's younger disciples to trumpet his newest creation with explanations and examinations in advance.

When replying to O'Faolain's January 1929 letter for the *Irish Statesman*, MacGreevy repeatedly describes the serial publication of *Work in Progress* as 'a transition state' and the figures in the book as 'transitory types ... not rooted in character ... and not rooted even in language'.[26] In an unpublished memoir of his friendship with Joyce written in the 1960s, MacGreevy again defines the (by now finished) composition as 'an evocation in transitional language of an appropriately transitional purgatorial state of being'.[27] The very word 'transition' recurs throughout MacGreevy's critical discourse when defending Joyce's composition from its numerous opponents, providing a rhetorical strategy through which the destabilising effects of *Work in Progress* and its innovative techniques might be adequately represented. The choice of vocabulary, here, suggests that MacGreevy's critical voice and style is very like Beckett's. When attributing a 'purgatorial' dimension to *Work in Progress* in his *transition* essay, Beckett highlights the conflicting impulses of divided selves and the confusion of the outside with the inside dreamworld. Though he does not politicise this metaphysics of time in relation to Ireland's present dispensation as MacGreevy does in his earlier essay ('Then there is the politically purgatorial side of it'),[28] Beckett does base his arguments on a passage from *Work in Progress* that alludes to the passing of 'our social something':

as by the providential warring of heartshaker with housebreaker and of dramdrinker against freethinker our social something bowls along bumpily, experiencing a jolting series of prearranged disappointments, down the long lane of (it's as semper as oxhousehumper) generations more generations and still more generations.[29]

The experience of time that Beckett divulges from this citation illustrates how the entirety of the past and present is being sounded out in the context of post-revolutionary Ireland. The 'falls' that Joyce's work composes along a vertical line of construction are at once parricidal and political. Each generational framework takes on different forms depending upon the context of its emergence in a non-teleological, multidimensional stream of time (a strategy that the author had first developed in the 'Oxen of the Sun' episode of *Ulysses*). 'Characters' in *Work in Progress* are vacillating, broken-up bits of people that stem from random agglomerations of past and present cultures. They are simultaneously historical figures, legendary myths, and the composite sums of innumerable ancestors and poetic inventions. One of the many aliases conferred upon 'Humphrey Chimpden Earwicker' is 'Here Comes Everybody'. Both MacGreevy and Beckett attribute these polymorphous creations to a textual space in which the notion of the individual self is lost and nothing can be definitively known.

A provocative example of the disappearance of the self as a fixed or exclusive category can be discerned from the fact that these two critics themselves appear as transitory types in a later instalment of the work's circulation. To trace MacGreevy's and Beckett's transition from supporters of the project to figures in the text, I will turn to a fragment from *Work in Progress* (Part II Section 3) published in *transition* 27.[30] This fragment is built around a story Joyce's father had originally told him, called 'How Buckley Shot the Russian General', though it is enacted by what Bernard Benstock has likened to 'a pair of radio comics telling their skit'.[31] Five interludes of newsflash material punctuate the Taff & Butt sketches, serving as diversions from the central tale. In the first interlude, 'Slippery Sam' and 'Tinkler Tim' emerge from a (Dickensian) crowd of orphans and thieving urchins, placing their bets on a horserace:

A lot of lasses and lads without damas or dads, but fresh and blued with collectingboxes. One aught spare ones triflets, to be shut: it is Coppingers for the children. Slippery Sam

hard by them physically present howsomedever morally absent was slooching about in his knavish diamonds asking Gmax, Knox and the Dmuggies (a pinnance for your toughts turffers!) to deck the ace of duds. Tinkler Tim, howbeit, his unremitting retainer, (the seers are the seers of Samael but the heers are the heers of Timoth) is in Boozer's Gloom, soalken steady in his sulken tents. […]

This eeridreme has being effered you by Bett and Tipp. Tipp and Bett, our swapstick quackchancers, in From Topphole to Bottom of the Irish Race and World.[32]

The surreal tendencies of this passage embody a psychic tension (as announced by 'Bett' and 'Tipp') that speculates on the results from the racecourse (a metaphor for predestination). Competing theories of providential order are allegorised here as gambling, with Tinkler Tim's 'unremitting retainer' awaiting the Final Judgement and Slippery Sam seeking advice on how to pick the loser ('to deck the ace of duds'). There is no verisimilitude to be found except in the parenthesis that mimics Slippery Sam's Dublin brogue '(a pinnance for your toughts turffers!)'. Rather, the scene takes place in an 'eeridreme', a half-dream or 'hypnologue' as the editor of *transition* might have put it.

Both MacGreevy and Beckett served as personal assistants to Joyce in Paris. Terence Killeen has compared their relationship to *Work in Progress* to that of 'Milton's daughters', stressing their devotion to the ongoing project despite the endless demands for transcription, proofreading and copy-editing that Joyce placed upon them.[33] To Sylvia Beach on 10 May 1928 in relation to the publication by Crosby Gaige of New York, Joyce writes that 'Proof F' of the 'Anna Livia Plurabelle' section 'is to go to Wells [publisher at Crosby Gaige] *after* MacGreevy has carefully copied all my revisions on to proofs D and E. Proof D is to go to [Padraic] Colum [who wrote a preface to the work] *after* MacGreevy has copied your copy of my notes to him …'[34] Joyce used MacGreevy to transfer emendations to subsequent settings of proofs for *transition* numbers 12 and 13.[35] In a letter to MacGreevy dated sometime between 27 April and 11 May 1930, Beckett, who was completing a French version of 'Anna Livia Plurabelle' with Alfred Péron (which Joyce later withdrew), mentions Ivan Goll, who was also assisting with *Work in Progress*. 'Another slave', he adds succinctly, as if both writers were more than familiar with Joyce's exploitative use of acquaintances.[36]

The 'transitional' and 'purgatorial' qualities that they repeatedly ascribe to Joyce's new work are most powerfully supported by the rhetorical strategies of displacement that the author uses to create a multiphonic and multisignifying text. In 'Dante… Bruno. Vico.. Joyce', Beckett praises the lexical deviance of *Work in Progress* as if the words themselves were fireflies briefly illuminating the nightly half of existence: 'Here words are not the polite contortions of 20th century printer's ink. They are alive. They elbow their way on to the page, and glow and blaze and fade and disappear.'[37] Beckett describes these 'words' as living things inseparable from their signified content but does not pursue the phenomenon of Joyce's portmanteau inventions. Preserving the simultaneous presence of two or more elements through superimposition, the portmanteau exists as a verbal microcosm of Giordano Bruno's law of identical contraries (to which Beckett in his essay only gives passing mention). The superimposition of phonetically similar but semantically dissimilar words acts as an opposing force to the restrictive pressures of a singular meaning:

> Oyes! Oyeses! Oyesesyeses! The primace of the Gaulls, protonotorious, I yam as I yam, mitrogenerand in the free state on the air, is now aboil to blow a Gael warning. Inoperation Eyrlands Eyot, Meganesia, Habitant and the one but thousand insels, Western and Osthern Approaches.[38]

In this revealing excerpt, the Irish Free State's isolationist course is compared to the theatrical cartoon short *Popeye the Sailor Man* ('I Yam What I Yam'), in which Popeye is shipwrecked on an island populated by unfriendly American Indians. Syntax and place names are turned inside out to frame an impossible ideal of territorial uniqueness ('the one but thousand insels'). 'Inoperation' signals a working within, as well as an impracticable project. 'Eyot' refers to a small island off Howth in Ireland and, as a more general word, to the position of Ireland at the eye of an impending storm. The 'free state on the air' refers at once to this maritime jeopardy and to the nature of the propagandistic transmission, whose enthusiastic report consists only of perpetual self-affirmations ('Oyes! Oyeses! Oyesesyeses!'). The passage mocks the monoglot simplicity with which the idea of a pure Gaelic race is being concocted with its own ridiculous portmanteau scrabbling. 'Protonotorious' serves as an indicator of the first, foremost, most primitive, original race. At the same time, it is a prefix that is added to a simple root

to make a more complex base. Annexed to multiple roots (or *operands*), Joyce's portmanteau inventions point to an untenable ideal of pure ancestry ('mitrogenerand in the free state on the air'), serving as excess of the desire for territorial fortification and nostalgic return.[39]

It is easy to overstate the purgatorial and dystopian qualities of *Work in Progress* based on the initial shaping of the book by its defenders and to ignore the comic and redemptive registers of the composition.[40] Curse, laughter, ribaldry, goodwill and coarseness are inextricably combined throughout Joyce's final work into a single arc of feeling. In a tribute essay published in *transition* on the writer's fiftieth birthday, MacGreevy argues that Joyce has provided

> the eternal Dublin, as Dante's Florence is the eternal Florence, Dublin meditated on, crooned over, laughed at, loved, warned. Dublin with its moments of hope and its almost perpetual despair, its boastfulness and its cravenness, its nationalism, its provincialism, its religion, its profanity, its Sunday mornings, its Saturday nights, its culture, its ignorance, its work, its play, its streets, its lanes, its port, its parks, its statues; its cobbles, and the feet, shod and unshod, worthy and unworthy – if a charity like Joyce's permits the use of so final a word as 'unworthy' in relation to any human being – that walk them.[41]

The 'eternal Dublin', in this instance, is less a transcendent notion hanging over and above human affairs than a celebration of the domestic quotidian, overlaid with cobbles and traversed by bare feet. The passage rejoices in an endless structure of variation, one that negates any linear conclusions about the ends of history and echoes *Work in Progress'* unfinished state. If the range of the 'true' Catholic artist is necessarily universal and must face all aspects of life (including the 'unsavoury element' under the 'surface beauties'), then the unbroken emphasis on verbal activities demonstrates how 'Ireland' itself is being reconceived as the object, rather than the subject, of Joyce's work in an act of spiritual repossession. The revolutionary Christology that MacGreevy adopts to consider *Work in Progress* conceives of the author as a spiritual creator giving new life and blood to the nation.

Disagreement over how 'pure' or 'sincere' that creator really is informs many of the early controversies about *Work in Progress*. In an essay entitled 'Style and the Limitations of Speech', Sean O'Faolain had concluded in dismissal of the composition:

Here lies the condemnation of a language such as Joyce's. It is not merely ahistoric – not merely the shadow of an animal that never was, the outline of a tree that never grew, for even then we might trace it to some basic reality distorted and confused – but it comes from nowhere, goes nowhere, is not part of life at all.[42]

In the 'Combat' section of *transition* 15, Jolas published a response to O'Faolain daringly entitled 'The New Vocabulary:

Basing his contentions on a high respect for historicism, [O'Faolain] regards Mr Joyce's new speech as 'a-historic', as failing to be 'part of life', and chides him for running counter to the eternal laws of nature.

The most cursory glance at the evolution of English, or other languages, shows that speech is not static. It is in a constant state of becoming. Whether the organic evolution of speech is due to external conditions the people themselves bring about, or whether it is due to the forward-straining vision of a single mind, will always remain a moot question ...[43]

In its simplest outline, the debate between Jolas and O'Faolain is useful for demonstrating the irreconcilability of two positions: the one more generally representative of a loyalty to an external object ('conditions the people themselves bring about') and the other of a fidelity to an inner experience ('the forward-straining vision of a single mind'). The controversy that develops between these two standpoints allows us to appreciate the exaggerated reference points of imitation and invention, inheritance and discovery, commitment and detachment then shaping debates about Irish life (for O'Faolain, we recall, *Work in Progress* 'is not part of life at all'). Here, the classical antinomies between socialist realism and poetic invention are firmly reinstated. It is interesting to note, therefore, how in his provisionally entitled 'A Note on Work in Progress', published in *transition* 14, MacGreevy begins the essay by defining Joyce's technique as 'noteworthy' because it signals 'not a reaction from realism but the carrying on of realism to the point where it breaks of its own volition into fantasy, into the verbal materialism of which realism, unknown to the realists, partly consisted'.[44] Rather than maintain an opposition between the twin pressures of realism and invention, MacGreevy advances a supplementary relationship between

the two that softens Jolas' and O'Faolain's preoccupation with the question of literary difference.

As MacGreevy appears to have been aware from his diagnosis of realism's alter ego, the tensions between authority and consciousness will continue to resonate so long as 'realism' is either denounced or elevated as an ideal (aesthetic or otherwise). Judged by the standards of socialist realism, which tends to regard interior states as an inadequate vehicle for the expression of material and historical processes, Karl Radek was undoubtedly correct to insist during the 1934 Soviet Writers' Congress that 'trying to present a picture of revolution by the Joyce method would be like trying to catch a dreadnought with a shrimping net'.[45] However, Radek's defence of socialist realism is scarcely consistent with the counter-revolutionary pressures that had led to Irish censorship. As we have seen, the aesthetic concerns of *transition* to which MacGreevy and Beckett express allegiance serve as a more complex instance of the need to strengthen individual liberty in favour of a lyrical absolute. Their reviews of *Work in Progress* repeatedly stress its transitory form and content as a means by which to avoid ideological saturation and the illusion of a fixed self.

THE EUROPEAN CARAVAN AND THE INTERNATIONAL COMMITTEE ON INTELLECTUAL COOPERATION

MacGreevy and Beckett also worked together in Paris on an anthology project entitled *The European Caravan: An anthology of the new spirit in European literature – France, Spain, England and Ireland*. The ambitious range of this anthology project – which compiled recent criticism, poetry and prose fragments from several different nations – was overseen by the Cervantes scholar Samuel Putnam.[46] George Reavey used one of his contacts from the Cambridge journal *Experiment*, the polymath Jacob Bronowski, to edit the 'England and Ireland' section. When introducing readers to this section in the anthology, Bronowski remarks that 'some of the best criticism I have seen is by the Irish contributors to the examination of Joyce's *Work in Progress* published two years ago'.[47]

After I.A. Richards' experiments with readers' comments or 'protocols' during the 1920s, psychologists had begun to draw on the so-called 'stock' of 'organised responses', 'doctrinal adhesions' and 'mnemonic irrelevances' demonstrated by student readerships to cleanse the social inhibitions,

personal distortions and critical preconceptions that had led to epistemic regressions in their understandings of literary texts.[48] It is in this context that the creator and founder of *Experiment* perceives the recent commentary by 'Irish contributors' on Joyce's *Work in Progress* to be 'some of the best criticism' that he has encountered. Beckett's analysis of *Work in Progress*, which had been published two years prior to *The European Caravan*, begins by declaring that

> The danger is in the neatness of identifications. And now here am I, with my handful of abstractions, among which notably: a mountain, the coincidence of contraries, the inevitability of cyclic evolution, a system of Poetics, and the prospect of self-extension in the world of Mr Joyce's *Work in Progress*. There is the temptation to treat every concept like 'a bass dropt neck fust in till a bung crate', and to make a really tidy job of it. Unfortunately, such an exactitude of application would imply distortion in one of two directions. Must we wring the neck of a certain system to stuff it into a contemporary pigeon-hole, or modify the dimensions of that pigeon-hole for the satisfaction of the analogymongers? Literary criticism is not book-keeping.[49]

In this playful but honest excerpt, Beckett admits his inability to carry out a clinical diagnosis of the text in front of him. Acknowledging the sheer inventiveness of Joyce's most recent work, Beckett stresses the importance of leaving enough space between the 'philosophical abstraction' and the 'empirical illustration' if the 'real unjustifiable' dynamics of creation are not to be simply explained away. Rather than disguise his interested position as a critic, Beckett reveals his concepts like a pack of cards to the reader ('my handful of abstractions'). The implication here is that it would be far too easy to say something germane about an activity that has already been conveniently situated and plotted in advance or that has a corresponding clarification structure of its own. The striking manner in which Beckett upbraids the characterisation of literature as an inert substance that can simply be expected to follow this or that logical pattern ('Literary criticism is not book-keeping') echoes parts of Bronowski's concern about the value of extending the availability of classifications when they have so little to do with '*the powerful and beautiful application of ideas to life*'.[50] Rather than discharge the energising currents of a book into ever-widening pools of information, Beckett wants to render experience fully and to prolong the activity of

reading. He is concerned with the integrity of literature's position in the mind of the reader and its power to raise questions about the very processes that define and perpetuate it. Above all, Beckett is concerned with *depth* – with the intimate process of discovering and nurturing ideas, and being changed by them.

Jorge Guillén's 'La Salida', which MacGreevy translated for *The European Caravan*, is arguably the most powerful meditation on the theme of discovery and personal transformation in the entire anthology.[51] In 'Going Out', the tone is purely expository. Spoken language is connected to the body. The physical experience that the poem articulates is no inanimate reconstruction but a process of creation, rebirth and the deepening of an approach to reality. The reader is invited to transform their consciousness of the outer world ('to slip on the gilded freshness of summer / Thanks!'), to release the tension of primal, physical reactions ('joyful / tact of the muscles / submitted to instinct', and to see which part of the body a new awareness erupts through.[52] This process of inner investment is vital to a renewed apprehension of life, to a rekindled awareness of the variety and spontaneity of being, and to the realisation of thoughts and sensations that have enjoyed no prior expression: '(runs of virgin spaces / unheard harmonies!)'.[53] By reconditioning the present through a succession of gerunds and infinitive verbs ('going' / 'waiting' / 'to go out' / 'to slip on' / 'to drown'), the poem highlights the aesthetic effects of regeneration.[54] In conceiving the anthology for an American audience, Samuel Putnam had hoped that *The European Caravan* would mark an 'after-War spirit in European literature', a policy that is evident in his selection of writers too young to have experienced the conflict.[55] MacGreevy's contributions to the anthology take on a wider significance as its only former combatant. As we have seen from his contributions to *transition*, it was not uncommon for him to place himself in the company of younger writers, even if experience of the First World War's battlefields had cordoned him off from the more decadent parts of Montparnasse's expatriate community.

A persistent concern with finding forms adequate to the expression of a post-war spirit led him to respond to the calls of major civic organisations. The International Committee on Intellectual Cooperation (ICIC) – an interwar initiative founded by the League of Nations to promote international exchange between scientists, philosophers, researchers, teachers, artists and public intellectuals – had considerable influence at this time in Paris. Early in 1932, Paul Valéry launched a powerful appeal on behalf of the

League of Nations. As a member of the Permanent Committee for Arts and Letters, Valéry had been asked by the organisation to evolve ideas about an intellectual order that could occupy the contemporary world apart from the interests of class, party and nation. MacGreevy responded to Valéry's appeal by translating two responses from those present at the Geneva meeting – those of the Brazilian scientist Miguel Ozorio de Almeida and of the Mexican writer Alfonso Reyes Ochoa (then ambassador to Brazil) – before drafting a reply of his own.[56] His response takes the form of a personal letter to Valéry which is headed simply 'Paris, April 4 1932'.[57] In it, MacGreevy recognises 'the very soul of the Pact' under the representation of the League of Nations, the full implications of which he claims to have been one of the first to realise:

> Besides, you were one of the first to think with me that it was precisely this question of the role of the spirit in the modern world which constituted the basis of what, in the jargon of Geneva, is known as Intellectual Co-Operation. There, from the beginnings of the League of Nations, when I was only one of its acolytes, lay, for me, the role of that department, and there, in spite of those who, being politicians, only laughed, I saw *the very soul of the Pact*, the idea which, in two or three centuries, historians would possibly consider to have been the most fertile of those the first World Charter erected into universal laws.[58]

What MacGreevy and Valéry foresee in this sponsorship of transcendent order marks not only one of the 'most fertile' achievements of the interwar period but also a distinctive alliance of poets. Their kinship with the first World Charter sounds alike with Percy Bysshe Shelley's conception of the poet as 'the unacknowledged legislator of the world': a figure who can rival civil, commercial and religious power by giving expression to an indestructible order deep inside the community.[59]

MacGreevy appears to have been on visiting terms with Valéry from the beginning of his time as a Normalien.[60] His translation of Valéry's *Introduction à la méthode de Léonard de Vinci* had a major impact on the style of appreciative art criticism that he would practise later in Ireland.[61] In the revised preface to the book on da Vinci, which was written in 1929 specifically for MacGreevy's translation of the book into English, Valéry realigns the concept of divinity with the enlightened, rather than the mystical, intelligence:

What could be more alluring than a God who repudiates mystery, who does not erect his authority on the troubles of our nature, nor manifest his glories to what is most obscure, sentimental, or sinister in us? Who forces us to agree rather than to submit, whose mystery is self-elucidation, whose depth an admirably calculated perspective. Is there a better sign of authentic and legitimate power than that it does not operate from behind a veil? … No revelations for Leonardo. No abyss opening on his right. An abyss would make him think of a bridge. An abyss might serve for his trial flights of some great mechanical bird …[62]

Valéry's Catholic imagination, operating under da Vinci's motto of *hostinato rigoro* (obstinate rigour), appears to have exerted a powerful hold on the translator. MacGreevy's taste in metaphysics was anything but quietist. The angels could be found dead on arrival, as in Raphael Alberti's poem of that name, 'Los Ángeles Muertos', which MacGreevy later translated for *The European Caravan*. Neither was it 'humanistic' in any affected sense of the term. 'Yes, my dear Valéry', MacGreevy writes to the newly elected French academician,

> I know that the word 'humanity' is a beautiful abstraction, damp with sentimentalities, and that if one so much as touches it the result is cascades of tears. Meanwhile, I shall continue to employ this one to indicate, without emotion, the whole of mankind, understood as an organic unity in the state in which we are living.[63]

It is out of his own experience of global conflict, civil war and cultural dislocation that MacGreevy writes in Valéry's confidence for a spiritual order that can incorporate chaos, flux and destruction into its overarching vision. 'Are we merely pieces of wreckage?' he queries. 'In any case, we have the incongruous aspect of bric-a-brac.'[64] Here, MacGreevy emphasises the mind's potential to shore the groundless fragments of a fractured landscape in ways that imply a holistic integration of subjective experience.[65] In *The Universal Self: A study of Paul Valéry*, Agnes Ethel Mackay argues that by analysing the scattered differences of things, optimist without hope, idealist with one unlimited ideal, Valéry had raised the human mind to the highest possible consciousness and unity; and re-established poetry to the classical status of a formal art, an art of thought, a spiritual construction. By this

means he proposed for humanity a new intellectual and universal Self, of whom the Angel remains a symbol for future generations.[66]

The urgent need to find 'an organic unity', as MacGreevy puts it when addressing Valéry, intersects with his views on national identity. In response to Valéry's 1932 appeal against the pressures of territorial division, MacGreevy examines the freedom of Christian civilisation in Europe before the nation states began to form themselves around the Thames Valley, the Île-de-France and the Castilian Plateau. Then, he claims, there was little possibility of exile or misconnection:

> In that diaphanous world there were always clerks – since we must call them by their name – coming and going. They moved from Paris to Bologna or Oxford or Salamanca without any particular feeling that they were exiling themselves, no more than if they moved from Aragon to Castile, from Provence to Picardy, from Milanese into Venetia.[67]

It was as 'three powerful nations' – France, England and Spain – came into being that a wedge was driven, according to MacGreevy, between Christianity and the Christian, 'disintegrating the one by opposing their sovereignty to it, crushing the other by opposing their absolutism to him'.[68] Through this idealised image of the medieval Christian citizen, MacGreevy's act of intellectual cooperation seeks to defend the mind from inner partition and to widen present standards of national commitment.

Vital questions arise from the dialogue between MacGreevy and Valéry about the role of the nation and what form its civic particularism should take. Can any intellectual order really constitute a presence more solid and compact than certain political formations of the nation state? Though the accuracy of these speculations may be disputed, one thing is clear: MacGreevy's correspondence with Paul Valéry and interactions with the ICIC serve as further examples of his desire to improve the spiritual and collective lives of individual nations. In the aftermath of the First World War, forging new partnerships and cultural exchanges had become not only a matter for politicians but for scientists, philosophers, researchers, teachers, artists and public intellectuals of all social backgrounds and ideological persuasions. MacGreevy's literary activities in Paris, as described in this chapter, reveal the importance of his social position in international cultural

debates of the late 1920s and early 1930s. These Parisian engagements and exposures were formative for his aesthetic and critical development as well as for the cultural reforms that he would eventually bring to Ireland.

3
MacGreevy and Postimpressionism

· ·

Writing as chief art critic for *The Studio* in London in 1938, MacGreevy suggested the ways in which postimpressionism informed his aesthetic:

For present-day painters, impressionism must, of necessity, be academic. Art is the most vital expression of the world at any moment of its history. But our world is not Monet's world. Neither is it Cézanne's world. Our point of departure is different, and our art must inevitably be different from theirs.[1]

At the heart of this ambition for cultural reform – and here we refer to the conspicuous use of collective pronouns ('*our* world / '*our* point of departure' / '*our* art') and to the provocative description of the impressionist movement as, by now, 'academic' – is a decision about how best to transform public taste with new lines of artistic inquiry. Roger Fry had helped to structure the transition away from the impressionist movement with his relentless promotion of 'postimpressionism': a term that he had coined with the secretary of the exhibition committee, Desmond McCarthy, at the 1910 and 1912 showings in London (to highly sceptical British audiences).

In abandoning the two most basic rules of Renaissance painting, the postimpressionists had changed the whole face of the arts. Their first ambition was to reject the Renaissance perspective mechanism that was developed during the Florentine quattrocento as a single 'vanishing' point or unifying source. This meant a return to the two-dimensional plane or canvas, where the traditional demands of perspective could be transformed by rotating the object of the perceiving gaze across a variety of angles and intersecting planes. Their second ambition was to paint *without* subject.[2]

By 'subject', I refer to the figurative representation of things seen, such as fruit, landscape and people. This second ambition altered art's focus to explore the materiality of the medium within which it worked. For the cubists, who were reacting against the 'formless mists' of impressionism, it meant the discovery of a solid geometrical foundation upon which all other forms of art could be based: an exploration of the inner principle rather than the outward appearance.

A rejection of Renaissance perspective is apparent in MacGreevy's poem 'Gioconda', where the most famous feature of the *Mona Lisa* (c. 1503–19) becomes the point of her effacement, so that we are left with 'Bluish snakes slid / Into the dissolution of a smile'.[3] Here, the impact of postimpressionism can be clearly felt. The poem all but removes the young Florentine woman, registering the partial loss of the subject quite literally as dis- or non-figuration in the composition. Beckett's vague insistence on 'the breakdown of the object' in 'Recent Irish Poetry' likewise implies an eager awareness of the cubist revolution on the visual arts.[4] This chapter shows how the formal concerns of the movement acted in powerful ways on MacGreevy and his contemporaries. For a group of Irish expatriates anxious to jettison cultural stereotypes that were irredeemably passéist, an avant-garde interest in postimpressionism provided an especially fertile mixture of activism and experimentation.

DEFENDING MAINIE JELLETT

Two female compatriots had left Ireland in 1921 to study in Paris, where, after working with André Lhote for a year, they managed to persuade a fully non-representational painter to take them on as pupils. Mainie Jellett and Evie Hone had begun working with Albert Gleizes, who taught a more abstract approach to cubism, from 1922, about five years prior to MacGreevy's arrival in the French capital. Academicians were dismayed when two of Jellett's paintings were shown at the Society of Dublin Painters exhibition in October 1923. Several newspaper reviews were hostile to her work. 'Æ' Russell in the *Irish Statesman* claimed that Jellett was 'a late victim to Cubism in some sub-section of this artistic malaria'.[5] *The Irish Times* even asked its readers (superciliously) to 'provide a solution' to 'Two Freak Pictures' by including her 1922 composition *Decoration* in its article.[6]

A sharp conflict appears to have developed here between the aims of the artist and the demands of the outside public. Though not particularly radical by international standards, the paintings that were exhibited in 1923 were among the first abstract compositions to be seen in Ireland. MacGreevy launched an impassioned defence of Jellett's work in *The Klaxon* – a journal founded by 'Con' Leventhal that aspired 'to kick Ireland into artistic wakefulness' in its first and only editorial.[7] MacGreevy's essay, entitled 'Picasso, Mamie [*sic*] Jellett and Dublin Criticism', is by far the longest in the journal. Struggling to understand why this form of artistic experiment should have so startled the Dublin audience, MacGreevy begins by noting that

It is ten years and more since Mrs. Duncan, the late Curator of the Municipal Art Gallery, organised two representative exhibitions of work by the leading French Post-Impressionists in Dublin, and one would have thought that by this time our young artists would have taken up, and got over, cubism, and our critics be familiar with cubism and every other kind of Post-Impressionist *ism*. But not they. Miss Jellett is the first resident artist to exhibit a cubist picture in Dublin, and our critics are as hopelessly at sea in front of her work as her benighted predecessors were about Picasso and Othon Friesz and Matisse in 1912.

There is less excuse for the critics of to-day, apart from the time they have had to get used to Post-Impressionist idioms, for where Picasso, with his wicked Catalan sense of humour, called his coloured patterns 'Portrait of André Salmon', 'Miss Gertrude Stein Reading', and so on, and drove our humourless great into a gratuitous frenzy thereby, Miss Jellett calls her pictures simply 'Oil Painting' and 'Tempera Painting', so no sense of humour on the part of the critic was called for.[8]

From the outset, MacGreevy invokes the earlier timeline of the first postimpressionist exhibitions in London to measure the belatedness of the Irish media reaction. Especially damaging to national morale is the implication that 'our critics' have unwittingly aped the same standards of British dissent over a decade later. Resisting the tired and narrow provincialism that had grounded itself during the 1923 Dublin exhibition, MacGreevy is quick to point out that Jellett's translation and rotation of geometrical shapes into a 'single element' in fact reveals a similarity of ideals between the *Book of Kells* (*c.* 800) and modern abstraction. Jellett had

indeed taken inspiration from the colour harmonies in some of the single decorated letters (Plates 1 and 2).

By highlighting the abstract patterning of space in ancient Celtic art, MacGreevy dismisses conservative perceptions of Jellett's work as something either foreign or outlandishly new. When defending her work in *The Klaxon*, MacGreevy downplays such reservations about the formal inventiveness of Jellett's paintings by tracing the aesthetic origins of her work back to the Holy Roman Empire of late antiquity. Interposing himself between the artist and the audience, MacGreevy points to 'her very pleasant piece of Byzantine decoration' in front of which 'the Dublin world of criticism gasped and asked "what does it mean? What does it symbolise?"'[9] Confronting the present standards of artistic worth that are being upheld by the contemporary Irish public, MacGreevy declares, in a final bid to rescue Jellett's paintings from any further misguided responses, that

> You might as well ask the reason why people have Adams ceilings in their houses. They mean nothing. Neither do the *Book of Kells* illuminations, neither does an Italian Renaissance doorway, or a 'Hicks' chair. There is pattern in all these things, and it is either beautiful pattern or it is not. The pattern in your mantelpiece may be carried out in coloured marble, the colours may be beautifully harmonised or they may not; if you are able to perceive whether they are or not, then you will be able to perceive what Miss Jellett is trying to do.[10]

What unites the examples given above is the idea of painting *without* subject. Form and colour do not have to be descriptive, literal or possessed of any other meaning, and it is with this consideration in mind that MacGreevy questions the public's need to capture symbolic reality. Alternatively, MacGreevy stresses the inner principle of beauty that directs the abstract pattern of illuminations and furnishings, to which he adds Jellett's resurgent piece of 'Byzantine decoration'. Voicing his approval for the autonomous trajectory that Jellett's work is now taking, MacGreevy notes that 'She is now beginning to understand what painting means, painting, that is, apart from literature or "message", or any other kind of illustration.'[11]

In a public lecture entitled 'A Word on Irish Art', which she delivered to the Munster Fine Arts Club in Cork in 1942, Jellett explains her reluctance to copy outward appearances. 'We want to delve and search for the inner

meaning, the principles and reasons behind it all', she tells her audience, 'particularly now as we find there is an affinity between the present-day artistic needs and the work of the early periods.'[12] Mainie Jellett was the grand-niece of Margaret Stokes, a leading scholar of medieval and Renaissance art who had produced several well-regarded volumes on Irish antiquity, including *Early Christian Art in Ireland* (1887 and 1911) and *High Crosses of Ireland* (incomplete at her death). That Stokes' scholarship was being assimilated in avant-garde circles is evident from a letter that Ezra Pound sent to MacGreevy in which he asked his recipient on account of his connections with Reginald Grundy's fashion and arts magazine *The Connoisseur*, whether 'the conny : sewer … wd. be game for Stokes stuff on the Quattrocento'.[13] Drawing on scholarship dedicated to the early Celtic period for which her great-aunt was prolific, Jellett connects 'the sense of filling and decorating a given space rhythmically and harmoniously' with 'Irish work' and compares the non-realist metalwork of the 1920s to the Celtic high crosses, a relationship that she, like MacGreevy, traces through the non-material elements of Byzantine art and the visual culture of early Catholic Europe.[14] Jellett combines the cubist disapproval of the perspectival mechanism of the Renaissance with an Irish precedent of the early Celtic period, where the emphasis had been to fill a specified area with interlacing patterns (the 'subject' being of secondary importance). It is in this context that MacGreevy praises 'Jellett and Hone' as the 'first' to bring into Irish painting 'the principles and the idiom of the modern French approach to the painter's problems'.[15] That 'modern French approach' – namely, painting without subject – is vital to the perception of consistency between the artistic aims of Celtic antiquity and those of contemporary cubist abstraction.

It was not only in the immediate aftermath of the Society of Dublin Painters exhibition in October 1923 that MacGreevy wrote in support of Jellett's postimpressionist works. One can still hear the resilience that he had shown in defending her achievement in a later article entitled 'Fifty Years of Irish Painting, 1900–1950'. Here, MacGreevy refers back to the initial reception of her art in 1923, stressing that

> as time went on, it became clear that Mainie Jellett and Evie Hone had accepted the new Parisian canons in art, not at all in order to épater les bourgeois, but purely with a view to submitting themselves to a rigorous

discipline which, eliminating the merely journalistic element in painting, concentrated on aesthetic essentials.[16]

Rejecting any sportive enthusiasm for the activist moment, MacGreevy draws attention to the refinement and discipline of both artists. For *The Irish Times* (the same paper that had featured Jellett's 'Two Freak Pictures'), he observes with pleased irony that 'what Paris had to teach such artists as Nano Reid, Mainie Jellett, Norah McGuinness, Frances Kelly, Grace Henry ... and others of the Dublin painters, was to be the highest degree of consciousness of which they were capable, their Irish selves'.[17] Here, MacGreevy repositions the postimpressionist influence as a power-ful medium through which Irish artists might actively discover their own identity.[18]

Once again for *The Irish Times*, MacGreevy draws attention to the fact that many of the nation's most progressive artists are women. In 'A Lively Exhibition, Water-colour Society', he argues that it is female painters who have 'buried the hatchet between experimental talents and academic'.[19] When writing for *The Irish Times* after the first Irish Exhibition of Living Art (IELA) had opened in Dublin in September 1943, MacGreevy praises Jellett as the society's chairwoman, recognising her long battle to promote modern art in Ireland. 'The IELA', he argues in the aptly named 'Living Art – A New Departure', is the 'fulfilment of her most cherished ambition' and 'the most vital and distinguished exhibition of work by Irish artists that has ever been held'.[20] By the time that the Retrospective Exhibition of Paintings and Drawings was opened by President Éamon de Valera at the Municipal Gallery of Modern Art in 1962, Jellett had reached levels of public acclaim unrecognisable from that of her initial Dublin reception (Plate 3). Though her compositions had initially provoked outrage in Dublin, it soon became recognised after her death how she had revitalised her native heritage through cubist abstraction. While MacGreevy did not share Jellett's confidence in the innate superiority of the flat surface over three-dimensional modes of presentation, he understood how the core features of postimpressionism – namely, the dis- or non-figuration of the subject, the abstraction of natural forms into pattern, and the refusal of Renaissance perspective – had allowed her to present new infusions of traditional Irish material.

In August 1948, MacGreevy translated a memorial essay by Albert Gleizes on Jellett for a publication honouring the life of the IELA chairwoman.[21] The memorial essay that MacGreevy translated for the volume is countersigned 'Les Majades': the name of the cubist group in Saint-Rémy-de-Provence to which the French master had retired, surrounded by his disciples. In this brief but perceptive article entitled 'Homage to Mainie Jellett', Gleizes reflects on the 'essential principle' of his work since the 1911 exhibition at the Salon des Indépendants. 'The *recall to order*', he states, 'was, no doubt, merely the most obvious feature of the Cubist movement ... when the very principle of classical art was quickly dissolving into formless mists, striking but slapdash, which justified themselves by invoking the individual's right to do what he liked.'[22] Where the tyranny of Renaissance perspective is vividly attributed by Gleizes to the politics of individual caprice, the cubist aptitude for bestowing solidity, harmony and equilibrium serves in this account as the restorative impulse towards social order. We recall that Jellett and Evie Hone had decided to approach Gleizes in 1922 when Ireland was struggling to find its national independence during a bitter civil war. Hone's *My Four Green Fields*, which was commissioned by the Irish government's Department of Industry and Commerce for the Irish Pavilion at the 1939 World's Fair, now occupies the main window in the entrance hall of the Department of the Taoiseach in Government Buildings: a fitting tribute to the role they both envisaged for art's civic integration.

INCORPORATING THE VISUAL: MACGREEVY'S *POEMS*

If the postimpressionist movement enabled Jellett and Hone to reconnect their work to the needs of state, then it also provided MacGreevy (a veteran of war) with new opportunities for lyrical expression. Especially revealing are the rhetorical antagonisms on which his poems shift: between three- and two-dimensional surfaces, figuration and pattern, counterpoint and harmony, and immobile and mobile forms ('still life' and 'quick life'). This section rereads MacGreevy's *Poems* as a postimpressionist text. We can trace the formal connections between postimpressionist aesthetics and MacGreevy's own in the following poem, entitled 'Promenade à Trois':

I was much watched by the afternoon.
His eyes are black

Hers blue –
The afternoon's elementals.

Now I am black and blue all over.[23]

Nothing in this poem is permitted to remain outside the field of observation. The 'I' is rotated like an object under the colour of competing gazes. At no point is the speaker the viewing subject; instead, the speaker is 'bruised' by the lovers' stare. The sight invades the seer and the seer relinquishes command, entailing a critical reversal of perspectives. The final line exerts no unifying force at which '[t]he afternoon's elementals' may converge but remains within a flat, two-dimensional plane: 'Now I am black and blue all over'. The speaker registers the living movement of colour as felt life – seen through the 'eyes' of lovers rather than as a scene distanced and formalised by the imposition of perspective. It is this sense of participation, of fully implicated posture, that allows the poem to play on the suggestion of a *ménage à trois*.

'Arrangement in Gray and Black' is unique among poems in the 1934 collection in that it responds to a single painting. *Whistler's Mother*, or *Arrangement in Grey and Black: Portrait of the painter's mother* (1871) as it is less commonly known, is a classic portrait type, the success of which lies in its combination of intimate realism, sombre colouring, and powerful use of profile (Plate 4). MacGreevy's 'Arrangement in Gray and Black' possesses none of the features that we might expect from Whistler's portrait. The poem deliberately omits the subject from the title, drawing attention instead to the arrangement of tonal harmonies. The subject – the shrinking form of a dying nun in prayer – is drawn into the consecutive full stops that follow each of the first four lines. The turn of the fifth line – 'Her faith?' – contrasts this attenuation of the nun's body with her belief in the life to come.[24]

MacGreevy's ready adoption of postimpressionist techniques diverges noticeably from the poetry of Louis MacNeice. In MacNeice's 'Eclogue for Christmas' (1933), Speaker A identifies himself with Picasso's Harlequin. 'And so it has gone on', Speaker A decries: 'I have not been allowed to be / Myself in flesh or face, but abstracting and dissecting me / They have made of me pure form, a symbol or a pastiche / Stylised profile, anything but soul and flesh'.[25] That MacGreevy was familiar with this objection is evident from his translation of Gleizes' essay on Jellett, which twice reformulates a general version of this protest: 'Does the suppression of figurative representation

not take the human value out of painting? Is the sensibility of the painter not running to its own destruction?'[26] MacGreevy's understanding of the later Picasso portraits, in which the artist's cubist experiment is seen to have refined the human balance of his work, contrasts sharply with MacNeice's didactic instinct. When defending Jellett from her critics during the October 1923 Dublin exhibition, MacGreevy adds that 'only the aesthetically thick-skinned see in [Picasso's] return to figure painting a confession of the error of his recent ways'.[27]

Unlike MacNeice, MacGreevy neither opposes the sensibility of the painter nor maintains a singular view of the artist's development. While they both harboured reservations about the desirability of total abstraction, MacGreevy's engagements with modern art in Paris from 1927 to 1933 arguably gave him deeper insight into the human and formal complexity of contemporary non-figurative work.[28] In 'Did Tosti Raise His Bowler Hat?', MacGreevy plays on the idea of purely significant forms:

What to say when they ask you
White to black
Black to white

White as lime white
(A trap)
Ireland
Slate blue and white
(Saved)

It is now goodbye, goodbye,
Goodbye to goo-oo-oodbye
Goodbye to black.[29]

Francesco Tosti was a popular composer of salon music during the *belle époque*. 'Bid Me Good-bye!' (*c.* 1888) (lyrics: George Whyte-Melville) was Tosti's most famous work, sometimes performed in Italian as 'Addio' (lyrics: Rizzelli). In 'Did Tosti Raise His Bowler Hat?', the final farewell between lovers ('Kiss me straight on the brows! / and part again! / Again! my heart! my heart! / What are we waiting for, you and I?') occurs only between tonal harmonies. The poem reacts against the sentimental prolonging of departure and gushing lyricism ('Goodbye to goo-oo-oodbye') by tying the

correspondence of colours to the saying 'Good-bye to all that', the title of Robert Graves' 1929 autobiography. Its alternating colour scheme also resonates with the iconography of Catholic salvation: 'blue' and 'white' are associated traditionally with the colours of the Virgin Mary.

To understand MacGreevy's peculiar emphasis on colour, I refer to Wassily Kandinsky's writings on the spiritual in abstract art. According to Kandinsky's *Concerning the Spiritual in Art* (1912), 'white' and 'black' are the governing poles of birth and death between which all the primary colours can be rotated in correspondence.[30] A vital part of Kandinsky's theorem is the need to establish an inner harmony in relation to the antithetical movement of colours. 'White' was not necessarily considered by postimpressionists as a non-colour. Rather, it was more often regarded as the symbol of a world from which all colour as a definite attribute had been drained or rendered mute. Alive to that sense of contradiction, MacGreevy uses colour in tandem with the violent reality by which it is mediated. In 'Gloria de Carlos V', named after the Titian masterpiece that he had seen in Madrid, even the purest moment of transfiguration is produced out of 'starch white streaked with cadaver black', reflecting the deaths of those without gas masks and the grotesques of Matthias Grünewald.[31] In 'De Civitate Hominum', the death of an airman is depicted in a manner dissonantly picturesque:

To A.S.F.R.[32]

The morning sky glitters
Winter blue
The earth is snow-white,
With the gleam snow-white answers to sunlight,
Save where shell-holes are new,
Black spots in the whiteness –

A Matisse ensemble.

The shadows of whitened tree stumps
Are another white.

And there are white bones.

Zillebeke Lake and Hooge,

Ice gray, gleam differently,

Like the silver shoes of the model.

The model is our world.
Our bitch of a world.
Those who live between wars may not know
But we who die between peaces
Whether we die or not.

It is very cold
And, what with my sensations
And my spick and span subaltern's uniform,
I might be the famous brass monkey,
The *nature morte* accessory.

Morte … !
'Tis still life that lives,
Not quick life —

There are fleece-white flowers of death
That unfold themselves prettily
About an airman
Who, high over Gheluvelt,
Is taking a morning look round,
All silk and silver
Up in the blue.

I hear the drone of an engine
And soft pounding puffs in the air
As the fleece-white flowers unfold.

I cannot tell which flower he has accepted
But suddenly there is a tremor,
A zigzag of lines against the blue
And he streams down
Into the white,

A delicate flame,
A stroke of orange in the morning's dress.
My sergeant says, very low, 'Holy God!
'Tis a fearful death'.
Holy God makes no reply
Yet.[33]

Here, we can hear the 'white noise' of a shell-shocked background.[34] An antithetical correspondence is arranged between colours in view of the flickering poles of life and death that are described in the first stanza ('With the gleam snow-white answers to sunlight / Save where shell-holes are new, / Black spots in the whiteness —'). The 'orange' burning aircraft is also traced in counterpoint, zigzagging its fall '*against* the blue' and '*into* the white'. The 'stroke of orange in the morning's dress' recalls the association of 'blue' with the Virgin Mary. 'Blue' also serves as a recessional background or ceiling for the deliverance of Christian prayer. The slippage of 'white' across various symbolic registers ('whiteness', 'whitened') gives the poem an uncanny coherence from the merging of snow, bones, burnt-out tree stumps, clouds and engine smoke to the gaps of the page between the line breaks. Pausing on the final 'Yet', the reader is asked to balance this scheme of death and continuing life.

Unlike W.B. Yeats' 'An Irish Airman Foresees His Death' (1919), where the speaker's voice is that of the airman, the chance of the airman's heavenly deliverance is observed from below by the powerless bystander. MacGreevy was stationed near Gheluvelt, a town in the Ypres Salient north-east of Zillebeke Lake, with the Thirteenth Division Artillery when he witnessed the fatal bombardment of the British pilot by German forces, and it is noticeable that the 'I' in the poem remains within the dress code of a junior officer of the Royal Field Artillery ('my spick and span subaltern's uniform').[35] Yet it is the distance of the speaker from the spectacle that is continually stressed in the verse. An explosion of colour marks the actual bombardment. Bomb-clouds are described as 'fleece-white flowers of death'. Stan Smith is right to expand the conceit of the silver-shoed model with 'our bitch of a world' to the way the invisible airman is forced to accept 'the flowers of flak as an actress might accept a bouquet'.[36]

The incorporation of visual imagery alters the reader's present conception of reality to unsettle his or her human instinct, driving a wedge

between the reader's active engagement and the pre-rehearsed emotional response. The confusion arises from the way in which the poet employs colour decoratively, for purely illustrative effect, as well as symbolically, with human suggestion (as in 'fleece-white', 'ice gray', and 'Winter blue'). The poet calls this opening arrangement 'A Matisse ensemble' after one of the most gifted colourists of the postimpressionist period, yet the bones and stumps of a war zone sit with deliberate unease beside *les fauves* or 'wild beasts' of modern art. The reference to *'nature morte'* is similarly ambivalent and plays on the softened translation of the English 'still life', which, unable to match the French double entendre, resonates with heavy irony in the context of the burnt-out landscape and staccato crop of dead trees. It is at this point that we might view the poem as, in effect, a deliberately *failed* still life, the very meaning of which changes over the course of the poem from a certain ending to an indefinitely extended temporality; indeed, the final 'Yet' stresses the total inadequacy of the sergeant's response and the fatality of seeing things too well.

As we have seen from readings of 'Promenade à Trois', 'Did Tosti Raise His Bowler Hat?', 'De Civitate Hominum' and other poems (see Chapter 1), a sense of macabre expectation underlines all MacGreevy's visual jokes and references. From the use of 'stillness' to signal both motionless and anticipated movement (*'Morte* ... ! / 'Tis still life that lives, / Not quick life') to the conviction in 'Epithalamium' that '(All discovery thus far / Had been such cold, unsignifying prelude)', the untimely occurrence of various horrific events (including shot-down aircraft and public executions) undermines the perception of beauty.[37] For an ex-junior officer who had grown out of his immaculate finery, poetry was perhaps, indeed, the *'nature morte* accessory': the medium through which he could forfeit the immediacy of personal shock to furnish a distant background of death.

4
Reconstructing the National Painter

· ·

'One of the wild geese of the pen'

Daniel Corkery, *Synge and Anglo-Irish Literature* (1931)

At various stages during his life, MacGreevy faced direct criticism from the 'Irish-Ireland' movement's leading representatives, particularly from Daniel Corkery, who berated him for his European connections. The counter-narrative that the Irish Gaelic activist had provided to Anglo-Irish historiography and literary history in *The Hidden Ireland* (1924) was deeply influential in the reshaping of public policy around an imaginatively 'pure', de-anglicised worldview. Following his appointment in 1930 as professor of English at University College Cork, Corkery had cemented his position as part of the educational orthodoxy of the Irish Free State, working as a brashly polemical propagandist. That his role was a significant one for directing the country's ideological framework is evident from the responses of one of his former students, Sean O'Faolain, who remonstrated in 1936 that 'He does, I think, influence our political evangels considerably; all that is behind our system of education in modern Ireland, much that enthuses and supports our more fervent politics, has come out of his books and his lectures.'[1]

As a writer and educator of considerable influence, Corkery was not afraid to exclude literary figures whose work deviated from his *kleines Reich* ('small realm').[2] In his 1931 study *Synge and Anglo-Irish Literature*, he singles out MacGreevy as 'one of the wild geese of the pen'.[3] The term 'wild geese' refers to a group of Irish soldiers who had left Ireland after the Williamite War to serve as mercenaries in armies across Europe. Here, however, it is intended spitefully by Corkery to incite popular opinion against MacGreevy's pan-European sympathies. MacGreevy refers to this

passage in his 1934 lecture to the Irish Society at Oxford. To his Oxford audience, he confides ironically that

> Professor Corkery names me as a wild goose with the rest, so I may perhaps – with all the protestations of modesty that the protocol demands after citing such an array of august names – suggest to him that it is not only in Cork, or even in Ireland, that Irishness may be developed; that I did not, of necessity, become less Irish in my mind during the six years I spent eating the not invariably sweet bread and climbing the sometimes quite bitter stairs – those to the fifth floor of a Latin Quarter hotel for instance – on the mainland of Europe.[4]

The ways in which MacGreevy lived the categories of nationalism from the inside ('in a green great-coat') while experimenting with artistic movements across Europe appear to have posed a consistent challenge to Irish nationalists of a more orthodox persuasion.[5] While he was sympathetic to parts of Irish-Ireland ideology, MacGreevy did not believe that a separatist impulse could be in any way tied to physical terrain. References to the visual arts abound in his desire to expose the internal inconsistencies in Corkery's thinking. 'Claude Lorrain', he notes in the same lecture, 'without even knowing France outside of Lorraine, was so French that he is still an inspiration to all French landscape painters.'[6] Of John Hogan – the sculptor who executed the colossal statue of Daniel O'Connell that now stands in Dublin City Hall – MacGreevy notes that 'for more than twenty years in Italy he stayed, taking only a very occasional holiday at home and returning for good only in 1848'.[7] The terms of opposition here resemble those that he had jovially deployed in response to 'Æ' Russell after arriving in Paris.[8] They also echo his defence of several female artists – including Mainie Jellett, Mary Swanzy, Nano Reid, Norah McGuinness, Frances Kelly and Grace Henry – whom he had consistently promoted against their conservative detractors for their ability to discover their 'Irish selves' through Parisian idioms.[9] This chapter shows how, as a public commentator on the arts, MacGreevy sought to revitalise Irish civic life from several different perspectives. Writing and lecturing as an art critic did not just provide MacGreevy with a defence against the pressures of cultural isolationism; it also allowed him to reconstruct the national painter as he saw fit.

ART AND NATIONALITY

In an essay entitled 'The Rise of a National School of Painting' (1922), MacGreevy argues that Jack Yeats is 'the first truly Irish painter' to have emerged from the country.[10] It is worth pausing over the force of this emphasis and its relationship with other forms of national identity that are perceived *not* to be representative. In an earlier article entitled 'Art and Nationality: The example of Holland' (1921), MacGreevy compares the separation of Ireland from the United Kingdom with the independence of the United Provinces, where a Dutch school of painting later matured. 'So long as she was incorporated with Flanders', he argues, 'the latter did her thinking, her inventing, her painting for her.'[11] MacGreevy maintains that another twenty-three years passed after independence before the Netherlands could escape the cultural dynamics of this false exchange and deepen its self-expression through painting.[12] The timing of this earlier article, which was published towards the end of the Anglo-Irish War of Independence, provides an important background for approaching MacGreevy's later monograph on Jack Yeats, which views the current regime as 'no more than a province of English art'.[13]

The publication of a full-length study on a living painter was highly unusual in Ireland. With few specialist platforms in the country then available for discussing art criticism, MacGreevy turned to Jack Yeats' London agent Victor Waddington for support, who financed its publication. The monograph was written in London in 1938 and published with a postscript in Dublin in 1945. The ultimate desire of 'representation' in this study is not for the Irish Free State but for what the Free State in turn is held to have usurped; namely, the common humanity of the people (a task that had previously been entrusted to literature in the absence of autonomous national institutions). In a passage that actively reflects his disillusionment with the current regime, MacGreevy claims that 'the people are represented only by disinterested men, and more particularly by artists'.[14] MacGreevy lends weight to this view by including an extract from a poem by Charles IX of France that is addressed to the leader of the Pléiade, Pierre de Ronsard. Beckett had forwarded a handwritten version of this poem to MacGreevy (entitled 'Epître à Ronsard') from his temporary lodgings at the Hôtel Libéria in Paris, which differs marginally from known versions of the published text.[15] Only the ninth and tenth lines of the poem are quoted in *Jack B. Yeats:*

An appreciation and an interpretation: 'Ta lyre, qui ravit par de si doux accords, / Te soumet les esprits, dont je n'ai que les corps' ('Your lyre, which delights by such sweet chords, / Makes subjects of men's minds; I have only their bodies').[16] The citation of this passage is significant for two reasons: first, because it provokes the recognition that the nation's real imaginative power lies outside the grasp of its official representatives; and second, because it acknowledges the poet as the truest arbiter of the national spirit.

There are two points to clarify in this connection. The first concerns the difficulty of expressing a common humanity in a nation where authority and consciousness have been forcibly divided by censorship. The second point of relevance concerns MacGreevy's ambition to find a popular, embodied and discursive meaning – one that refuses the inner conflict of Devlin and Beckett's poetry collections of the 1930s (*Intercessions* and *Echo's Bones*). Both these considerations provide the background for an attempt to recover the collective solidarity that had disappeared from the lyric once the avant-garde had become detached from the writings of street balladeers and poet revolutionaries.

In 1923, Jack Yeats had argued in a speech delivered to the Celtic Race Congress in Paris that 'the roots of True Art are in the affections; no true artist can stand aloof'.[17] MacGreevy cites this lecture in his 1945 monograph on Jack Yeats, affirming that 'At the Celtic Race Congress in Paris in 1923, he read a paper in which he gave it as his opinion that the most stirring sights in the world are a man ploughing and a ship on the sea. He still paints the people, and with an even more passionate directness in recent years than in his earlier days.'[18] In 1928 alone, Jack Yeats had completed several pictures of Dublin workmen. *Dinner Hour at the Docks* features a docker whose wife has just brought him his lunchbox (Plate 5). In this artwork, which focuses on the resting labourer carefully peeling a banana while sheltering from the rain, it is possible to see how the 'passionate directness' that MacGreevy locates between Jack Yeats and his painted subjects might better represent the wider community. Indeed, in *Jack B. Yeats: An appreciation and an interpretation*, MacGreevy is at pains to define the artist as

> not merely a *genre* painter like the painters of the *petit peuple* in other countries, and not merely a nation's painter in the sense that Pol de Limbourg, Louis Le Nain, Bassano, Ostade or Jan Steen were national

painters, but *the* national painter in the sense that Rembrandt and Velazquez and Watteau were national painters, the painter who in his work was the consummate expression of the spirit of his own nation at one of the supreme points in its evolution.[19]

Here, as in much of his public commentary, MacGreevy lays a special emphasis on the figures to whom the artist is drawn, such as the dockers, strolling players and circus entertainers who do not hold any privileged positions of power and who populate many of the artist's paintings. By repeatedly employing the term '*petit peuple*' to describe these depicted figures, MacGreevy draws upon a history of French republican ideals and revolutionary resistance;[20] though the artist never explicitly set out to serve any political project, the type of national commitment that MacGreevy discerns from Jack Yeats' example is intended to celebrate their place in a new political entity.

The following three sections show how MacGreevy's various writings on art, and on Jack Yeats in particular, provide Ireland with the historical provenance for a new era of painting. The first section, entitled 'Against Portraiture', discusses MacGreevy's desire to abandon a patronage system of the arts; the second, entitled 'Non-academic Painting', inspects MacGreevy's positioning of Jack Yeats outside the canonising practices of established institutions; and the third, entitled 'Ethics', examines MacGreevy's concerns about the authentic artistic rendering of social life in post-revolutionary Ireland.

AGAINST PORTRAITURE

When defending Mainie Jellett's use of postimpressionist techniques during the Society of Dublin Painters exhibition in October 1923, MacGreevy states unequivocally that 'we are not interested in dead Dutch boors and dead English gentlemen … We have had quite enough representations of lower middle-class Dutch and upper middle-class English interiors to go on with.'[21] An impatience with the formal conventions of portraiture and with the class structures that dominate its subject matter recurs throughout MacGreevy's art criticism. In a review of 'Local Museums and Galleries' in London, he praises Grace Henry's *Stephen Gwynn, or The Orange Man* (1918–19) as 'a means to an end of the artist's own, that end being the

improvisation of beautiful linear and colour patterns for which the sitter served chiefly as a point of departure'.[22] Henry's portrait treats the slanted figure with thick daubs of colour, admitting a degree of artistic freedom apart from the standard sitter – an Irish unionist peeling an orange (the 'Orange Peel' being Daniel O'Connell's nickname for the British statesman Sir Robert Peel, who eventually repealed the Corn Laws).

Usually, the portrait genre demands that considerable attention be given to the visual likeness of a powerful individual. However, in his 1945 monograph on Jack Yeats (the first third of which is dedicated to a history of agrarian unrest), MacGreevy seeks to deepen a sense of artistic self-assurance away from an 'unrepresentative possessing class'.[23] It is no accident that he should have spent much of this study justifying the more difficult aspects of the artist's later work, in which colour and movement are permitted to interfere with traditional figuration and line drawing. In a late painting entitled *Seek No Further II* (1947), the figure is carved directly out of the thickness of the impasto. The deliberately misleading title of this composition foregrounds a process of exploratory apprehension that, far from homing in on a reducible and knowable person, demands of the viewer a willingness to remain open before an unknown possibility. Here, as in other late works that chart the artist's increasingly opaque stylistic development, the sculpted dimensions of the medium suspend the 'represented' figure to stress its elusive recalcitrance: its 'yet-ness'.

What draws MacGreevy to these thick and densely textured oil paintings is the artist's capacity to make the act of representation *less* decisive and predictable. In *Jack B. Yeats*, MacGreevy argues that his compatriot's stylistic transformation away from the sketched rendition of subjects 'would seem to coincide with a modification of technique which dates from about 1924'.[24] Hilary Pyle, Bruce Arnold and David Lloyd have all acknowledged a significant change in Jack Yeats' style during this period, though there is no exact agreement over its timing or evolution.[25] Nevertheless, it is possible to clarify the important aspects of this change, which involve a departure from his early draughtsmanship in favour of the immediate application of paint, a dramatic focus on movement and gesture, and a strengthening of colour based on personal mood and feeling. In *Pictures in the Irish National Gallery* (1945), which was published in the same year as his Jack Yeats monograph, MacGreevy ties the development of the artist's later style to a principle of non-domination that breaks with the restrictions imposed

upon an earlier generation of Irish artists, such as James Barry, who had to adapt his paintings to an imperial gaze that 'only wanted pictures of itself and its surroundings'.[26] As is evident from letters and essay drafts that were sent between them, which include parts of the 1945 monograph, Jack Yeats' personal views of his achievement do not differ widely from MacGreevy's own, but likewise attach an extreme importance to the liberation of the Irish visual imagination.

MacGreevy's reservations about professional portraiture as a viable standard for revolutionary art are further evidenced by a famous beheading. When turning to Andrea Mantegna's *Judith with the Head of Holofernes* (*c.* 1495) in *Pictures in the Irish National Gallery* in 1945, he emphasises the seriousness of the heroine's purpose: 'This Judith is grave with the gravity of a woman condemned to be an assassin for the honour and salvation of her countrymen'.[27] In one of his last public lectures delivered to the Italian Institute in Dublin in 1963, MacGreevy again acknowledges (with a resigned passivity of his own) the 'sad fate that has forced her to become an assassin'.[28] The patriotic appeal of the biblical story would appear to reside in the inviolability of the widow, whose decapitation of the Assyrian general leads to the deliverance of Israel in the deuterocanonical Book of Judith. Mantegna paints the heroine in the blue robe of the Virgin Mary, looking on in resignation as she is about to hide the head from view (Plate 6). MacGreevy had seen several versions of paintings based on the parable, which help to clarify his views on the artistic styles most capable of unearthing the event's dramatic significance. The revolutionary content of Mantegna's *Judith* is nowhere to be found in Lucas Cranach's rendition of the beheading. Though well executed, the figurative detail of Cranach's composition has none of the subversive narrative meaning that Mantegna renders so forcefully. In *Pictures in the Irish National Gallery*, MacGreevy notes that

> The *Judith* is a study of one of the artist's favourite models dressed in the luxurious costume of the time. As such, it is a fine picture. There is excellent drawing and modelling and the materials of the dress, even to the embroidered gloves, are well rendered. As a realisation of the drama it sets out to present on the other hand, the picture hardly holds its own with our Mantegna.[29]

The 'As such' is a turn of expression that damns with faint praise. What is missing from Cranach's concentration on the figure is the dramatic significance of the event, an area in which the 'gravity' of Mantegna's composition easily outweighs the appeal of a luxurious costume piece. The lavish detail that Cranach adds to the heroine, who resembles several pictures of the royal Saxon princesses (Sybille, Emilie and Sidonia) with whom he was familiar at the Court of Wittenberg, brings the composition closer to that of a professional portrait painting (Plate 7). As MacGreevy identifies, the Judith who is represented here provides little narrative impetus for a story in which a woman takes her own initiative to show how the arrogantly strong are defeated by the weak. In short, the technical figuration of Cranach's *Judith* lacks the poetic licence necessary for unlocking the story's radical and discursive potential. Cranach's *Judith* is removed from the action and placed in a shallow interior space; the landscape that can be glimpsed through the window cut-out over her left shoulder is purely fantastical; and, most revealingly, her hands are covered with pristine ladies' gloves.

In another version of the Judith story that MacGreevy had seen – completed by his favourite artist, Giorgione Barbarelli – the female protagonist steps on the severed head of her victim with her bare foot (Plate 8).[30] What distinguishes Giorgione's composition from Cranach's rendition of the story is the allegorical invention, which abandons the use of customary iconographical elements to show an intensely physical heroine revelling after her deed. As Terisio Pignatti notes, 'Giorgione inserts a completely new motif into the garments which reveals the left leg of the woman.'[31] In a moment of daring sensuality, the seducer-assassin lays bare her thigh while crushing the enemy tyrant. Giorgione's example is especially instructive for MacGreevy's readings of revolutionary art. What Giorgione's rendition of the Judith story most crucially enables is the freedom to extemporise from existing material and to surprise with invention rather than imitation. The subject of the painting is no passive agent operating within a predetermined framework, but an emboldened woman rejoicing in her subversive actions.

NON-ACADEMIC PAINTING

Appealing to the painter's transcendent and mystical timing allows Mac-Greevy to distinguish revolutionary art from any generic or institutionalised equivalent. In the following passage, he praises Jack Yeats' independence from formal training:

The outside influences to which Jack Yeats may have submitted himself in the process of his formation as a painter are hard to discern. His painted work seems to have been extremely personal from the beginning. We may allow ourselves to believe that he would readily acknowledge the qualities of a Constable, a Daumier, a Millet. Yet it is to be doubted whether he has ever got anything more than encouragement to go his own way from them or from any painter. There is no trace of even remotely approximate imitation of other painters in his work. He has obviously found his own way to artistic maturity.[32]

In a particularly emphatic sentence, four successive qualifiers ('trace of' / 'even' / 'remotely' / 'approximate') are used to separate the artist from other possible predecessors, highlighting the unusual independence of the artist's passage to 'artistic maturity'. The odd word choice ('extremely personal from the beginning') maps the subjective tendency of the artist onto that of the critic. The passionate pronouncements of this adjectival critical style refuse to locate the artist within an established narrative, preferring to foreground the terms of the valuation ('We may allow ourselves to believe'). A language of self-assurance, upheld by both artist and critic, heralds a new kind of painting, one that rejects the academy (and, implicitly, academic discourse) as either a goal or explanation for the artist's achievement.

It is worth asking why 'outside influences' are jettisoned from this particular conception of art and art criticism. A distrust of the canonising practices and election processes then dominant in Irish institutions prevents MacGreevy from establishing any direct relationship between contemporary Irish artists and the galleries that had failed to showcase their work. In 'Fifty Years of Irish Painting, 1900–1950', MacGreevy refers to a joint exhibition of Nathaniel Hone and John Butler Yeats held from 21 October to 3 November 1901 as the 'point of departure of the modern Irish School of Painting'.[33] There is potent irony in the fact that the exhibition to which he refers had been organised in the rooms of the Royal Society of Antiquaries in reaction to the Royal Hibernian Academy's (RHA) persistent neglect of two of its most able members.[34] The joint exhibition was largely conceived by Sarah Purser, to whom MacGreevy had sympathetically confided in 1924 three years after she had painted his portrait (see Frontispiece) that the then total absence of female academicians in the RHA may one day lead the world to conclude 'it is because women are better artists than themselves'.[35]

Further discrepancies arise in relation to the Municipal Gallery of Modern Art, an institution at which MacGreevy had sought the head post in 1921.[36] Following the substantial delay in the gallery's establishment, Dublin Corporation had pursued an extremely cautious administrative policy.[37] Apart from Jack Yeats, many of Ireland's experimental artists had continued to work abroad. In an article entitled 'The Dublin Municipal Gallery' (1946), MacGreevy explains, with regard to an institution that has strayed well outside Hugh Lane's original vision, that

> Every institution tends to grow conservative in its policy and administration and it is to be regretted that in certain directions, where Lane and Lane's helpers would have taken an encouraging and even enthusiastic line, the Gallery collection is inadequately or wholly unrepresentative. Thus, in the Ireland of to-day, there are artists of distinctly vital impulse who, like the artists of France any time this fifty, sixty or seventy years, tend to be experimental rather than conventional. Traces of this experimental movement are not quite as imperceptible at the Gallery, as, say, at the annual exhibition of the Royal Hibernian Academy, but they are scarce enough. More surprising, however, is the fact that another movement, an internationally recognised movement, in modern Irish art is wholly unrepresented … To name only the dead, we had Michael Healy, the pioneer artist of the movement and his younger contemporary, Harry Clarke, both of whom, though in very different ways, achieved supreme rank in this department of art. And the movement is still vital. There are distinguished Irish stained-glass artists producing noble work both here at home and overseas at the present time. Yet there is not, I think, a single stained-glass cartoon at Charlemont House.[38]

Hugh Lane had wanted a central site for the gallery on Liffey Bridge, but the Municipal Gallery had finally opened its permanent quarters during June 1933 in Charlemont House. At first glance, the Municipal Gallery may appear to attract softer reproach than the Royal Hibernian Academy, of which MacGreevy was a frequent critic. However, for a gallery founded to provide a home for living art, 'to name only the dead' is damning with faint praise. We note the paradox that 'in certain directions', the collection is 'inadequately or wholly unrepresentative' and key artists 'wholly un-represented'. The critical discourse enacts a false identity between the artist and the nation through the very adjectives and adverbs that precede these

COLOUR PLATES
SECTION

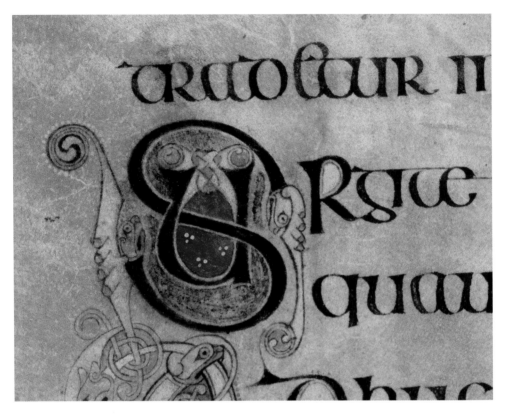

PLATE 1: Detail (initial letters *S* and *U*) from page folio 116v of the *Book of Kells* (*c*. 800)
Hand ink on stretched calfskin (vellum), 33 x 25 cm
Illuminated manuscript
Medieval and Renaissance Latin Manuscripts, IE TCD MS 58
© The Board of Trinity College Dublin
Photo © Dublin, Trinity College Library

PLATE 2: *Green Abstract* (1927)

Mainie Jellett (1897–1944)

Oil on canvas, 84 x 67.3 cm, NGI 2007.75

National Gallery of Ireland Collection

Photo © National Gallery of Ireland

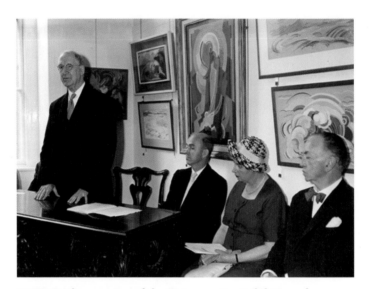

PLATE 3: The opening of the Retrospective Exhibition of Paintings and Drawings by Mainie Jellett at the Municipal Gallery of Modern Art, Dublin (26 July 1962)

Photo © The Estate of Thomas MacGreevy

Left to right: Éamon de Valera (President of Ireland and former Taoiseach); Cearbhall Ó Dálaigh (Chief Justice of Ireland); Bay Jellett (Mainie Jellett's sister); Thomas MacGreevy

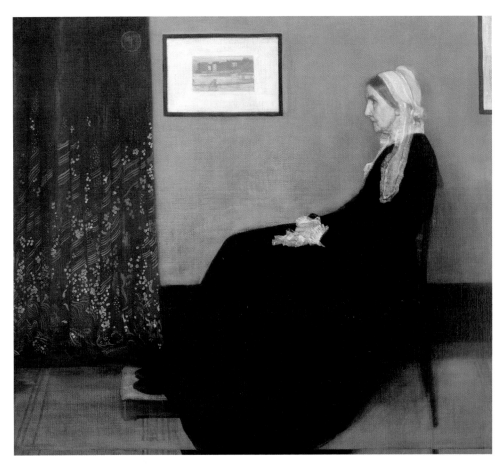

PLATE 4: *Arrangement in Grey and Black: Portrait of the painter's mother* **(1871)**

James Abbot McNeill Whistler (1834–1903)

Oil on canvas, 144.3 cm x 162.4 cm

© Musée d'Orsay, Paris, France / Bridgeman Images

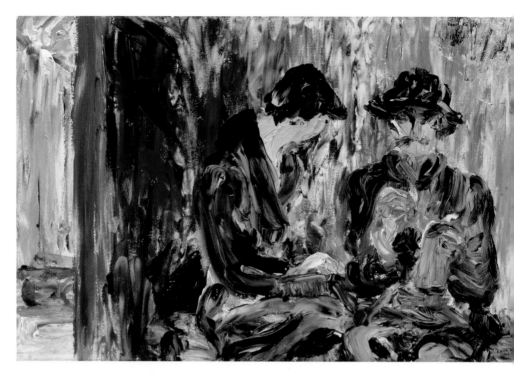

PLATE 5: *Dinner Hour at the Docks* (1928)

Jack Yeats (1871–1957)

Oil on panel, 23.5 x 36.5 cm

Presented by Mrs Smyllie, in memory of the late Mr R. Smyllie (1966), NGI 1791

National Gallery of Ireland Collection

Photo © National Gallery of Ireland

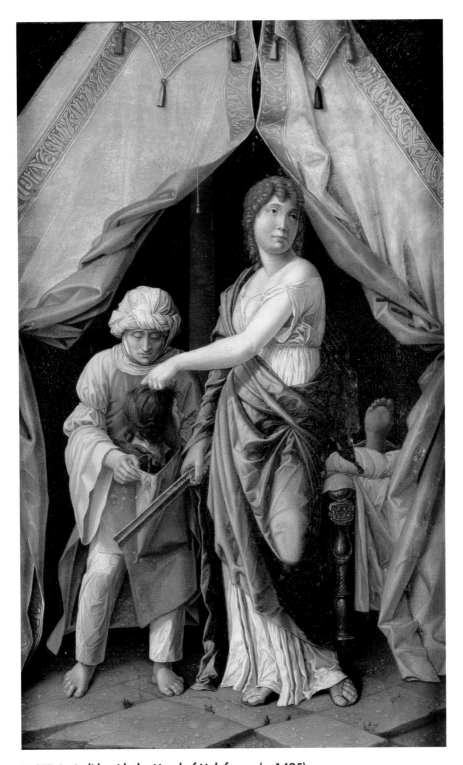

PLATE 6: *Judith with the Head of Holofernes* (c. 1495)

Andrea Mantegna (1431–1506)

Tempura with gold and silver on panel, 30.8 x 19.7 cm

© Czartoryski Museum, Cracow, Poland / Bridgeman Images

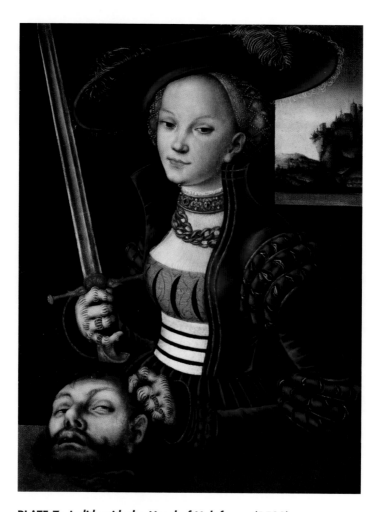

PLATE 7: *Judith with the Head of Holofernes* (1530)
Lucas Cranach the Elder (*c.* 1472–1553)
Oil on beech wood, 74.9 x 56 cm
GKI 1182 / DE_SPSG_GKI1182
© Jagdschloss Grunewald, Berlin, Germany

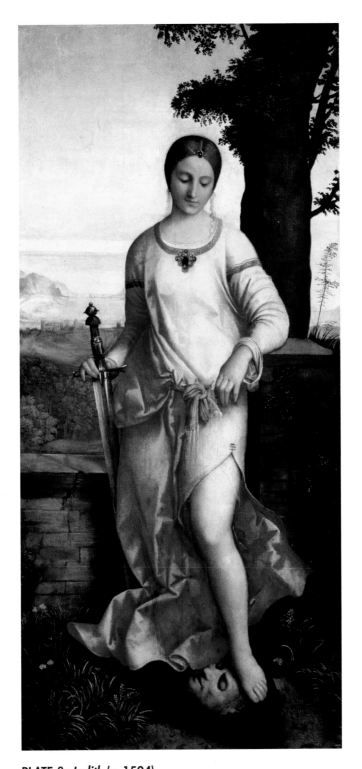

PLATE 8: *Judith* (*c.* 1504)

Giorgione Barbarelli (*c.* 1477–1510)

Oil on canvas transferred from panel, 144 x 68 cm

© State Hermitage Museum, St Petersburg, Russia /
Bridgeman Images

PLATE 9: *Humanity's Alibi* (1947)

Jack Yeats (1871–1957)

Oil on canvas, 60 x 92.5 cm

Gift from Dr John A. Falk (1973)

Bristol Museum & Art Gallery, K4195

Photo © Bridgeman Images

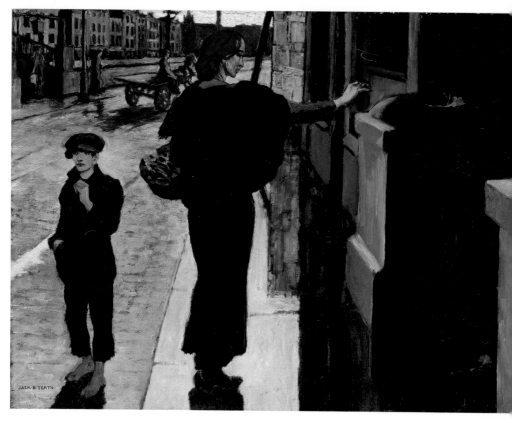

PLATE 10: *Bachelor's Walk – In Memory* (1915)
Jack Yeats (1871–1957)
Oil on canvas, 45.7 x 61 cm
On loan to the NGI from a private collection, L 2009.1
Private Collection
Photo © National Gallery of Ireland

descriptions. The question remains open, however, despite these modal qualifiers: 'unrepresentative' of what, or whom? Though the discussion remains confined in this instance to Ireland's stained-glass movement, the passage upholds an ideal of living art that might reach a broader audience.

In an article entitled 'Three Historical Paintings by Jack B. Yeats', MacGreevy argues that *The Green Above the Red* (a title borrowed from Thomas Davis' famous nationalist street ballad) has unleashed a new force into Irish painting:

> Many people in Dublin still recall the stir that was created in the early years of the century by a picture called *The Green Above the Red* in which the young artist integrated popular, political sentiment into serious paint-ing. It was the first time such a thing had happened in Ireland. Here, as in other similar pictures [that Jack Yeats] painted during those years, was the embryo of an Irish 'historical' or heroic art which might come to maturity as and when the occasion demanded.[39]

'Irish "historical" or heroic art' is here defined not in relation to time past but in terms that suggest a powerful rebirth of the nation. As the outward manifestation of an inward spirit, the 'young artist' is seen to have redeemed the damaged life of the nation and returned it to its essential self. A good example of this embryonic potential coming to the forefront of a major public event is Jack Yeats' *Bachelor's Walk – In Memory* (1915), which MacGreevy mentions both in this 1942 article and in his 1945 monograph (Plate 10).

On Sunday 26 July 1914, when the artist had not been present, a patrol of the King's Own Scottish Borderers had opened fire at a large crowd on the pavement, killing three civilians and injuring thirty-two more near the spot where the flower girl stands.[40] The patrol had been heckled for hours by protestors on their return to the Royal Barracks after intercepting a supply of arms collected at Howth by Irish Volunteers. A hostile crowd on Bachelor's Walk had showered the patrol with bricks, stones and rotten fruit. The conclusion of the Royal Commissioners was that 'Promiscuous firing by 21 soldiers of the Scottish Borderers took place without orders, but the commissioners think the troops were under the impression that the order had been given.'[41] What interests MacGreevy about *Bachelor's Walk – In Memory* is both its timing after the event, and the accidental nature of the flower-girl's actions, which strike up a unique correspondence with the past:

The flower girl may or may not have known the dead, but impelled by the instinctive yet mysterious poetry of her own nature, unheeded by her own world, a world of street-urchins, of loungers leaning against the river parapet, of men on carts driving spirited horses along the quays, of people crossing the Metal Bridge to the other side of the Liffey – with the life of the city going on around her, and unaware that an artist who had eyes to see and hands to immortalise her gesture was looking on, she offered her sacrifice.[42]

Bachelor's Walk – In Memory focuses not on the event itself but on a moment of unconscious resonance. Crucially, the flower-girl's decision to discard two carnations from her basket has no necessary connection with the violence that occurred there earlier. Her actual intentions remain ambiguous and, most importantly, 'unheeded'. 'Chance light' is just one of the descriptions that MacGreevy uses to describe *In Memory of Boucicault and Bianconi* (1937), one of the artist's largest memory paintings, where the shadowy forms of the strolling players appear in the glimmering lamps of a mail-car service.[43] The rediscovery of a past event is dramatised powerfully in yet another of the artist's large canvases, *Helen* (also 1937), which shows the Queen of Sparta preparing to relaunch ships on the voyage home to Greece while a ragged figure chalks the word *Ilium* on the pavement. Though the event itself has been disastrous, like *Bachelor's Walk – In Memory* its dramatic content acquires poetic form due to an unobserved gesture which has determined the concept of Troy that others will remember.

For the composition of *Bachelor's Walk – In Memory*, Jack Yeats had walked the very next day to where the tragedy had taken place, though he postponed sketching the scene until later the following week. In his sketchbook, he jots down that '[w]here the people were shot on Sunday a few paces further towards O'Connell Bridge flower girls had thrown flowers I suppose one of those killed fell there'.[44] David Lloyd notes that this is 'a remarkable transition for an artist whose early work was, often perforce, based on the rapid notation of daily events'.[45] By lengthening the forces of retrospection – as is openly acknowledged in the painting's subtitle ('*In Memory*') – Jack Yeats creates a suspension between the time of the event and the time of the future audience. Without replaying the past or confining the present to an explicit act of commemoration, the artist's depiction of the flower girl and of the unreflective daily life about her gives space to the Ireland that has moved on from the shot civilian.

ETHICS

In his 1945 monograph on Jack Yeats, MacGreevy stresses the importance of the artist's ability to counteract the violence of military conflict. The need to realise a more generous profusion of individual life is most powerfully evident in his claim that 'Ireland was more than adult in experience of unpleasant reality and the opportunity to develop a greater leaven of humanism, of sympathetic imagination, in the make-up of the people, was overdue.'[46] MacGreevy objects to the pessimistic way in which critics have admitted 'all the subjectivism of horror' to the Irish situation but none of 'the subjectivism of loveliness' and highlights the manner in which recent political experiences have distorted the human capacity for sympathy.[47] It is this conviction that forms the background for his insistence that Jack Yeats 'has nothing to do with nightmare' and is 'not a Bosch or a Picasso', as if he had long grown tired of being asked such questions about the artist's idiosyncratic proclivities.[48] In contrast to surrealist dismemberment, alienation, disjunction, scission and disaggregation, MacGreevy records Jack Yeats' definition of 'beauty' as 'the affection which binds people and things to other people and things'.[49] The centrality that MacGreevy accords to 'affection' in this instance is corroborated by Jack Yeats' 1923 lecture at the Celtic Race Congress in Paris, which argues that the 'power of wide affection' is 'the greatest equipment of the artist'.[50]

The artist's ability to direct human sentiment away from fear, sensationalism and superstition and towards shared activities and amusements ('the epicureanism is clear') is vital to the liberated art that MacGreevy envisages. 'Jack Yeats's people', MacGreevy writes, 'are frequently depicted in the pursuit of pleasure, at the circus or music-hall, at race meetings, or simply in conversation with each other. Yet often the expression on their faces suggests restraint, thoughtfulness, an inner discipline.'[51] MacGreevy takes care to qualify these depicted figures as independent and intelligent actors whose humanity cannot be glossed over and subdued from an outside perspective. Most revealingly, he focuses on the original Greek meaning of the term 'epicurean' as the pleasure of living modestly, of gaining knowledge of the workings of the world, and of limiting fear, pain and desire to attain an inner state of peace and tranquillity. It is with these characteristics in mind that he endows 'Jack Yeats's people' and, by extension, those of the nation that he wishes to see represented.

Most tellingly, given the prolonged effects of trauma and division after seven years of paramilitary conflict, MacGreevy reiterates the importance of depicting fun activities. Drawing on the importance of memory in Jack Yeats' paintings even as a critic, MacGreevy mentions during an opening speech for the Municipal Gallery in Dublin in 1962: 'I remember a painting called *Humanity's Alibi* which was of the man who appears out of a barrel and acts as a cockshy and target for things thrown at him as one of the side shows at a circus.'[52] In *Humanity's Alibi*, the daring courage of the solitary performer acquires symbolic meaning for mankind's battle with adversity. Though the cockshy is positioned as an easy target for all comers, the vilified figure instils in the viewer a sense of comic release. As is suggested by the title and the cockshy in the composition, the painting offers a mock-heroic version of the persecution of Christ (Plate 9).

The unfortunate 'Barrel man' was a traditional attraction of the Gaelic festival (*feis*) that Jack Yeats had attended at Coole, which featured music-hall entertainers, clowns and circus performers that are represented elsewhere in his sketchbooks. The cockshy's stunt involved him rising out of a barrel to face a sky filled with flying sticks, which had been given to the crowd to throw. The show would recommence after 'A Maggie Man' had collected the sticks and handed them back to the audience. As with the dockers, flower girls, pavement artists, car drivers and barefooted children that populate so many of the artist's paintings, the cockshy is susceptible to the casual encounter and immediately tied to the quotidian. Indeed, the sympathetic attention that Jack Yeats is seen to have given to people of every description – to the entire body politic – is enough for MacGreevy to constitute 'a new chapter in the history of art', one that differs from partisan or tendency painting by involving the 'whole life' of the nation.[53]

In *Jack B. Yeats*, MacGreevy argues that for there to be less of a repetitive interchange between personal and national forms of expression, the artist must be able to retain enough of their own intellectual currency to move outside the binary forces of 'aggressive imperialism' and those of 'morbidly nationalist' or 'exaggerated nationalism'.[54] Of central importance to this vision of civic integration – of calmness, indivisibility and wholeness – is the artist's 'sympathetic imagination', which allows him or her to transcend partisan ideologies, restrictive stereotypes, and external designators of identity. MacGreevy's emphasis on the 'whole life' of the nation as a malleable effect of the artist's work – rather than a matter of preconception

– is supported in dialogue with other writers and critics. When recording his impressions to MacGreevy after the Jack Yeats Exhibition at the National Academy of Design in New York, Wallace Stevens recognises how the artist has overcome the expectation of strict conformity to supposedly 'Irish subjects':

> I had rather expected pictures of smaller size dealing with subjects … [that] were Irish. They were not like that at all. They were not paintings of reality seen in the spaces of the imagination. They were largely the spaces of the imagination itself with all sorts of real references, of course, but still essentially unreal.[55]

What both poets recognise in Jack Yeats' work is the life of the *inner being*. Stevens' allusion to a reality shot through with 'the spaces of the imagination' resonates with MacGreevy's desire to restore motion and fluidity to preconceived identities and to make the world a more unpredictable and imaginative place. In a 1938 interview with Shotaro Oshima, Jack Yeats states that 'Things in the external world may seem always the same to some people, but an artist finds them different when a change is brought about inside him. He must not try to go against this inner change.'[56] The importance of this inner transformation and timing is repeated in MacGreevy's 1945 monograph on the artist, which argues that

> there is a time to withdraw as there is a time to stay, a time for contemplation and a time for action, and it is through a wise alternation of the two processes and a reasonable blending of the two elements in our nature, that fullness of being and a surer understanding of essentials are attained.[57]

Following on from this 'reasonable blending' of the active and contemplative sides of human nature, MacGreevy claims that Jack Yeats 'has been able to deepen the springs of personal consciousness as he has found necessary, and able also to project the forms he has found at the springs of consciousness with as great a mastery as those he perceives objectively'.[58] As has been shown in terms of the artist's decision to paint from memory, the retention of external forms in his consciousness is vital for producing a subjective tendency in the artwork. It is the unavoidable dimensions of this inner life

that enrich the representation of 'Irish subjects' with varying psychological and personal content, an imaginative space that informs Jack Yeats' later compositions to an increasingly intensive degree.

BECKETT–YEATS–MACGREEVY

In this final section, I consider Beckett's objections to MacGreevy's monograph on Jack Yeats and show how these criticisms add to the complexities of Jack Yeats' art and Ireland's national background. In his response to a draft of the monograph that MacGreevy had sent him, Beckett disputes that

> You will always, as an historian, give more credit to circumstance than I, with my less than suilline interest in the fable convenue, ever shall be able to … I received almost the impression for example, as the essay proceeded, that your interest was passing from the man himself to the forces that formed him – and not only him – and that you returned to him from them with something like reluctance. But perhaps that also is the fault of my mood and of my chronic inability to understand as member of any proposition a phrase like 'the Irish people', or to imagine that it ever gave a fart in its corduroys for any form of art whatsoever, whether before the Union or after, or that it was ever capable of any thought or act other than the rudimentary thoughts and acts belted into it by the priests and by the demagogues in service of the priests, or that it will ever care, if it ever knows, any more than the Bog of Allen will ever care or know, that there was once a painter in Ireland called Jack Butler Yeats. This is not a criticism of a criticism that allows as a sentient subject what I can only think of as a nameless and hideous mass, whether in Ireland or in Finland, but only to say that I, as a clot of prejudices, prefer the first half of your work, with its real and radiant individuals, to the second, with our national scene. Et voilà.[59]

Beckett sent this letter to MacGreevy from the Grande Chaumière in Paris on 31 January 1938, three weeks after he had been stabbed on the Avenue d'Orléans by a pimp. Narrowly missing his left lung and heart, the attack on the night of 6 January had confined him to hospital for over two weeks. When Beckett later met the improbably named Robert-Jules Prudent in

court and asked him why he had attacked, the Frenchman responded wryly: '*Je ne sais pas, monsieur. Je m'excuse.* ['I don't know why, sir. I'm sorry.'] Amused by his assailant's response, and ever wary of guarding his privacy, Beckett chose not to press charges, having previously written to MacGreevy from the hospital that his assailant 'seemed more cretinous than malicious'.[60]

The context surrounding this letter is important since it allows us to appreciate how greatly the absurd contingency of the event had coloured Beckett's imagination. The irreducible singularity that Beckett attributes to the artist, with its kamikaze denial of social and historical forces, sits awkwardly beside MacGreevy's desire to re-historicise Jack Yeats' work in the context of an Irish Republic. Indeed, the letter is written in terms that deliberately indulge Beckett's 'clot of prejudices' on such 'a sentient subject' as that of national identity. His indifference to any wider collective in Ireland beyond that of 'real and radiant individuals' contrasts profoundly not only with the 'affection' that MacGreevy perceives as the 'greatest equipment of the artist' but with Jack Yeats' own statements of concern about the natural and human scene.[61] Where MacGreevy draws attention to the range of the social lives that Jack Yeats depicts so vividly in his paintings, Beckett highlights his 'chronic inability to understand as member of any proposition a phrase like "the Irish people"', questioning whether such metonymy is possible in a society so broken and divided.[62]

Seven years later during his brief post-war visit to Dublin, Beckett wrote a review for *The Irish Times* on MacGreevy's monograph following its release in 1945. In the subtitles of 'MacGreevy on [Jack] Yeats', he pointedly distinguishes between those aspects of Jack Yeats that MacGreevy emphasises as 'The National Painter' and those which he himself promotes as 'The Artist'.[63] At the end of the review, Beckett deliberately undermines the social dimension that MacGreevy adds to the paintings:

The being in the street, when it happens in the room, the being in the room when it happens in the street, the turning to gaze from land to sea, from sea to land, the backs to one another and the eyes abandoning, the man alone trudging in sand, the man alone thinking (thinking!) in his box – these are characteristic notations having reference, I imagine, to processes less simple, and less delicious, than those to which the plastic *vis* is commonly reduced, and to a world where Tir-na-nOgue makes no more sense than Bachelor's Walk, nor Helen than the apple-woman, nor

asses than men, nor Abel's blood than Useful's, nor morning than night, nor inward than the outward search.[64]

In this passage, Beckett refers obliquely to Jack Yeats' *Something Happening in the Street* (1944); to *Bachelor's Walk – In Memory* (1915); to *Helen* (1937); to *Tinkers' Encampment: The blood of Abel* (1940), which MacGreevy had seen in the spring of 1941 and discussed in the 1945 'Postscript' to his monograph on *Jack B. Yeats*; and to *Morning* (1936), which Beckett had purchased for himself. In each of these cases, Beckett refuses to extrapolate any further meaning – be it national, ethical or theological – from the artist's work.

Several questions might follow on from this reasoning. According to what arrangement of civic and cultural priorities is an affirmative political dimension, one that labels itself 'Irish', to be understood? From what theory of resistance is its collective identity to be derived? As we have seen, MacGreevy invokes the *'petit peuple'* against an official state-driven nationalism to form the basis of an authentic vernacular culture. However, a problematic duality persists in these structures of representation. On the one hand, MacGreevy argues that Jack Yeats has transported the 'idea that the people to whom he belongs have of themselves'.[65] On the other hand, MacGreevy argues that Jack Yeats has projected the vision of a people not fully formed by, or conscious of, their national identity, and has therefore created 'the attitude that the world will have to them afterwards'.[66] A circular argument evolves here in which it is the function of the artist to be both created by the nation and to create it by virtue of representing it.

The unresolved tensions of alienation and attachment, mind and matter, spirit and body that direct Beckett and MacGreevy's debates about Jack Yeats' art have further implications. Beckett's images of alienation, suspension, scission and disjunction – while clearly illustrative of his solitary and idiosyncratic apprehension of Jack Yeats – do not simply undermine MacGreevy's attempts to establish an underlying continuity between the artist, the landscape and the people. Modifying his humanist tendencies carefully in dialogue with Beckett appears to have allowed MacGreevy to accommodate, and complicate, the former's insistence on 'pure inorganic juxtapositions' and 'a nature almost as inhumanly inorganic as a stage set'.[67] Especially intriguing in this connection is the paradoxical expression 'metaphysical concrete' that occurs in correspondence between them. Beckett uses this expression in reference to Picasso's *Figures au Bord de la Mer* (1931),

which they had both seen while they were living together in Paris: '(do you remember the tremendous figure on a shore that I liked so much in the big Paris Exhibition?), metaphysical concrete'.[68] Beckett employs exactly the same expression when recording his observations of Karl Ballmer's *Kopf in Rot / Head in Red* composition (*c.* 1931) into his German diary, during which he is reminded of his earlier experiment with the lyric ('my Vulture'):

> Transparent figures before landscapes ... Wonderful red Frauenkopf, skull earth sea & sky. I think of Monadologie & my Vulture. Would not occur to me to call this painting abstract. A metaphysical concrete. Nor Nature convention, but its source, fountain of Erscheinung. Fully a posteriori painting. Object not exploited to illustrate an idea, as in say [Fernand] Léger or [Willi] Baumeister, but primary. The communication exhausted by the optical experience that is its motive & content. Anything further is by the way.[69]

It is surprising how well these brief notations complement MacGreevy's reading of Jack Yeats' stylistic development: the apparent solidity of human figures is drawn into a background of light and shade (generating a threshold between what can and cannot be represented); the didactic exploitation of a message is refused; and meaning is advanced on a principle of non-domination and self-assurance. As such, Ballmer's 'Head in Red' composition of 'skull earth sea & sky' is voiced as nothing 'construit' (deliberately constructed) but as manifestation of a deeper productive tension. What Beckett recognises in Ballmer's painting is a technique not prepared in advance and applied to inert material (as per 'convention') but developed 'fully *a posteriori*' out of the material itself so that both the inner experience and the outer form are created anew by a reciprocal process of interaction. Beckett's nominalisation of 'Erscheinung' from 'Schein', in its positive sense and as the basis of art, means phenomena, apparition, becoming visible (and *not* illusion). An indication of what this process entails as the outcome or upshot of Ballmer's work can be discerned from Beckett's earlier description of Joyce's *Work in Progress* in *transition* as a circulation of language 'not *about* something; *it is that something itself* – Here form *is* content, content *is* form'.[70] Crucial to Beckett's argument in each of these instances, whether applied to language or painting, is the fusion of medium and signification as an indivisible whole and unity.

The source of Beckett and MacGreevy's disagreement is not, then, over the inseparability of form and content that they observe, and praise, in Jack Yeats' late oil paintings. Rather, their dispute arises over how this reciprocal process of interaction at the level of the artistic medium might itself become a point of national significance. As we have seen, MacGreevy enlists the autonomous claims of Jack Yeats' art in pursuit of self-determination in the national body politic. In other words, he stresses the *non*-representational values of the artwork as a necessary preliminary to the political struggle in any form (one that 'fulfils the perennial need to check up on authority's liability to abuse its privileges').[71] By contrast, Beckett's analysis of Jack Yeats' art remains uncomplicated by the need to find in Ireland a cultural alternative to that which the Irish Free State occupies politically. Where MacGreevy finds a resurgent spirit in Jack Yeats' work that shines through the outward disintegration of the nation, Beckett aestheticises the artist's self-assurance in purely existential terms, citing his ability to bring light 'to the issueless predicament of existence'.[72] That Jack Yeats' art should have prompted such divergent responses from two of his closest contemporaries as to its possible (or impossible) political implications reflects back on the split between Ireland's earlier revolutionary aspirations and its conservative artistic direction.

It is worth recalling that Jack Yeats' work became critically important to MacGreevy during the second quarter of the twentieth century after the 'great national stir' of the revolution had been superseded by the imposition of government forces. During this counter-revolutionary stasis, MacGreevy advances a pacifist account of cultural development that celebrates itinerant life: the world of flower girls, circus performers and entertainers whose very livelihood is to go about giving pleasure. That this underlying affinity with a classless and disenfranchised group is expressed independently and imaginatively by the artist – and not through the official nationalism of the political regime – is crucial to MacGreevy's reconstruction of the national painter. What unites the poet and the painter in this connection is that they both are creators *of* the people; that is, of the ways in which a society may be formed, remembered and collectively experienced.

This chapter has demonstrated how MacGreevy's informal style makes art a topic of general concern. As a public commentator, he repeatedly connects the most powerful examples of nationality and artistry to zeitgeist and the spirit of the age rather than to the traditional practices of the

academy. As is evident, too, from his defence of Mainie Jellett, from his promotion of Jack Yeats, and from the conception of his own time abroad as 'a step on the way home', his discursive interventions consistently resist and recast prearranged notions of 'Irishness' in full view of alternative attitudes and ideals. 'Beyond the national point of departure', MacGreevy states in a 1948 radio interview with Jack Yeats for the BBC Third Programme, 'are the essential humanities.'[73] This intriguing phrase, which echoes one of the artist's most recent paintings *Humanity's Alibi* (Plate 9), refers to a collective spirit beyond the reach of partisan ideologies, restrictive stereotypes and official state-driven power. Through his criticism, interviews and public commentary, MacGreevy soon found himself in a powerful position from which to shape the reception of Irish art. The final chapter of this book turns its attention to the National Gallery, where, I argue, a public space was constructed in which Ireland's civic and cultural priorities could at last find an affirmative political dimension.

5
The National Gallery Revisited, 1950–63

· ·

You that would judge me do not judge alone
This book or that, come to this hallowed place
Where my friends' portraits hang and look thereon;
Ireland's history in their lineaments trace;
Think where man's glory most begins and ends
And say my glory was I had such friends.

W.B. Yeats, 'The Municipal Gallery Revisited' (1937)[1]

It is no accident that art galleries should have attracted so many Irish writers otherwise in pursuit of literary careers. The motives of the public who visit them cannot be fixed or predetermined but must work on a principle of engagement that is free and voluntary. Curatorial titles, scripts, plaques and captions may guide the experience of looking, but in ways that remain susceptible to individual response. It is this ability to engage the public through concrete and intimate encounters that is stressed in the final lines of W.B. Yeats' 'The Municipal Gallery Revisited' (1937). Here, the verb 'hang' acts as a deliberate pun both on the position of the paintings and on the ability of the speaker to command attention. The 'I' yokes together the twin forces of past and present to make 'Ireland's history' personal, which culminates with the final rhyming couplet ('ends / friends'). Beginning and ending is connected by the speaker to the life of each portrait on display – 'Casement upon trial'; 'Griffith staring in hysterical pride'; 'O'Higgins' countenance' – and to a deeper anxiety about what will endure as the audience passes from picture to picture.

The strange ritual of gallery-going sets it apart from most forms of interaction with history. In the gallery, cultures mix in provocative relation

to one another as paintings from different countries hang in neighbouring rooms. Many critics have commented on the phenomenon of experiencing a gallery, including MacGreevy's friend Paul Valéry, who in his seminal 1923 essay 'The Problem of Museums' appears to have regarded the institution as an omnivorous Saturn eating her children: 'The museum exerts a constant pull on everything. It is fed by the creator and the testator. All things end up on the wall or in a glass case ... I cannot but think of the bank at a casino, which wins every time.'[2] While Valéry is right to stress the museum's role as preserver of a community's official memory, he overstates its power to collect against the viewing participant. In Ireland, the transfer of private collecting practices into the public domain had many unintended consequences for the old regime and its hegemonic motives. As Marie Bourke has mentioned in relation to the antiquities based in the National Museum of Ireland, the capacity of collectors to abstract artworks from their ordinary lives and to set them aside for special consideration had inadvertently contributed to a form of cultural self-belief.[3] The collecting habits of curators, exhibitionists and dealers had unwittingly redirected feelings of political membership in new and subversive directions.

Seen from this perspective, the expansion of museum culture in Dublin provides an important arena for discussing the continuation of an avant-garde impulse. For a nation recently liberated from British rule, the need to frame a wider cultural heritage inside the gallery's doors was vital and contemporary. In a private letter to Dorothy Wellesley, W.B. Yeats quotes from one of his senatorial speeches, which declares the overriding importance of cultural unity: 'only by songs, plays, stories, can we hold our thirty million [Irishmen] together, keep them one people from New Zealand to California. I have always worked with this principle in my mind.'[4] As Yeats wryly acknowledges to Wellesley, however, when undercutting his public persona, that goal is paradoxical insofar as it refers both to mediated descendants in a country called Ireland and to an imagined community of individuals who may live anywhere in the world.[5] It is in this context that the National Gallery is crucial. As a dramatic field that takes from private donors and gives their collections back to a larger audience, the gallery not only brings the public into existence; it also raises more vital questions about what that 'public' is.

THE DIRECTOR'S POLICIES

That MacGreevy remained passionate about revitalising the public's relationship with art and building a better platform for artistic education is most clearly reflected by his efforts to raise visiting numbers to the National Gallery. Within the first year of his directorship, MacGreevy oversaw the introduction of turnstiles to monitor viewing figures. This strategy resulted in more accurate records for measuring the size of the viewing public, which grew from 37,547 in 1958 to 53,451 in 1961.[6] The fastest rate of increase appears to have occurred during the second half of his tenure, once the effects of his policies started to become apparent.

It is revealing that one of his first initiatives as director of the National Gallery was to make art a topic of biweekly discussion for children and adults of all ages and backgrounds. MacGreevy invited young artists, such as the sculptor Dónal Murphy, to contribute to a new lecture series, which resulted in group visits on Wednesdays and Sundays. Because of these lectures and guided tours, the National Gallery soon became an independent space for teaching and learning.[7] According to art historian James White, who later succeeded him as director, MacGreevy 'produced more publications than any of his predecessors' on the topic of art history, 'and lectured widely to a variety of audiences'.[8] Examples include MacGreevy's concise catalogue of the oil paintings at the National Gallery, which provided a script for visitors; his public addresses on French artists such as Paul Pouchol, which introduced the public to lesser-known contemporary artists who had exhibited at the Salon des Indépendants; and his presidential speeches to the International Association of Art Critics, which extended the reputation of the gallery abroad.[9]

By starting with a complete rehanging of the gallery's collection, MacGreevy caused much disquiet among his predecessors. Brinsley MacNamara wrote to one of the previous holders of the directorship, Thomas Bodkin, complaining that 'The collection is being turned upside down and inside out ... you may scarcely be able to recognise the Gallery as the same place when you next call.'[10] Peter Somerville-Large recounts in his 150-year history of the National Gallery, which dates back to its foundation by a British Act of Parliament in 1854, that 'The rehanging was [achieved] at the expense of the Portrait Gallery, in which MacGreevy had no interest.'[11] Chapters 3 and 4 have demonstrated MacGreevy's general aversion to portraiture as an artistic medium. These latent attitudes appear to have resurfaced in his

curatorial vision. Two years after MacGreevy had stepped down as director, Henry Mangan, chairman of the Office of Public Works and a member of the board of directors at the National Gallery, wrote an angry memo on the state of the National Portrait Collection, which, since 1875, had been located on the ground floor of the National Gallery to the rear of the Dargan Wing.[12] Taking his cue from Mangan's memo, Somerville-Large observes that

> In Inner Room No 1 the late James McNeill, Governor General of the Irish Free State, was jammed in a corner close to a side door; on the other side was Strongbow [Daniel Maclise's *The Marriage of Strongbow and Aoife* (*c.* 1854)]. The portraits, some in double lines, were huddled together on the walls and sides of several projecting partitions. In a smaller, equally crowded room, Cromwell, King William, Swift, and George Bernard Shaw shared space with [the] bronze busts of Kevin O'Higgins, Arthur Griffith, Michael Collins, Austin Stack and Cathal Brugha, arranged on the windowsills.[13]

The relegation of the Irish Free State Commissioner James McNeill to a cramped, peripheral position by the side door reveals much about the new spaces for national memory that were created by this rehanging. Compressed into 'a smaller, equally crowded room' are two separate traditions – Protestant and Catholic – that together constitute a modern Ireland imaginatively different from the ideological rifts that the Irish Free State had sought to sustain between 'Anglo' and 'Irish' Ireland. Imperial conquerors are required to inhabit the same locale as assassinated revolutionaries. As well as revealing the complexities of the director's personal orientation with regard to modern Irish history, MacGreevy's rehanging of the gallery also prompts wider questions about how and where these figures might meet the public. The few portraits that he did purchase for the National Gallery found a place for major artists who had been neglected by the Royal Hibernian Academy: namely, Nathaniel Hone's *Horace Hone Sketching* (NGI 1297) and John Yeats' portrait of Susan Mitchell (NGI 1298).

Before taking up his directorship, MacGreevy had sought to introduce living art to the gallery's collection. The frustration of this particular objective reaches back to his earlier dispute with Thomas Bodkin, then director of the National Gallery, who had argued in an article about a

founding member of the Royal Academy, the eighteenth-century portrait and miniature painter Nathaniel Hone, that 'No Irish painter, living or dead, has equalled, much less surpassed, the purely aesthetic quality of his art.'[14] MacGreevy responded to his art-historical nemesis by parodying these canonical pronouncements: 'No Hone that I have ever seen could, I think, equal, much less surpass, the aesthetic quality, the impressive design, the massive movement, the fine colour of *Morning After Rain* in the last Jack Yeats exhibition.'[15] Polemic raged on between these two figures over the enduring canons of aesthetic, with MacGreevy refusing to give way to Bodkin's earlier pronouncements on Hone as the latter published his reply to 'the self-constituted and super-sensitive champion of Mr [Jack] Yeats' in the *Irish Statesman*.[16] This strikingly caustic invective offers a glimpse into the prevalent attitudes against living art that MacGreevy would face once in charge of the institution. As noted in the previous chapter, MacGreevy's monograph on Jack Yeats, which was published by the artist's agent in London five years prior to his directorship, was highly unusual in Ireland.

As director, MacGreevy tried on several occasions to thwart the National Gallery's official stance of not exhibiting contemporary painting. The pressure he exerted in national newspapers on Jack Yeats' behalf was in direct contravention of the board's policy of not purchasing works by living artists, with the board having placed a fifty-year embargo after their death before acquisitions could be made. This is a surprising policy for a national collection in development and implies an astonishing degree of conservatism and nervousness over the appearance of Irish culture. Despite this ruling, MacGreevy found ways of circumventing the board's jurisdiction. He encouraged numerous bequests and donations to the gallery, which saw the acquisition of five works by Jack Yeats, four of which were obtained while the artist was still alive. Richard Best's legacy brought three early works by Jack Yeats to the National Gallery (NGI 1406–9) and Mrs J. Egan gave the gallery one of its most popular paintings, *Before the Start* (NGI 1549). In the final year of his directorship, MacGreevy purchased *Double Jockey Act* (NGI 1737), though the artist was now dead.[17]

Jack Yeats had briefly attended board meetings at the gallery while MacGreevy was in charge, but ceased to do so after July 1953. In 1954, following the death of the artist, the Irish government notified the National Gallery that it was willing to contribute £2,000 of the £2,700 required towards the purchase of three paintings by Jack Yeats from the Dawson

Gallery, among which was *Bachelor's Walk – In Memory*. After holding an emergency meeting to consider the possibility of these acquisitions, the board upheld its existing policy and declined the assistant funds. Undeterred, in April 1957, MacGreevy once again brought up the possibility of buying his paintings. 'If at all possible', he entreated Éamon de Valera, 'Mrs [Randal] Plunkett should be persuaded to surrender private ownership of *Bachelor's Walk – Memory* [*sic*], which is one of the most moving and beautiful pictures by the artist ever painted.'[18] As discussed in the previous chapter, the painting completed a year after the King's Own Scottish Borderers had opened fire at a large crowd on Bachelor's Walk in Dublin concentrates on the ambiguous intentions of a flower girl, who discards her remaining blooms where members of the public had been shot.[19] MacGreevy's appeal to the Taoiseach was unsuccessful. After the picture was stolen from Dunsany Castle in 1990, the National Gallery of Ireland finally acquired it on loan following its recovery in London in 2007.

Despite the board's refusal to purchase work by living artists and the government's reluctance to pressure private collectors to exhibit important paintings, the unprecedented quantities of bequests that MacGreevy received as director eventually forced the institution into accepting significant works of modern art. Halfway through his directorship, Evie Hone died, leaving the National Gallery a collection of postimpressionist paintings, including collages by Juan Gris and Pablo Picasso (NGI 1313 and 1314). Jellett's initially controversial painting *Decoration* (1923), which MacGreevy had vociferously defended thirty years previously, was also bequeathed to the National Gallery of Ireland in 1955 (NGI 1326).[20] MacGreevy also presided over Hugh Lane's complicated legacy, a large part of which had been left to the National Gallery of Ireland rather than to the Municipal Gallery of Modern Art that Lane had founded. Lane's benefaction consisted of forty-two paintings and the remainder of his estate, which was sold after legalities to provide a fund for the institution.[21] But by far the most important donation that MacGreevy received in his capacity as director was the collection of nineteenth-century French art that Sir Alfred Chester Beatty left to the gallery. This single bequest included ninety-three French paintings and an especially fine sample from the Barbizon school.[22] Beatty would later offer the gallery twenty-two French impressionist pictures on loan for a Dublin exhibition and a late Cézanne watercolour of *La Montagne Sainte-Victoire* (1902–4; NGI 3300) as a gift.[23] Such was MacGreevy's skill at

reaching out to the naturalised British citizen, who had moved to Dublin in 1950, that the millionaire philanthropist developed a running joke in relation to his Irish correspondent, calling himself and the director 'M & B' after the pre-penicillin antibiotics.[24]

Other dignitaries with whom MacGreevy worked to procure advice and assistance included Professor Magnani of the University of Rome, Sir Kenneth Clark (ex-director of the National Gallery in London) and James J. Rorimer (incoming director of the Metropolitan Museum of Art, New York). MacGreevy's international experiences in Paris, Rome, London and, later, New York made him alert to deficiencies at the National Gallery of Ireland, and he wasted no time in outlining the backward state of the institution. Pointedly, he used Thomas Bodkin's *Report on the Arts in Ireland* to justify his argument that 'as a nation we are woefully ill-equipped to judge of the visual arts'.[25] Bodkin's report was originally sent to MacGreevy on the instruction of the Taoiseach, cementing MacGreevy's new role as chief adviser to the government in matters relating to art. Two years after MacGreevy's appointment to the directorship, Bodkin revisited the National Gallery, expressing in curiously dulcet French tones to his former adversary, the honorary Chevalier: 'Cher ami et colleague, it was an extreme pleasure to see you the other day and to survey the splendid work you have done in the NGI … Thanks to you its long eclipse has now ended.'[26]

While the changes that MacGreevy brought to the institution appeared to some to be fruitlessly disruptive, a grudging recognition is evident even here from Bodkin that he had helped to turn its fortunes around. Despite persistent underfunding from the government, MacGreevy enhanced the gallery's international reputation, improved its visiting numbers and reasserted the institution's educational purpose as a place in which to attract and inform all members of the public. Where he had previously written poems as *faits sociaux* of Ireland's political turmoil, MacGreevy's directorship of the National Gallery allowed him to work directly with the government and to transform the cultural priorities of the next generation. The hard graft of public administration empowered him to occupy the political centre and to manage the norms of civic discourse. A letter sent halfway through MacGreevy's tenure in 1955 to the Irish Department of Education provides clear evidence of the agency behind his decision to discontinue his literary career: '… for five years I have put everything else to one side. I was known as a writer and I am no longer, to all intents and purposes, a writer – and

have given all my time, in season and out of season, to the National Gallery and its problems.'[27]

What critics have imputed in this respect to agonising personal hiatus or to a narrative of flawed Irish achievement can be read more profitably in terms of MacGreevy's growing reputation as a public intellectual and the creation of a modern audience in Dublin.[28] As this chapter has maintained, MacGreevy's leadership of the National Gallery brought with it a new version of the popular and democratic. When he took over as head of Ireland's most famous cultural institution, attendances at the gallery were still falling.[29] His policies helped to reverse the erosion of an independent viewing public. Every room was rehung during his thirteen years as director and plans set in motion for enlarging the gallery's physical dimensions.[30] Having supported Mainie Jellett, Mary Swanzy, Nano Reid, Norah McGuinness, Frances Kelly, Grace Henry and other female artists for 'burying the hatchet between experimental talents and academic', MacGreevy was now able to feed the very concept of an 'Irish people' on postimpressionist pictures. Most importantly, his relentless campaign for the inclusion of contemporary art allowed him, over time, to re-enter the Irish mainstream, to eradicate the conditions of mutual mistrust between experimental artists and the public, and to bring art within the reach of all.

NOTES

Introduction

1. Augustine Martin, 'MacGreevy in the Best Modern Way', *Irish Literary Supplement*, vol. 10, no. 2, autumn 1991, p. 26.

2. Ibid.

3. Ibid.

4. See J.C.C. Mays' 'How Is MacGreevy a Modernist?', in Alex Davis and Patricia Coughlan (eds), *Modernism and Ireland: The poetry of the 1930s* (Cork: Cork University Press, 1995), pp. 103–28; Stan Smith's 'Living to Tell the Tale: Fallon, Clarke, MacGreevy, Coffey', in *Irish Poetry and the Construction of Modern Identity: Ireland between fantasy and history* (Dublin: Irish Academic Press, 2005), Chapter 3; and Susan Schreibman's 'Introduction', in *Collected Poems of Thomas MacGreevy: An annotated edition* (Dublin: Anna Livia, 1991), pp. xix–xxxviii.

5. Derek Mahon, letter to *The Irish Times*, 10 July 1982. Few dividing lines are less frequently crossed than those between the Belfast poets of the Heaney generation, who are globally renowned for their nature poetry, and experimental writers from the South. The aesthetic differences run deep. In interview with Dennis O'Driscoll, Seamus Heaney openly derided Beckett's 1934 essay 'Recent Irish Poetry' as having 'foisted on us' a 'fantasy' of modernist alternative. See Dennis O'Driscoll, *Stepping Stones: Interviews with Seamus Heaney* (London: Faber & Faber, 2008), p. 239. Edna Longley has also taken umbrage at what she sees as the 'hegemonic project' of modernist critical paradigms that deny the vitality and variety of nature poetry. See Edna Longley, 'England and Other Women', *London Review of Books* vol. 10, no. 9, 5 May 1988, pp. 22–3; and her selection of nature poets in *The Bloodaxe Book of 20th Century Poetry from Britain and Ireland* (Hexham: Bloodaxe, 2000). See also Edna Longley's *W.B. Yeats and Modern Poetry* (Cambridge: Cambridge University Press, 2013), which reads Yeats' presence in the field of modern poetry alongside nature poets such as Edward Thomas.

6. See Gerald Dawe (ed.), *The Cambridge Companion to Irish Poets* (Cambridge: Cambridge University Press, 2018).

7. See the Special Issue on Irish Experimental Poetry edited by David Lloyd and John Brannigan for the *Irish University Review*, vol. 46, no. 1 (Edinburgh: Edinburgh University Press, 2016), which features several essays on Irish poetic experiment – including mine entitled 'Towards an Analysis of Irish Experimental Poetry', pp. 20–37 – alongside contemporary poetry by Sarah Hayden, Maurice Scully, Trevor Joyce, Fergal Gaynor, Billy Mills and Catherine Walsh.

8. See Frank Kermode's 'Preface', in Bart Eeckhart and Edward Ragg (eds), *Wallace Stevens Across the Atlantic* (Basingstoke: Palgrave Macmillan, 2008), p. xvii. A rare and remarkable gift to inspire trust and to spark deep intellectual friendships led a wide array of authors, artists, intellectuals and politicians to regard MacGreevy as a creative peer and as an invaluable confrère.

9. See Thomas MacGreevy, 'Autobiographical Fragments', TCD MS 8054, p. 24.

10. See TCD MS 8140/3 for a summary of MacGreevy's army experience.

11. MacGreevy, 'Autobiographical Fragments', TCD MS 8040A/53.

12. The publication of a controversial short story by Lennox Robinson provided the catalyst for MacGreevy's departure from Ireland. 'The Madonna of Slieve Dun', which was published during August 1924, features a farmer's daughter named Mary Creedon who imagines herself as the Madonna after she is sexually assaulted. Unable to come to terms with the event, she recasts her pregnancy in the form of an Immaculate Conception yet dies giving birth to a girl (on Christmas Eve). See Lennox Robinson, 'The Madonna of Slieve Dun', *To-Morrow*, vol. 1, no. 1, August 1924. Other scandalous contributions to the journal *To-Morrow* included W.B. Yeats' 'Leda and the Swan', Liam O'Flaherty's 'A Red Petticoat', and Margaret Barrington's imperial sex drama 'Colour', though it was the focus of Robinson's short story on the Immaculate Conception that upset the clergy, causing suppression of the journal after only two issues. For further information about this scandal and its far-reaching implications, see Anthony Olden's 'A Storm in a Chalice', *Library Review*, vol. 25, no. 7, autumn 1976, pp. 265–9 (p. 269). The Irish Advisory Committee of the Carnegie United Kingdom Trust, for which MacGreevy worked at the time as the country organiser and assistant secretary, became embroiled in the controversy surrounding the story when one of its members resigned, stating that they could no longer work with Robinson. Robinson, the trust's secretary, was dismissed, and the activities of the trust, which provided books for free public library services, suspended. When the administration of the Irish office of the Carnegie scheme was redirected through Scotland under the control of Dunfermline, MacGreevy was offered a new post at an increased salary of £400. Without accepting the offer or confronting the priests, he returned to London.

13. Eliot also ventured MacGreevy's name to Leonard Woolf, the literary editor of *The Nation and Athenaeum*, to help him find additional work during periods of financial difficulty. T.S. Eliot to MacGreevy, n.d., TCD MS 8113/6.

14. Thomas MacGreevy, 'Living with Hester', TCD MS 7989/1, 50. For more information about MacGreevy's second sojourn in London, see my chapter entitled 'The Other Dublin: London Revisited, 1925–7' in Susan Schreibman (ed.), *The Life and Work of Thomas MacGreevy: A critical reappraisal* (London: Bloomsbury, 2013), pp. 141–54.

15. Thomas MacGreevy, 'Dysert', *Criterion*, vol. 4, no. 1, January 1926, p. 94.

16. Marianne Moore to MacGreevy, 26 March 1926, TCD MS 8121/1. 'We particularly admire the "Nocturne of the Self-Evident Presence" and, as we said to T.S. Eliot, are most tempted to disregard the fact that we must not, at present, accept additional verse.'

17. See TCD MS 7989/1, 84 and TCD MS 7989/1, 73 respectively.

18. The poem was published in the *Irish Statesman* on 1 May 1926 after MacGreevy sent it to 'Æ' Russell.

19. MacGreevy arrived in Paris just before Beckett as a cover for William MacCausland Stewart, who had decided to take the offer of a post in Scotland. Impressed by the quality of MacGreevy's work, Gustave Lanson had promised him that he could stay on as lecturer for the following academic year (that of 1927–28) even though Trinity College, Dublin had already proposed another lecturer for the forthcoming semester. A compromise soon appears to have been reached. Under these unique circumstances, MacGreevy and Beckett found themselves working together as *lecteurs d'anglais* at the same college. See Archives Nationales, France (ANF), 61 AJ 202: IRLANDE: échange de lecteurs avec le Trinity College Dublin: Affaire Beckett et MacGreevy (1927–9). According to the exchange between Msr Vessiot, director of the ENS, and E.J. Gwynn, the Trinity provost: 'C'est pour donner satisfaction au désir manifeste par Trinity College relativement à M. Beckett que nous avons eu à l'École, au 1928–29, deux lecteurs anglais au lieu d'un' (p. 2).

20. See *Introduction to the Method of Leonardo da Vinci*, translated from the French of Paul Valéry of the Académie Française by Thomas MacGreevy (London: John Rodker, 1929).

21. As Tara Stubbs has shown in '"So kind you are, to bring me this gift": Thomas MacGreevy, American modernists and the "gift" of Irishness', MacGreevy sought to 'keep up nearer to the margin' of poetry during this period through his correspondence with American modernist poets [*TMCR* 227–41]. See MacGreevy to Babette Deutsch, 5 November 1946; *WUL* MS 034 (Box 1, Folder 3). MacGreevy sent copies of his artistic monographs, including his study on Nicolas Poussin, to Marianne Moore. See TCD MS 8121/9.

22. O'Malley to MacGreevy, 31 January 1940. The Tamiment Library & Robert F. Wagner Labour Archives, Ernie O'Malley Papers AIA.060, Box 25, Folders 11–13.

23. See MacGreevy's *T.S. Eliot: A study* (London: Chatto & Windus, 1931); *Richard Aldington: An Englishman* (London: Chatto & Windus, 1931); *Jack B. Yeats: An appreciation and an interpretation* (Dublin: Victor Waddington, 1945); and 'A Note on "Work in Progress"', *transition* 14, 1928, pp. 216–19.

24. Susan Schreibman, 'Introduction', in *TMCR*, p. xxv.

25. Rhiannon Moss, 'Irish Modernism in an International Frame: Thomas MacGreevy, Seán O'Faoláin and Samuel Beckett in the 1930s', PhD thesis, Queen Mary, University of London, September 2009.

26. Terence Brown, *Ireland: A social and cultural history, 1922–2002* (London: Harper Perennial, 1981), p. 156. Brown's study notes how neo-liberal discourse has favoured the subjective impulse in modernity rather than re-imagined the ties between nationalism and culture.

27. Matei Calinescu, *Five Faces of Modernity: Modernism, avant-garde, decadence, kitsch, postmodernism* (Durham, NC: Duke University Press, 2003 [first published 1977]), pp. 121–2. For the larger context of Calinescu's definitions, see the chapters on 'Avant-garde and Aesthetic Extremism' and 'The Idea of the Avant-garde', pp. 95–148.

28. See Gerald Dawe, 'Reimagining a Lost Generation', *Irish Times*, 26 August 2000. Lacking a romantic narrative to match that of their revolutionary predecessors (the eponymous 'men of 1916'), Ireland's post-revolutionary generation has often been regarded as one of depressing failure. Nicholas Allen's *Modernism, Ireland and Civil War* (Cambridge: Cambridge University Press, 2009) is one of the few studies to have conveyed a powerful sense of the atmosphere that Irish writers and artists inhabited during the 'continuing controversy' of the post-revolutionary state.

1. Becoming a Poet: MacGreevy and the aftermath of the Irish revolution

1. Thomas MacGreevy, *Richard Aldington: An Englishman* (London: Chatto & Windus, 1931), p. 12.

2. Thomas MacGreevy, 'A Cultural Irish Republic' (November 1934), TCD MS 8003/9, p. 2. Many admire the visually striking iconography of the coins produced under the Irish Free State (W.B. Yeats was chair of the coin committee). It is MacGreevy's point about the narrowly tactical logic of the national government that I am pursuing here.

3. Piaras Mac Éinrí has mentioned the overprinting of the stamps, which is reported to have continued in the case of high-value denominations well into the 1930s, in discussion with Patricia Coughlan. See Davis and Coughlan (eds), *Modernism and Ireland*, p. 205.

4. Some of these letter boxes were repainted back again to red by An Post in 2016 to coincide with the GPO's Witness History exhibition for the Easter Rising centenary, adding further layers of contradiction to this cultural palimpsest.

5. MacGreevy, 'A Cultural Irish Republic', TCD MS 8003/14/5. Four years later, to members of the NUI Club in London, MacGreevy would again outline the risks of cultural provincialism in a lecture entitled 'The Cultural Dilemma for Irishmen: Nationalism or provincialism?', December 1938, TCD MS8003/8/9a.

6. Mainie Jellett, 'A Word on Irish Art', part of a lecture delivered to the Munster Fine Arts Club in Cork (1942), reprinted in Eileen MacCarvill (ed.), *The Artists Vision: Lectures and essays on art, with an introduction by Albert Gleizes* (Dundalk: Dundalgan Press, 1958), pp. 103–5 (p. 105).

7. James Devane, 'Nationality and Culture', *Ireland To-Day*, vol. 1, no. 7, December 1936, p. 16. See also Devane's 'Is an Irish Culture Possible?', *Ireland To-Day*, vol. 1, no. 5, October 1936, pp. 21–31.

8. 'Editorial', *An Gaodhal*, 20 October 1923.

9. Seumas O'Sullivan, 'Editorial', *Dublin Magazine* (new series), vol. 1, no. 2, April–June 1926, p. 1.

10. See Leviticus 20:2. See also John Milton's characterisation of Moloch in Book II of *Paradise Lost* (1674), lines 43–108, as the most reckless fallen angel. As stressed by reader-response critics of the 1960s, who were reacting against orthodox versions of the Christian myth that predetermine our sympathies, Milton's Christian epic, which is written in the style of oral recitation, deliberately exposes the listener-pupil to error and allows them to learn from mistakes (unlike the fallen angels who are incapable of such self-recognition).

11. These figures are taken from Samuel Beckett's 'Censorship in the Saorstát' (1934) (*D*, pp. 84–8). Beckett notes his own registration number as 465, which was assigned to him after his collection of short stories, *More Pricks than Kicks*, was banned in Ireland in 1934.

12. See 'Con' Leventhal's 'The *Ulysses* of Mr. James Joyce' (written pseudonymously as Laurence K. Emery), which was later published in truncated form in his own short-lived magazine *The Klaxon* (winter 1923); and Roy Foster's 'Bad Writers and Bishops 1924–25', in *W.B. Yeats: A life II: The arch-poet, 1915–39* (Oxford: Oxford University Press, 2003), p. 271.

13. Brendan Behan to Sindbad Vail, *Points*, no. 15, autumn 1952, p. 71.

14. See 'Michael Smith Asks Mervyn Wall Some Questions About the Thirties', *Lace Curtain*, no. 4, summer 1971, pp. 77–86, for a personal account of Irish public opinion at this time. For book-length studies on the topic, see Michael Adams, *Censorship: The Irish experience* (Dublin: Scepter Books, 1968), and Julia Carlson (ed.), *Banned in Ireland: Censorship and the Irish writer* (London: Routledge, 1990). For a revisionist account that inverts, rather than reassesses, dominant stereotypes about Ireland's cultural isolationism, see Brian Fallon's *An Age of Innocence: Irish culture, 1930–1960* (Dublin: Gill & Macmillan, 1998). Though Fallon does not dispute the existence of restricting forces, he controversially argues that other factors, such as the failure to revive the Irish language, exceeded the negative impact of censorship.

15. Elaine Sisson, 'A Note on What Happened': Experimental influences on the Irish stage, 1919–29', *Kritika Kultura*, no. 15, 2010, pp. 132–48 (133).

16. Beckett to MacGreevy, 5 October 1930, *TLSB*, p. 50. A six-year retaliatory trade war with Britain commenced the following year.

17. See R.F. Foster, *Words Alone: Yeats and his inheritances* (Oxford: Oxford University Press, 2011), p. 143. A 'Great Irish Revival Number' had been featured in the January 1886 edition of the *Irish Fireside*, a popular Irish weekly edited by Rose Kavanagh.

18. The *Irish Independent* had a circulation of about 152,000 at this time and was the country's largest selling newspaper – a daily broadsheet whose dominance in generating public opinion Éamon de Valera sought to offset by establishing *The Irish Press* in 1931 as the *Irish Independent*'s main competitor.

19. Sean O'Faolain, 'Commentary on the Foregoing', *Ireland To-Day*, vol. 1, no. 5, October 1936, p. 32.

20. See 'Editorial', *Ireland To-Day*, vol. 1, no. 1, June 1936, p. 1.

21. Samuel Beckett, 'Recent Irish Poetry', *Bookman*, 'Irish Number', August 1934, in *D*, p. 73. *The Bookman*'s final issue was published in December 1934. Other notable interventions include W.B. Yeats' 'The Need for Audacity of Thought', which was turned down by the *Irish Statesman* and published later in *The Dial*, vol. 80, no. 2, February 1926, pp. 115–18 under Marianne Moore's editorship.

22. Devlin to MacGreevy, 31 August 1934, TCD MS 8112/5.

23. For more information about George Reavey's literary agency (the Bureau Littéraire Européen, which he started with the Russian émigré Marc Slonim in 1932) and publishing imprint (the Europa Press, which he founded in 1935), see Sandra O'Connell's 'George Reavey (1907–1976): The endless chain – a literary biography', PhD thesis, Trinity College Dublin, 2006. A fluent Russian speaker (his own childhood was spent in Nizhny Novgorod), Reavey produced, under his Europa Press imprint, two of the collections analysed in this chapter: Beckett's *Echo's Bones* (1935) and Devlin's *Intercessions* (1937). For further discussion on the context of these original publications and their printed format, see Thomas Dillon Redshaw, '"Unificator": George Reavey and the Europa poets of the 1930s', in Davis and Coughlan (eds), *Modernism and Ireland*, pp. 249–75. MacGreevy introduced Reavey to Beckett in Paris.

24. Samuel Beckett, 'Recent Irish Poetry', in *D*, p. 71, p. 70.

25. Ibid., p. 74.

26. Ibid., p. 72.

27. Ibid., p. 73.

28. Ibid., p. 76; emphasis mine.

29. Ibid., pp. 71–2. Beckett alludes to W.B. Yeats' 'Three Movements', a poem in which the fish lie gasping 'on the strand' (not on the shore). The corruption is Beckett's.

30. Ibid., p. 71.

31. See the *Times Literary Supplement*, 'Review: Intercessions', 23 October 1937; and Beckett, 'Commentaries', *transition* 27, April–May 1938, pp. 289–94.

32. Beckett, ibid.

33. The essay, which is now in the Baker Memorial Library at Dartmouth College, remained unpublished until 1983.

34. Beckett, 'Recent Irish Poetry', in *D*, p. 72.

35. 'Assonance, more elaborate in Gaelic than in Spanish poetry, takes the clapper from the bell of rhyme.' Austin Clarke, *Pilgrimage and Other Poems* (London: Allen & Unwin, 1929), p. 43. For more on the connection between Beckett and Clarke, see W.J. McCormack's 'Austin Clarke: The poet as scapegoat of modernism', in Davis and Coughlan (eds), *Modernism and Ireland*, pp. 75–102 (pp. 80, 87–8).

36. See Austin Clarke, 'Irish Poetry To-day', *Dublin Magazine* (new series), vol. 10, no. 1, January–March 1935, p. 26.

37. Samuel Beckett, *Murphy* (London: George Routledge & Sons, 1938), p. 89.

38. Beckett, 'Recent Irish Poetry', in *D*, p. 71.

39. MacGreevy, *Richard Aldington: An Englishman*, p. 13.

40. Ibid., p. 12.

41. Ibid., p. 15.

42. Ibid.

43. The actual dates of the Celtic movement over which W.B. Yeats presided have been disputed since William Patrick Ryan's first book on the subject in 1894. Terence Brown notes that 'It was not in fact until June 1898 that Yeats published his essay in *Cosmopolis* on "The Celtic Element in Literature", which is considerably later than the date usually attributed to the movement's beginnings.' See Brown, 'The Literary Revival: Historical perspectives', in *The Literature of Ireland: Culture and criticism* (Cambridge: Cambridge University Press, 2010), pp. 14–26 (pp. 19–20).

44. Beckett, 'Recent Irish Poetry', in *D*, p. 70.

45. Denis Devlin, 'Now', in *CPDD*, p. 104.

46. Denis Devlin, 'Bacchanal', in *CPDD*, p. 65.

47. Devlin acted as a foreign diplomat in Paris before he was made the Irish ambassador to Italy.

48. Devlin to MacGreevy, 15 February 1937, TCD MS 8112/12.

49. Denis Devlin, 'Daphne Stillorgan', in *CPDD*, p. 62.

50. Ibid.

51. Ibid. Like the oncoming train in 'Daphne Stillorgan', the deconstruction of pastoral is vital to the disruptive homecoming of Beckett's 'Sanies I' in which the poet-cyclist loops about the coastal towns and villages north of Dublin, leaving a trail of mud in his wake: 'a Wild Woodbine / cinched to death in a filthy slicker'. Once again, the disturbance of a calm pastoral scene fails to remove these animal spirits from the lyric: 'distraught half-crooked courting the sneers of these fauns these / smart nymphs / clipped like a pederast as to one trouser-end'. Sean Lawlor and John Pilling (eds), *The Collected Poems of Samuel Beckett* (London: Faber & Faber, 2012), p. 13. Hereafter referred to as *CPSB*.

52. Johann Wolfgang von Goethe, *Poems of Goethe*, trans. Edwin H. Zeydel (Chapel Hill, NC: University of North Carolina Press, 1957), p. 33. For Beckett's engagement with Goethe, especially his transcriptions from Goethe's autobiography and *Faust*, see Mark Nixon, *The German Diaries, 1936–37* (London: Continuum, 2011), pp. 65–74.

53. Samuel Beckett, 'The Vulture', in *CPSB*, p. 5.

54. Ibid.

55. Ibid. 'Offal' may also be a pun on Offaly, a county located in the very centre of Ireland.

56. Thomas MacGreevy, 'New Dublin Poetry', *Ireland To-Day*, October 1937, pp. 81–2 (p. 81).

57. Samuel Beckett, 'Alba', in *CPSB*, p. 10.

58. Ibid.

59. Beckett to MacGreevy, 26 April 1935, TCD MS 10402: '*The Dublin Magazine* is out, but my poem not in.' The June 1936 number of *transition* opens with a section entitled 'Vertigral', which places three of the poems that had appeared earlier in *Echo's Bones* ('Dortmunder', 'Malacoda' and 'Enueg II') after James Agee's 'Lyric' and 'A Song'. See *transition* 24, June 1936, pp. 7–38. All the poems that feature in this section experiment with dawn and evening settings.

60. Samuel Beckett, 'Da Tagte Es', in *CPSB*, pp. 10, 22.

61. See Mark Nixon, *The German Diaries, 1936–37* (London: Continuum, 2011), p. 84. Nixon dates Beckett's reading of Robertson's book to spring 1934 based on Beckett's notes on the 'Minnesinger', which were written just before Beckett sent 'Con' Leventhal 'Da Tagte Es' on 7 May 1934.

62. 'Serena II', Enc. Beckett to MacGreevy, 3 November 1932, TCD MS 10402/35.

63. 'Serena III', Enc. Beckett to MacGreevy, 9 October 1933, TCD MS 10402/55.

64. Samuel Beckett, 'Sanies II', in *CPSB*, p. 14.

65. Ibid., p. 15.

66. Beckett to MacGreevy, 3 November 1932, TCD MS 10402/35. 'Serena II' Enclosed.

67. Samuel Beckett, 'Dortmunder', in *CPSB*, p. 11.

68. See Brian Coffey's 'Nightfall, Midwinter, Missouri', in *Poems and Versions, 1929–1990* (Dublin: Dedalus, 1991), p. 70.

69. Thomas MacGreevy, 'Crón Tráth na nDéithe', in *CPTM*, pp. 19–20.

70. The readings in this chapter disengage MacGreevy's *Poems* from some of the more tenuous points of Beckett's comparison, which deliberately downplay the collection's social and political force. In his review of MacGreevy's *Poems*, Beckett makes no attempt to select from a range of poetic material but quotes from four of the most 'quietist' religious passages he can find (the extracts from 'Gloria de Carlos V' and 'Seventh Gift of the Holy Ghost' being most apposite for his purposes). Beckett omits from the citation where the 'ascension' in the former poem begins: 'Those without gas masks were lost' (MacGreevy, 'Gloria de Carlos V', in *CPTM*, p. 38). We may wonder, at this point, who, exactly, is 'obliterating the squalid elements of civil war' (Beckett, *D*, p. 69). See Beckett's 'Humanistic Quietism', *Dublin Magazine*, July–September 1934, pp. 79–80.

71. On 14 April 1922, two hundred anti-Treaty IRA militants opposed to the new official status agreed for Ireland within the Commonwealth of Nations stormed the Four Courts and several other buildings in central Dublin. The Irish National Army, initially rooted in the IRA that had fought against the British, bombarded the Four Courts for three days, which led to their surrender. Michael Collins, who acted as the army's commander-in-chief, also advanced Free State troops to the occupied Irish Public Record Office, which ignited and exploded, leaving historical documents floating over the city.

72. MacGreevy, 'Crón Tráth na nDéithe', in *CPTM*, p. 17.

73. Leinster House acted as the Irish Free State parliament's home while Dáil Éireann was surrounded by sandbags. The statue of Queen Victoria was placed in front of Leinster

House in 1903. It was removed in 1947 and handed over forty years later to Sydney, Australia.

74. Susan Schreibman, 'Notes', in *CPTM*, p. 122.

75. MacGreevy, 'Crón Tráth na nDéithe', in *CPTM*, p. 23. Wreaths were laid outside the cenotaph after the assassination of Michael Collins.

76. MacGreevy, 'A Cultural Irish Republic', November 1934, speech delivered to the Irish Society at Oxford, TCD MS 8003/14/5.

77. MacGreevy to T.S. Eliot, 30 May 1925, TCD MS 8113/4.

78. Thomas MacGreevy, 'Aodh Ruadh Ó Domhnaill', in *CPTM*, pp. 34–5.

79. J.C.C. Mays, 'How is MacGreevy a Modernist?', in Davis and Coughlan (eds), *Modernism and Ireland*, pp. 103–28 (p. 113).

80. MacGreevy, 'Aodh Ruadh Ó Domhnaill', in *CPTM*, p. 35.

81. The previous title is included as part of MacGreevy's 'Paris Notes – Walking to Mountjoy'. See TCD MS 7989/1/21.

82. See Dorothy MacCardle's interpretation of this episode in *The Irish Republic: A documented chronicle of the Anglo-Irish conflict and the partitioning of Ireland, with a detailed account of the period 1916–23 with a preface by Éamon de Valéra* (London: Gollancz, 1937 [Dublin: Wolfhound Press, 1999]), pp. 424–5, which employs the language of 'martyrs' and 'assassins' rather than that of killers and murderers.

83. Thomas MacGreevy, 'The Six Who Were Hanged', in *CPTM*, p. 9.

84. Ibid., p. 8.

85. Ibid., p. 9.

86. Ibid.

87. Thomas MacGreevy, 'Cinema', TCD MS 7989/2/102; MacGreevy, 'Giorgionismo', *The New Review*, vol. 1, no. 2, ed. Samuel Putnam, May–June–July 1931, p. 119.

88. Thomas MacGreevy, 'Giorgionismo', in *CPTM*, p. 49.

89. Eda Lou Walton, 'Review: *Poems* by Thomas MacGreevy', *New York Herald Tribune*, 9 December 1934.

90. Stan Smith, 'Living to Tell the Tale: Fallon, Clarke, MacGreevy, Coffey', in *Irish Poetry and the Construction of Modern Identity: Ireland between fantasy and history* (Dublin: Irish Academic Press, 2005), p. 45. An earlier version of Smith's essay was published in *The Lace Curtain*, no. 6, autumn 1978, pp. 47–55, entitled 'From a Great Distance: Thomas MacGreevy's frames of reference'. The phrase 'from a great distance' is taken from the final line of Wallace Stevens' 'Our Stars Come From Ireland', which the American poet had sent to MacGreevy as a celebration of their proximity in the life of the imagination. MacGreevy first saw the manuscript for 'Our Stars Come From Ireland' two years before it appeared in *The Auroras of Autumn* (New York: Alfred A. Knopf, 1950). See MacGreevy to Stevens, 29 December 1948; *HLMD* 152.

91. Smith, 'Living to Tell the Tale', p. 45.

92. Ibid.

93. MacGreevy, 'The Six Who Were Hanged', in *CPTM*, p. 8.

94. Wallace Stevens to MacGreevy, 6 May 1948, in Holly Stevens (ed.), *Letters of Wallace Stevens* (London: Faber & Faber, 1966), no. 650, p. 596. In an article entitled 'How Does She Stand?', *Father Mathew Record*, September 1949, pp. 3–4 (p. 3), MacGreevy explains his intentions by citing the same three lines as Stevens.

95. Stevens had long been attempting to ascribe some positive content to metaphysics. See the essays Stevens had been compiling since 1942 for *The Necessary Angel: Essays on reality and the imagination* (London: Faber & Faber, 1951).

96. MacGreevy to M.E. Barber, 16 April 1947, TCD MS 8097/59.

97. Thomas MacGreevy, 'Homage to Hieronymus Bosch', in *CPTM*, p. 12.

98. Ibid.

99. Ibid.

100. Beckett, 'Recent Irish Poetry', in *D*, p. 70.

101. Thomas MacGreevy, 'Unpublished notebook', TCD MS MF 8067.

102. See Susan Schreibman, 'The Unpublished Poems of Thomas MacGreevy: An exploration', in Davis and Coughlan (eds), *Modernism and Ireland*, pp. 129–49.

103. Thomas MacGreevy, 'Appearances', TCD MS MF 637/2.

2. MacGreevy as Parisian *Littérateur*, 1927–33

1. Thomas MacGreevy, 'Autobiographical Fragments', TCD MS MF 719, 8004/4. MacGreevy's strategic allegiance to the '*petit peuple*' as a class or group ideology that he preferred to work with is explored in further detail in Chapter 4.

2. See Edward Titus, 'Editorially: Criticism à l'Irlandaise', *This Quarter*, vol. 3, no. 4, April–May–June 1931, pp. 569–84.

3. After considerable delay, Russell declined to publish MacGreevy's article on Irish censorship (see MacGreevy to George Yeats, 1 December 1928, NLI MS 30.859). Russell published his own article on Irish censorship in England rather than feature it in his own journal (see 'AE' Russell, 'The Censorship in Ireland', *Nation & Athenaeum*, 22 November 1928). To his credit, Russell did feature George Bernard Shaw's strongly worded article on Irish censorship (see Shaw, 'The Censorship', *Irish Statemen*, vol. 11, no. 11, 17 November 1928).

4. Beckett to MacGreevy, *c.* summer 1929, *TLSB*, pp. 10–11.

5. Beckett, 'Assumption', *transition* 16/17, June 1929, pp. 268–71.

6. Beckett to George Reavey, 6 May 1936, *TLSB*, p. 332. Beckett's collection of short stories had been banned in Ireland less than half a year before his collection of poems was published in Paris. In August 1934, Beckett wrote a coruscating attack on the passing of the Censorship of Publications Act, entitled 'Censorship in the Saorstát' (the Irish name for the Free State), though the article was not published until 1983 – almost fifty years after it had been commissioned. *The Bookman* had commissioned this article in August 1934 before its circulation ceased (after December). Owing to a mistiming of responses between Maria Jolas, Reavey and Beckett, Reavey failed to secure publication for the article in *transition*. Beckett mentions the commission in a letter to MacGreevy dated 7 August 1934 [*TLSB*, pp. 217–18] and its completion in another letter sent to him on 27 August [TCD MS 10402/62]. The typescript is now in the Baker Memorial Library at Dartmouth College.

7. See Beckett to MacGreevy, TCD MS 10402/93.

8. Beckett and MacGreevy are among nine poets and critics to have attached their signatures to the 'Poetry is Vertical' March 1932 manifesto. See *transition* 21, pp. 148–9.

9. Eugene Jolas, 'Proclamation', *transition* 16/17, June 1929, p. 13. This proclamation announces twelve points of contention. Eugene Jolas and Stuart Gilbert are among sixteen authors to have undersigned the document.

10. Samuel Beckett, 'Commentaries: Denis Devlin', *transition 27*, April–May 1938, pp. 289–94 (p. 289).

11. Ibid., p. 290.

12. Stuart Gilbert, 'The Creator Is Not a Public Servant', *transition* 19/20, June 1930, pp. 147–50 (p. 148).

13. Denis Devlin had originally asked Beckett to review his collection of poems for *Ireland To-Day*, but it was MacGreevy who wrote the review. See Beckett to MacGreevy, 4 September 1937: 'I would much rather you did the Intercessions for Ireland To-day than I did' [*TLSB*, p. 530]. MacGreevy had previously commented on the typescript of *Intercessions*, which Devlin had presented to him for advice on revisions. See Devlin to MacGreevy (22 January 1937, TCD MS 8112/11; and 15 February 1937, TCD MS 8112/2).

14. Samuel Beckett, 'Commentaries: Denis Devlin'.

15. See Karl Radek, 'James Joyce or Socialist Realism?', delivered to the Soviet Writers' Congress, *Contemporary World Literature and the Tasks of Proletarian Art*, August 1934, pp. 151–4. Together with the Bolshevik Dmitriy Manuilsky, Radek had attempted to stage a second German revolution in October 1923, before Lenin died.

16. Thomas MacGreevy, 'Treason of Saint Laurence O'Toole', *transition* 21, pp. 178–9. See Chapter 1 for a reading of this poem. As discussed in the previous chapter, this poem makes use of surrealist disfiguration when depicting the failed reprieve of an eighteen-year-old IRA Volunteer, who had been captured by the British Military and sentenced by court martial after an abortive ambush on a British army truck by republican militants had led to the death of three British soldiers.

17. Thomas MacGreevy, 'School ... of Easter Saturday Night (Free State)', *transition* 18: From Instinct to New Composition, Word Lore Totality, Magic Synthetism, November 1929, pp. 114–16. See Chapter 1 for a reading of this poem. The wide range of articles that *transition* featured from all over Europe, America and Russia allows us to contrast the cultural situation in Ireland with that of other post-revolutionary societies. The autumn 1929 edition that features MacGreevy's 'School ... of Easter Saturday Night (Free State)' includes a reproduction of El Lissitzky's 'Project for Public Rostrum', which the artist had built for Lenin in 1920, complete with elevators, platforms, balconies, megaphones and screen displays. See Louis Lozowick, 'El Lissitsky', *transition* 18, pp. 284–6 (p. 285). In Russia, the new state had been quick to sponsor avant-garde artists and secure them commissions, hoping to inspire new forms of artistic expression that could create an entirely new culture. Lenin's cultural ambassador, Anatoly Lunacharsky, was a prolific writer and art critic who supported the avant-garde in his role as the first Soviet commissar of public enlightenment (Narkompros). Writers, painters, graphic designers, photographers, film-makers and textile designers were all encouraged to produce brave new art for a new society. The difference of official endorsement throws the cultural situation in Ireland, which remained torn between pre- and post-revolutionary standards, into sharp relief.

18. For Stevens' analysis of 'Homage to Hieronymus Bosch', see Chapter 1.

19. See John Nash, 'Thomas MacGreevy and "The Catholic Element" in Joyce', in Tim Conley (ed.), *Joyce's Disciples Disciplined: A re-exagmination of the 'exagmination of Work in Progress'* (Dublin: UCD Press, 2010), pp. 71–9.

20. The 'Proteus' passage that Shane Leslie cites in his *Dublin Review* article is reproduced in MacGreevy's essay, which points to an energy of correspondence between them. See MacGreevy, 'The Catholic Element in Work in Progress', in *Our Exagmination Round His Factification for Incamination of Work in Progress* (Paris: Shakespeare & Co., 1929), pp. 121–7 (p. 123).

21. Shane Leslie, 'Ulysses', *Quarterly Review*, October 1922, pp. 219–34; partially reprinted in *James Joyce: The critical heritage, vol. 1, 1902–1927*, ed. Robert H. Deming (London: Routledge & Kegan Paul, 1970), pp. 206–11 (p. 210). Previously, Leslie had praised the 'genius' and 'literary ability' of the author of *A Portrait of the Artist as a Young Man* (1916). When confronted with *Ulysses* (1922), however, Leslie questions 'whether the literary power is a sufficiently extenuating circumstance', as if he were judging the work of a criminal (p. 211).

22. Thomas MacGreevy, 'A Note on "Work in Progress"', *transition* 14, 1928, pp. 216–19.

23. Ibid.

24. Ibid.

25. Ibid. (p. 218). The essay was first published under this provisional title before it was amended by Joyce to 'The Catholic Element in Work in Progress' for a later collection of essays designed to enhance public understanding of the work.

26. Thomas MacGreevy, 'Anna Livia Plurabelle', *Irish Statesman*, 16 February 1929, pp. 475–6 (p. 475).

27. MacGreevy, Unpublished fragment, TCD MS 8114/16. The heavily amended typescript appears to have been intended for the collection *The Joyce We Knew*, edited by Ulick O'Connor (Cork: Mercier Press, 1967), though it never appeared in the volume. Hugh J. Dawson has reproduced parts of this document alongside other autobiographical fragments in 'Thomas MacGreevy and Joyce', *James Joyce Quarterly*, vol. 25, no. 3, spring 1988, pp. 305–21 (p. 317). Other unpublished extracts concerning MacGreevy and Joyce have been reproduced in Richard Ellmann's *The Consciousness of Joyce* (New York: Oxford University Press, 1977), pp. 49–50. There are three unpublished typescripts by MacGreevy on Joyce catalogued TCD MS 8114/10, TCD MS 8114/16 and TCD MS 8114/17 respectively.

28. See Thomas MacGreevy, 'A Note on *Work in Progress*', *transition* 14, p. 217.

29. Beckett's 'Dante… Bruno. Vico.. Joyce', *transition* 16/17, pp. 245–6.

30. James Joyce, 'Fragment from *Work in Progress*' (Part II, Section 3), *transition 27*, pp. 57–78.

31. Bernard Benstock, *Joyce-Again's Wake: An analysis of Finnegans Wake* (Seattle: University of Washington, 1965), p. 242.

32. Joyce, 'Fragment from *Work in Progress*', pp. 63–4.

33. See Terence Killeen, '"Our Shem": MacGreevy and Joyce', in *TMCR*, pp. 173–88 (p. 175).

34. *James Joyce's Letters to Sylvia Beach*, eds. Melissa Banta and Oscar Silverman (Bloomington, IN: Indiana University Press, 1987), p. 139.

35. See University of Buffalo Joyce Collection Online Catalogue: http://library.buffalo. edu/pl/collections/jamesjoyce/catalog.

36. Beckett to MacGreevy, c. May 1930, *TLSB*, p. 21. Later extracts from MacGreevy's unpublished memoir also confirm this impression. See Hugh Dawson, 'MacGreevy and Joyce', *James Joyce Quarterly*, vol. 25, no. 3, spring 1988, pp. 305–21 (p. 311).

37. Beckett, 'Dante... Bruno. Vico.. Joyce', *transition* 16/17, p. 249.

38. James Joyce, *Finnegans Wake*, ed Robbert-Jan Henkes, Erik Bindervoet and Finn Fordham (Oxford: Oxford University Press, 2012 [first published London: Faber & Faber, 1939]), p. 604.

39. Finn Fordham has noted how, after hearing how Buckley shot the Russian general, it is the 'idiology' (Joyce's portmanteau invention for idiotic logic) of the listener (Taff) to substitute the living self for an impossible ideal of immunity and protection 'in an effort towards autosotorisation' ('soter' is derived from the Greek epithet meaning a saviour or deliverer from harm). For a discussion of this notoriously difficult passage in Joyce's *Finnegans Wake*, eds Robbert-Jan Henkes, Erik Bindervoet and Finn Fordham, p. 352 (lines 17–20), see Finn Fordham, *Lots of Fun at Finnegans Wake: Unravelling universals* (Oxford: Oxford University Press, 2007), pp. 106–7.

40. Richard Ellmann notes from Joyce's letter to his patron on 28 May 1929 that the author planned to include a critical essay on humour in a never-realised sequel to *Our Exagmination*. See Richard Ellmann, *James Joyce, New and Revised Edition* (New York: Oxford University Press, 1982), p. 626. Ellmann refers to Joyce's letter to Harriet Weaver of 28 May 1929 for proof of this intention. See Stuart Gilbert (ed.), *Letters of James Joyce* (London: Faber & Faber, 1957), p. 281. See also Dougald McMillan, *transition 1927–1938: The history of a literary era* (London: Calder & Boyars, 1975), p. 189. Three topics were chosen for the proposed book: night, chemistry and humour.

41. 'James Joyce at the Half Century' by Padraic Colum, Stuart Gilbert, Eugene Jolas, Thomas MacGreevy and Philippe Soupault, *transition* 21, March 1932, pp. 241–55 (p. 254).

42. Sean O'Faolain, 'Style and the Limitations of Speech', *Criterion*, vol. 8, no. 30, September 1928, pp. 67–87. On 5 January 1929, O'Faolain wrote another letter about 'Anna Livia' to the *Irish Statesman* decrying Joyce's apparent departure from the boundaries of natural speech. Sean O'Faolain, 'Correspondence: Anna Livia Plurabelle', *Irish Statesman*, vol. 9, 5 January 1929, pp. 354–5. O'Faolain renamed the article 'Almost Music' for *Hound and Horn*, vol. 1, January–March 1929, pp. 178–80.

43. Eugene Jolas, 'The New Vocabulary', *transition* 15, February 1929, pp. 171–4. For O'Faolain's reply to Jolas, see 'Letter to the Editor', *Irish Statesman*, 2 March 1929, pp. 513–14, in which he rebukes the notion of 'transition' as a necessary ideal for the journal, arguing that 'the major point' of his previous letter was not to question the evolutionary life of speech, but to claim 'that the artist must seek for a point of suspension between the eternal coming-on and going-off of meaning' (p. 514).

44. MacGreevy, 'A Note on Work in Progress', *transition* 14, autumn 1928, pp. 216–19 (p. 216). MacGreevy would later write his own response to O'Faolain's letter for the *Irish Statesman* which inaccurately repeats the arguments that he had outlined earlier in his *transition* article. See MacGreevy, 'To the Editor of the Irish Statesman: Anna Livia Plurabelle', *Irish Statesman*, 16 February 1929, pp. 475–6. Terence Killeen argues that this letter is likely to have been prompted by Joyce, who took seriously O'Faolain's criticism about his new work in the previous issue. See Terence Killeen's '"Our Shem": MacGreevy and Joyce', in *TMCR*, pp. 173–88 (p. 187).

45. See Karl Radek, 'James Joyce or Socialist Realism?'; reprinted in Robert H. Deming (ed.), *James Joyce: The critical heritage, vol. 2, 1928–1941* (London: Routledge & Kegan Paul, 1970), p. 625.

46. Samuel Putnam, 'Introduction', in Samuel Putnam, Maida Castelhun Darton, George Reavey and Jacob Bronowski (eds), *The European Caravan: An anthology of the new spirit in European literature – France, Spain, England and Ireland* (New York: Warren & Putnam, 1931), p. v.

47. Jacob Bronowski, 'England and Ireland', in *The European Caravan*, p. 437.

48. See I.A. Richards, *Practical Criticism* (London: Kegan Paul, Trench, Trubner & Co., 1929).

49. Beckett, 'Dante… Bruno. Vico.. Joyce', *transition* 16/17, pp. 242–53 (p. 242).

50. Bronowski, 'England and Ireland'.

51. MacGreevy's translations of the *Generación del 27*, which he had worked on while completing his 1931 monograph on T.S. Eliot, are included in a section entitled 'The Poets of Today' (see MacGreevy, *The European Caravan*, pp. 407–13). This section features poetic sequences by Rafael Alberti, Antonio Machado, Juan Ramón Jimenéz and Federico García Lorca as well as by Jorge Guillén. The presence of Eliot is particularly strong in the poems that MacGreevy selects for translation: all of which focus on the ennui brought about by waste, paralysis, burnt-out landscapes and false angels.

52. Thomas MacGreevy, 'Going Out', in *CPTM*, p. 80.

53. Ibid.

54. Ibid.

55. Putnam, 'Introduction', in *The European Caravan*, p. v.

56. MacGreevy, Translated reply by Don Miguel de Almeida, 3 April 1932, TCD MS 7998/13.

57. MacGreevy to Paul Valéry, 4 April 1932, TCD MS 7998/94a.

58. Ibid., italics added.

59. Percy Bysshe Shelley, 'A Defence of Poetry; or, Remarks Suggested by an Essay Entitled "The Four Ages of Poetry"' (1821, though published posthumously in 1840), in *Shelley's Poetry and Prose*, eds Donald H. Reiman and Neil Fraistate, 2nd edn (New York: Norton, 2002), p. 513.

60. See MacGreevy to George Yeats, 20 January 1927, NLI MS 30.859: 'I go over tomorrow & shall see the head of the Normale as well as Valéry. Address till Monday c/o W. Stewart, École Normale Supérieure, 45 rue d'Ulm, Paris V.' Valéry lived close to the Irish embassy on the Avenue Foch.

61. MacGreevy was not the only one of his immediate circle to translate Valéry's work. Devlin translated 'Le Cimitière Marin' and 'Les Pas' into Irish. See 'An Roilig [*sic*] ar Bhruach na Mara' and 'Na Coiscémeanna', NLI Collection No. 38: Literary Papers of Denis Devlin, MS 33,749/14 (1) and (2).

62. Paul Valéry, *Introduction to the Method of Leonardo da Vinci*, translated from the French of Paul Valéry of the Académie Française by Thomas MacGreevy (London: John Rodker, 1929), p. 3.

63. MacGreevy to Valéry, 4 April 1932, TCD MS 7998/94a, 10.

64. Ibid.

65. Ibid.

66. Agnes Ethel Mackay, *The Universal Self: A study of Paul Valéry* (Glasgow: William MacLellan, 1961), p. 247.

67. MacGreevy to Valéry, 4 April 1932, TCD MS 7998/94a, 3.

68. Ibid., p. 5.

3. MacGreevy and Postimpressionism

1. MacGreevy, 'Artists of Tomorrow: The annual exhibition of students' work at the Westminster School of Art', *Studio*, August 1938, pp. 110–11.

2. In a 1912 proclamation entitled 'Du Cubisme', Albert Gleizes and Jean Metzinger had enthusiastically declared 'Que le tableau n'imite rien' ('Let the picture imitate nothing') (reprinted in *Modern Artists on Art*, second enlarged edition, ed. Robert L. Herbert (New York: Dover, 2000), pp. 2–16 (p. 6)). However, under the heading of his essay 'Hommage à Mainie Jellett', in Eileen MacCarvill (ed.), *The Artist's Vision: Lectures and essays on art, with an introduction by Albert Gleizes* (Dundalk: Dundalgan, 1958), pp. 25–46 (p. 25), Gleizes includes the following quotation from St Thomas Aquinas: '*ars imitatur naturam in sua operatione*' (art should imitate nature in the manner of her operation). The cubism to which I allude had already been tempered by an understanding of the undesirability of abolishing natural forms.

3. Thomas MacGreevy, 'Gioconda', in *CPTM*, p. 50.

4. Beckett, 'Recent Irish Poetry', *D*, p. 70. Critics frequently omit from citation the fact that the 'breakdown, whether current, historical, mythical or spook' is announced in 'Recent Irish Poetry' as 'the new thing that has happened, *or the old thing that has happened again*' (*D*, p. 70, italics added). Beckett's subclauses are carefully crafted to ensure that while this 'breakdown' is intended as a synchronic break with the past, it is also plotted along a diachronic axis of regression that counters a narrative of progressive development by situating this antagonistic moment within a Vichian conception of history (as *ricorso* or 'eternal return').

5. George Russell (initialled 'Y.O.' for his art criticism), 'Review', *Irish Statesman*, 27 October 1923.

6. 'Two Freak Pictures', *Irish Times*, 23 October 1923.

7. See Lawrence K. Emery (pseudonym for A.J. 'Con' Leventhal), 'Confessional', *Klaxon*, vol. 1, no. 1, winter 1923–24, pp. 1–2 (p. 1).

8. Thomas MacGreevy, 'Picasso, Mamie [*sic*] Jellett and Dublin Criticism', *Klaxon*, vol. 1, no. 1, winter 1923–24, pp. 23–7 (p. 23); accessed TCD MS 8015/192-4; 8002/8; 10381/205.

9. Ibid., p. 24. MacGreevy's relocation of Jellett's work within the context of the Holy Roman Empire of late antiquity is worth comparing with Yeats' turn to Byzantine art during the mid-1920s. In an age that still revered him for the Irish Literary Revival but was less understanding of the new direction his work had taken, Yeats reminisces in his esoteric treatise *A Vision* (privately published in 1925) that architects and illuminators in early Byzantium 'spoke to the multitude and the few alike'. Catherine Paul and Margaret Mills Harper (eds), *The Collected Works of W.B. Yeats: A vision. The original 1925 version*, vol. 13 (New York: Scribner, 2008), pp. 279–80.

10. MacGreevy, 'Picasso, Mamie [*sic*] Jellett and Dublin Criticism', p. 24.

11. Ibid.

12. Jellett, 'A Word on Irish Art', p. 105.

13. Ezra Pound to MacGreevy, TCD MS 8118/47. As Brita Lindberg-Seyersted has suggested in her edition of Pound's letters to Ford Madox Ford, Pound probably wrote to MacGreevy from Rapallo between June and September 1932 when MacGreevy was living in Paris.

14. Jellett, 'A Word on Irish Art'.

15. Thomas MacGreevy, 'Evie Hone and Mainie Jellett', TCD MS 8002/4 (c. 1942).

16. Thomas MacGreevy, 'Fifty Years of Irish Painting, 1900–1950', TCD MS 8002/13 (p. 9). The French phrase was a rallying cry often used by poets of the late nineteenth century, including Charles Baudelaire and Arthur Rimbaud. It means 'to shock the bourgeoisie'.

17. MacGreevy, *Irish Times*, 6 February 1942.

18. MacGreevy, 'Picasso, Mamie [*sic*] Jellett and Dublin Criticism', p. 26.

19. Thomas MacGreevy, 'A Lively Exhibition, Water-colour Society', *Irish Times*, 30 March 1943, p. 3.

20. Thomas MacGreevy, 'Living Art – A New Departure', *Irish Times*, 16 September, 1943, p. 3.

21. Thomas MacGreevy, 'Notes', TCD MS 8002/5. As can be inferred from MacGreevy's index to the chapter and from further annotations in his hand, his contribution to the first book publication on Mainie Jellett extends well beyond his translation of Gleizes' tribute. 'After the death of Mainie Jellett [in 1944]', MacGreevy writes, 'her friends asked me to edit her lectures and articles on contemporary art, for publication as a book.' Preparations for Eileen MacCarvill's volume on Mainie Jellett, TCD MS 8002/6–7. MacGreevy turned down an offer from Faber & Faber which through T.S. Eliot, had invited him to submit a manuscript, preferring the struggle to get Eileen MacCarvill's volume published in Ireland.

22. Gleizes, 'Hommage à Mainie Jellett', p. 25 (MacGreevy's translation; italics in the original). Gleizes spent much of his career explaining how timid his aspirations had really been and argued that the aims of the group had been 'skied' by their public reception. Not all the artists involved in the 1911 exhibition shared this opinion.

23. Thomas MacGreevy, 'Promenade à Trois', in *CPTM*, p. 47.

24. Ibid.

25. Louis MacNeice, 'Eclogue to Christmas' (December 1933), in *Collected Poems*, ed. Peter McDonald (London: Faber & Faber, 2007), pp. 3–4.

26. 'Est-ce que la suppression des représéntations figurées habituelles n'enlèverait pas à la peinture sa valeur humaine? Est-ce que la sensibilité du peintre ne courrait pas à sa perte?' Gleizes, 'Hommage à Mainie Jellett', p. 27.

27. MacGreevy, 'Picasso, Mamie [*sic*] Jellett and Dublin Criticism', p. 25.

28. This is not to deprecate MacNeice's engagement with postimpressionism, which was mediated by his friendship with Anthony Blunt during the 1930s, but to suggest that his engagement with the movement is occasionally blurred by his didactic instinct. For an extended discussion of MacNeice's interest in visual art, see Tom Walker, '"Even a Still Life is Alive": Visual art and Bloomsbury aesthetics in the early poetry of Louis MacNeice', *Cambridge Quarterly*, vol. 38, no. 3, 2009, pp. 196–213.

29. Thomas MacGreevy, 'Did Tosti Raise His Bowler Hat?', in *CPTM*, p. 37.

30. Wassily Kandinsky, *Concerning the Spiritual in Art*, trans. Michael T.H. Sadler (London: Tate Modern, 2006 [Munich, 1912]), p. 82. See Figure III. The Russian artist features as a general topic of discussion in letters of exchange between MacGreevy, Beckett and Reavey. Beckett wrote to MacGreevy on 21 February 1938 just after MacGreevy had attended the Kandinsky Exhibition at the Guggenheim Jeune, requesting details on the exhibition (see Beckett to MacGreevy, 21 February 1938, *TLSB*, p. 608). Two months after the outbreak of the Second World War, Beckett met Kandinsky in person, describing him as a 'Sympathetic old Siberian' to George and Gwynedd Reavey (see Beckett to George and Gwynedd Reavey, 6 December 1939, *TLSB*, p. 670). Beckett's engagement with Kandinsky extends to an essay commissioned by the Galerie Maeght in Paris, in which he questions whether the painter can ever be set free from the demands of representation – an objective that Kandinsky had sought to fulfil by placing a special emphasis on the abstract values of colours. See Beckett, 'Peintres de l'empêchement', *Derrière le Miroir*, 11–12 Juin 1948 (Paris: Galerie Maeght / Editions Pierre à Feu) , pp. 3–7.

31. Thomas MacGreevy, 'Gloria de Carlos V', in *CPTM*, p. 36. During a recording of his poetry reading in the Widener Library at Harvard, MacGreevy introduces this poem by confessing that 'I am a little proud of the fact that when I associated the names of Picasso and Grünewald in order to contrast their effective nightmares, with Titian's realisation of ideal beauty, I did not know that Picasso had studied Grünewald's great Crucifixion at Colmar, and that it inspired him to a remarkable series of drawings directly related to the picture.' 'Transcript of TCD Tape 106', TCD MS 10082/15.

32. The poem is dedicated to Alexander Stewart Frère Reeves, who served in the Royal Flying Corps during the First World War. He was the managing director of Heinemann when MacGreevy's *Poems* was first published in May 1934.

33. Thomas MacGreevy, 'De Civitate Hominum', in *CPTM*, pp. 2–3.

34. While the pauses in Beethoven's Seventh Symphony appear to have attracted Beckett's aural imagination with their pregnant possibility, MacGreevy's visual imagination is drawn to a 'white' that has the appeal of the nothingness before birth: an ice-age world of emotion recollected in 'Freezing comfort', as it is described in 'Fragments'. See MacGreevy, 'Fragments', in *CPTM*, p. 38.

35. MacGreevy, 'Autobiographical Fragments', TCD MS 8040A/342–5. The Irish portrait painter William Orpen was also stationed there. Orpen's painting *Zonnebeke* (1918) and poem 'The Church, Zillebeke' (October 1918) offer instructive contrasts with MacGreevy's treatment of the landscape. See Gerald Dawe, *Earth Voices Whispering: An anthology of Irish war poetry, 1914–1945* (Belfast: Blackstaff Press, 2008), p. 46.

36. Smith, 'Living to Tell the Tale', p. 45.

37. Thomas MacGreevy, 'Epithalamium', TCD MS MF 7989/2, 3.

4. Reconstructing the National Painter

1. Sean O'Faolain, 'Daniel Corkery', *Dublin Magazine* (new series), vol. 11, no. 2, April–June 1936, p. 61.

2. Irish novels by Banim, Trollope, Moore and Somerville and Ross were all banished from Corkery's supposedly 'authentic' canon of Irish literature. See Roy Foster's 'Varieties of Irishness' [inaugural lecture] Maurna Crozier (ed.), *Cultural Traditions in Northern Ireland* [Proceedings of the Cultural Traditions Group Conference: Institute of Irish Studies, The Queen's University Belfast, 3-4 March 1989], pp. 5–24.

3. See Daniel Corkery, *Synge and Anglo-Irish Literature* (Cork: Cork University Press, 1931), p. 4.

4. MacGreevy, 'A Cultural Irish Republic' (1934), TCD MS 8003/9, 13. *The Dublin Magazine* had published Patrick O'Hegarty's response to Corkery's *Synge and Anglo-Irish Literature* in its January–March 1932 edition, which is worth comparing with MacGreevy's response to the same book. As an Irish-language enthusiast and Gaelic League activist in London at the start of the century, O'Hegarty's nationalist credentials make his extreme distaste for Corkery's 1931 study especially interesting. O'Hegarty's objection to the work, which he did not even acknowledge as 'a book of criticism' but 'of propaganda', provides a clear illustration of the tensions that had developed in 1930s Irish nationalism between liberal-romantic standards of freedom (dating back to Wolfe Tone) and a racially exclusive sectarianism. See Patrick O'Hegarty, 'A Review of Daniel Corkery's *Synge and Anglo-Irish Literature*', *Dublin Magazine*, vol. 7, no. 1, January–March 1932, pp. 51–6.

5. MacGreevy, 'Crón Tráth na nDéithe', in *CPTM*, p. 17.

6. MacGreevy, 'A Cultural Irish Republic', p. 13.

7. Ibid.

8. See Chapter 2.

9. See Chapter 3.

10. Thomas MacGreevy, 'The Rise of a National School of Painting' (1922), TCD MS 8002/19.

11. Thomas MacGreevy, 'Art and Nationality: The example of Holland' (1921), *Old Ireland*, 8 October 1921, pp. 487–8. This article is a paraphrased extract from Eugene Fromentin's account of the origins of Dutch art in *Les maîtres d'autrefois* (1877). For more on the Netherlands–Ireland comparison, see MacGreevy's 'Pictures in the National Gallery', *Capuchin Annual*, vol. 22, 1943, pp. 386–443 (p. 428).

12. MacGreevy, 'Art and Nationality: The example of Holland' (1921), TCD MS 8006/6.

13. Thomas MacGreevy, *JBY*, p. 9.

14. Ibid., p. 32.

15. Beckett to MacGreevy, 5 January 1938, *TLSB*, p. 579. Martha Dow Fehsenfeld and Lois Overbeck point out the differences between the version that Beckett hand wrote and sent to MacGreevy and that were published in *Parnasse Royal: Poèmes choisis des monarques François et autres personnages royaux*, ed. Gauthier Ferrières (Paris: Chez Sansot, Libraire, 1909), pp. 105–6. See *TLSB*, pp. 581–2.

16. MacGreevy, *JBY*, p. 32.

17. Jack Yeats, 'The Future of Painting in Ireland', NLI: Jack B. Yeats Archive / Yeats Museum Y17-1 (four-page typescript).

18. MacGreevy, *JBY*, p. 26.

19. Ibid., p. 10.

20. Ibid.

21. MacGreevy, 'Picasso, Mamie [*sic*] Jellett and Dublin Art Criticism', p. 27. For an account of the conservative media reaction that resulted from this exhibition, see Chapter 3.

22. Thomas MacGreevy, 'Local Museums and Galleries', TCD MS 8003/7a. Grace Henry had a romantic liaison with Stephen Gwynn while she was working to establish the Society of Dublin Painters (of which Jack Yeats was a founding member).

23. MacGreevy, *JBY*, pp. 17–18.

24. Ibid., p. 27.

25. See Hilary Pyle's *Jack B. Yeats: A biography* (London: Routledge & Kegan Paul, 1970), p. 160; Bruce Arnold's *Jack B. Yeats* (New Haven, CT: Yale University Press, 1998); and David Lloyd's 'Republics of Difference: Yeats, MacGreevy, Beckett', *Field Day Review*, vol. 1, 2005, pp. 43–70. Jack Yeats did make some positive attempts to rationalise what he was doing in his new style. Hilary Pyle has explored his use of the CIE system of colour metrics in his 1927–39 notebooks. See Hilary Pyle, 'Jack B. Yeats, "A Complete Individualist"', *Irish Arts Review Yearbook*, vol. 9, 1993, pp. 86–101 (p. 99).

26. Thomas MacGreevy, *Pictures in the Irish National Gallery* (Cork: Mercier Press, 1945 [reprinted London: B.T. Batsford, 1946]), p. 45.

27. Ibid., p. 9.

28. Thomas MacGreevy, 'Some Italian Pictures in the National Gallery of Ireland: Lecture given at the Italian Institute in Dublin' (Dublin: Italian Institute, 1963), p. 12.

29. MacGreevy, *Pictures in the Irish National Gallery*, p. 47.

30. MacGreevy visited Castelfranco, the home town of Giorgione, before his return to Paris in 1930. See Charles Prentice to MacGreevy, 11 November 1930; *URCW* MS 2444, 130/541. While MacGreevy's fixation with the Venetian painter attracts satirical mention in numerous letters of correspondence (see MacGreevy to George Yeats, 28 November 1926 [NLI MS 30.859], Verso, p. 2, where he talks of 'Jawrgione' as if he is only too aware of his propensity to be verbose on the topic), his engagement with the artist was perfectly serious as mediated by the scholarship of Bernard Berenson, Lionello Venturi and others, and remained a source of lifelong inspiration to him.

31. Terisio Pignatti and Filippo Pedrocco, *Giorgione* (New York: Rizzoli, 1999), pp. 120–2.

32. MacGreevy, *JBY*, p. 10.

33. Thomas MacGreevy, 'Fifty Years of Irish Painting, 1900–1950', *Capuchin Annual*, 1949, p. 497.

34. See S.B. Kennedy's *Irish Art and Modernism: 1880–1950* (Belfast: Queen's University, 1991) for a more detailed account of the conservatism of the Royal Hibernian Academy.

35. See J. Campbell's 'Art Students and Lady Travellers', in *Irish Women Artists: From the eighteenth century to the present day* (Dublin: The National Gallery of Ireland & Douglas Hyde Gallery, 1987), pp. 17–21 (p. 20).

36. MacGreevy's 'Application for the Curatorship of the Municipal Gallery' (TCD MS 8142/1) was backed by Lennox Robinson, Lady Gregory, Dermod O'Brien and Seán Keating.

37. In perhaps the most famous example of its guarded attitude, Dublin Corporation refused to accept Georges Rouault's *Christ and the Soldier* (1930) on loan.

38. Thomas MacGreevy, 'The Dublin Municipal Gallery', *Father Matthew Record*, January 1946, p. 4.

39. Thomas MacGreevy, 'Three Historical Paintings by Jack B. Yeats', *Capuchin Annual*, 1942, pp. 238–51 (p. 240).

40. The event took place on Sunday, 26 July 1914. One further civilian died later of bayonet wounds.

41. See 'Notes and Comments, Bloodshed at Dublin', *New Zealand Herald*, vol. 60, no. 15, 772, 21 November 1914, p. 6.

42. MacGreevy, 'Three Historical Paintings by Jack B. Yeats', p. 249.

43. MacGreevy, *JBY*, p. 30.

44. Sketchbook no. 189 of 204, NGI-Y1 Jack Butler Yeats Archive. A selection of these sketchbooks, which form part of the 1996 Anne Yeats gift to the National Gallery, were exhibited in the Beit Wing (Room 13) from 2 February to 3 June 2013.

45. David Lloyd, 'Republics of Difference: Yeats, MacGreevy, Beckett', *Field Day Review*, vol. 1, 2005, pp. 64–5.

46. MacGreevy, *JBY*, p. 32.

47. Ibid., p. 30.

48. Ibid., p. 8.

49. Thomas MacGreevy, 'Municipal Gallery Dublin: Jack Yeats Exhibition Transferred from the Venice Biennial', November 1962, TCD MS 7999-5a/3.

50. Yeats, 'The Future of Painting in Ireland', p. 2.

51. MacGreevy, *JBY*, p. 16.

52. MacGreevy, 'Municipal Gallery Dublin: Jack Yeats Exhibition Transferred from the Venice Biennial'.

53. MacGreevy, *JBY*, pp. 8–9. MacGreevy's positioning of Anglo-Irish artists (such as Jack Yeats) as a vital standard for contemporary art puts him noticeably at odds with the 'Irish-Ireland' mainstream, as embodied by such figures as Daniel Corkery, who tended to view the Protestant Ascendancy heritage as alien and extraneous to the pursuit of a native culture.

54. Ibid., pp. 18–19.

55. Wallace Stevens to MacGreevy, 26 June 1952; *HLMD* 152. Jack Yeats helped to visualise the transatlantic correspondence between MacGreevy and Wallace Stevens by completing a portrait of MacGreevy that he could send to Stevens as an enlarged photograph. See MacGreevy to Stevens, 26 May 1946; *HLMD* 152.

56. Shotaro Oshima, 'An Interview with Jack Butler Yeats', 7 July 1938, in *A Centenary Gathering* (Dublin: Dolmen Press, 1971), pp. 52–3.

57. MacGreevy, *JBY*, pp. 31–2.

58. Ibid., p. 29.

59. Beckett to MacGreevy, 31 January 1938, *TLSB*, pp. 599–600.

60. Beckett to MacGreevy, 21 January 1938, *TLSB*, p. 588.

61. See Yeats, 'The Future of Painting in Ireland'. Many of Beckett's forthright opinions about Jack Yeats' work appear to have been formulated beforehand in correspondence with Cissie Sinclair. See Beckett to Sinclair, 14 August 1937, *TLSB*, pp. 535–6.

62. Beckett does not oppose the idea of a 'public' per se but its assimilation under a nationalist framework. In a letter to MacGreevy, he switches *noblesse oblige* (nobility carries obligations) for 'roture' (membership of the common people). See Beckett to MacGreevy, 10 December 1937, *TLSB*, p. 566.

63. Samuel Beckett, 'MacGreevy on [Jack] Yeats', *Irish Times*, 4 August 1945, in *D*, pp. 95–7.

64. Ibid., p. 97.

65. MacGreevy, *JBY*, p. 37.

66. Ibid.

67. Beckett to MacGreevy, 14 August 1937, *TLSB*, p. 540.

68. Beckett to MacGreevy, 28 November 1936, *TLSB*, p. 387.

69. This is Mark Nixon's transcription from the German diaries. See *Samuel Beckett's German Diaries, 1936–1937* (London: Continuum, 2011), figure 6. For an alternative transcription, see Roswitha Quadflieg, 'Samuel Beckett "Alles kommt auf so viel an"*.* Das Hamburg Kapitel aus seinen "German Diaries"', *Tagebuch Samuel Beckett von 1936* (Hamburg: Hoffman und Campe Verlag, 2006), pp. 168–9. Beckett was on a tour of Germany from 29 September 1936 to 2 April 1937, during which he wrote prolifically to MacGreevy about his artistic findings and discoveries (MacGreevy was unable to join him).

70. Beckett, 'Dante… Bruno. Vico.. Joyce', in *D*, p. 27 (italics in original).

71. MacGreevy, *JBY*, p. 29.

72. Beckett, 'MacGreevy on [Jack] Yeats', p. 97.

73. 'A Conversation Between Jack Butler Yeats and Thomas MacGreevy', broadcast on the BBC Third Programme, 17 May 1948, British Library (BL), 11783, 84 + 85 (78rpm).

5. The National Gallery Revisited, 1950–63

1. W.B. Yeats, 'The Municipal Gallery Revisited' (1937), in *The Poems*, ed. Daniel Albright (London: Everyman's Library, 1992), pp. 366–8 (p. 368). It is unknown what paintings were on display at the gallery when W.B. Yeats visited it. For an analysis of the poem's manuscript, see Wayne K. Chapman, '"The Municipal Gallery Re-visited" and Its Writing', *Yeats Annual*, vol. 10, ed. Warwick Gould (London: Macmillan, 1993), pp. 159–87.

2. Paul Valéry, 'The Problem of Museums', in Jackson Mathews (ed.), *The Collected Works of Paul Valéry*, vol. 12 (New York: Pantheon, 1960), pp. 204–5. For more on MacGreevy's correspondence with Valéry during the late 1920s and early 1930s, see Chapter 2.

3. See Marie Bourke, *The Story of Irish Museums, 1790–2000: Culture, identity and education* (Cork: Cork University Press, 2011 [reprinted 2013]), p. 427.

4. W.B. Yeats to Dorothy Wellesley, 13 August 1937, in *Letters on Poetry from W.B. Yeats to Dorothy Wellesley* (Oxford: Oxford University Press), pp. 142–3.

5. 'Yet my dear, I am as anarchic as a sparrow', Yeats to Wellesley, ibid.

6. For clarification of these figures, see Marie Bourke, 'A Director of His Time', in *TMCR*, p. 101.

7. See Dónal Murphy to MacGreevy, NGIA, MacGreevy (enclosing twenty-four lectures on the history of European painting).

8. James White, 'Introduction', in *National Gallery of Ireland* (with thirty-two colour plates and 191 monochrome plates) (London: Thames & Hudson, 1968), p. 40.

9. MacGreevy was president of the IACA when they met in Dublin in 1953.

10. Brinsley MacNamara to Thomas Bodkin, TCD MS 6962/120-269.

11. Peter Somerville-Large, *1854–2004: The story of the National Gallery of Ireland* (Dublin: National Gallery of Ireland, 2004), p. 355.

12. Henry Mangan, 'Memo on National Portrait Gallery', 14 March 1962, TCD MS 6962/32.

13. Somerville-Large, *1854–2004: The story of the National Gallery of Ireland*, p. 355.

14. Thomas Bodkin, 'Hone Exhibition', *Irish Statesman*, 27 September 1924, p. 81.

15. Thomas MacGreevy, 'Pictures by Nathaniel Hone', *Irish Statesman*, 18 October 1924, pp. 172–3 (p. 172).

16. Thomas Bodkin, 'Letter to the Editor', *Irish Statesman*, 25 October 1924.

17. See NGIA Minutes, 5 April 1963.

18. Thomas MacGreevy, 'Reminder requested by An Taoiseach Mr de Valera of subjects that came up when he received me on 15/04/1957', TCD MS 8148/250.

19. For a discussion of this painting, see Chapter 4.

20. For a discussion of this painting and an account of the controversy it caused, see Chapter 3.

21. See Robert O'Byrne, *Hugh Lane's Legacy to the National Gallery of Ireland* (Dublin: National Gallery of Ireland, 2000).

22. NGIA Minutes, 5 July 1950.

23. 'I herewith offer the Cézanne watercolour of the Montagne Ste [Sainte-] Victoire as a gift', NGI Archives, Chester Beatty file, 13 September 1954.

24. M&B 693 was one of the first generation of sulphonamide antibiotics. It was discovered by Lionel Whitby at the British firm May & Baker Ltd and logged in its Test Book on 2 November 1937. For more on the MacGreevy–Beatty correspondence, see TCD MS 8133. My thanks to Susan Schreibman for her lecture at the Chester Beatty Library, entitled 'Letters from Nice: Chester Beatty's friendship with Thomas MacGreevy' (21 November 2013).

25. NGIA: National Gallery of Ireland Director's Report for 1950.

26. Thomas Bodkin to MacGreevy, 19 March 1952, TCD MS 6962/32. The National Gallery of Ireland had been placed under the control of the Irish Department of Education in 1924 soon after its relationship with the British Treasury was terminated. Thereafter, the Irish Department of Education failed to match the level of previous investment. The exact rationale behind this persistent underfunding is unclear. That the National Gallery continued to rank low on the Irish Department of Education's list of priorities is evident from MacGreevy's numerous conflicts with the administration once he

had taken over as director in 1950. During the second year of MacGreevy's directorship, the Taoiseach admitted that 'Our National Gallery has been crippled and hampered for want of money.' *Dáil Debates*, Arts Bill 1951 – Second Stage, the Taoiseach, vol. 125, 24 April 1951.

27. MacGreevy to Irish Department of Education, 19 August 1955, NGI Admin Box 24. This letter was sent on the understanding that the directorship would soon be restored to a full-time position. The post had been reduced to a part-time position by Hugh Lane so that he could continue his business as an art dealer in London.

28. See Schreibman, 'Introduction', in *CPTM*, pp. xix–xxxviii (p. xxxvi); and Anthony Cronin, 'Thomas MacGreevy: Modernism not triumphant', in *Heritage Now: Irish literature in the English language* (Dingle: Brandon Books, 1982), pp. 155–60.

29. Peter Somerville-Large claims that 40,664 people visited the gallery in 1950 compared to 43,298 the year before. See Somerville-Large, *1854–2004: The story of the National Gallery of Ireland*, p. 354.

30. NGI Admin Box 31: Report by MacGreevy on National Gallery Premises (1959). MacGreevy commissioned architectural designs for a new wing and expanded entrance to the building.

BIBLIOGRAPHY

Clarification of sources

Thomas MacGreevy's papers were presented to Trinity College, Dublin by Margaret Farrington and Elizabeth Ryan in 1976 and 1978. Any unsigned articles from these papers which are recognisable as MacGreevy's hand have been ascribed to him. In cases where a copy of a poem was sent to MacGreevy in its entirety, I have chosen to read this version over revised editions of the text. When an article has been reprinted, priority has been given to referencing the original. Upon his return to Ireland in 1941, he changed his surname from McGreevy to MacGreevy, inserting the Gaelic prefix 'Mac' before his anglicised surname (as Ernie O'Malley had added the 'O' in front of 'Malley'). In line with established practice, which has been followed by nearly all commentators and archivists, this book has adopted the later spelling of his name for consistency. All earlier variants have been adjusted to the later spelling.

All translations from French are mine unless otherwise stated. Ellipses that exist in the original citation have been left to stand independently without editorial marks. Those that have been added to the quoted text for reasons of punctuation or omission are placed in square brackets. Manuscript and typescript sources are abbreviated MS. An additional designation MF accompanies these abbreviations where either of these sources has been accessed via microfilm. All other abbreviations are listed as follows:

(annot.)	Annotated draft
n.d.	No date of publication provided
n.imp.	No publisher's imprint provided
ANF	Archives Nationales, France
BL	British Library
CPDD	*Collected Poems of Denis Devlin*, ed. J.C.C. Mays (Dublin: Dedalus, 1989)
CPTM	*Collected Poems of Thomas MacGreevy: An annotated edition*, ed. Susan Schreibman (Dublin: Anna Livia, 1991). No edition of MacGreevy's *Poems* is currently in circulation, though they have twice been republished since the 1934 Heinemann impression: first in 1971 by the New Writers Press and then in a revised and annotated edition in 1991 by the Dublin imprint Anna Livia Press.
CPSB	*The Collected Poems of Samuel Beckett*, eds Sean Lawlor and John Pilling (London: Faber & Faber, 2012)
D	*Disjecta: Miscellaneous writings and a dramatic fragment [by Samuel Beckett]*, ed. Ruby Cohn (London: John Calder, 1983)
HLMD	Huntington Library Manuscripts Department, San Marino, California
JBY	*Jack B. Yeats: An appreciation and an interpretation* (Dublin: Victor Waddington, 1945)
NGI	National Gallery of Ireland
NLI	National Library of Ireland
TCD	Trinity College, Dublin (Manuscripts and Archives Research Library)
TLSB	*The Letters of Samuel Beckett: Vol 1, 1929–1940*, eds Martha Dow Fehsenfeld and Lois More Overbeck (Cambridge: Cambridge University Press, 2009)

TMCR *The Life and Work of Thomas MacGreevy: A critical reappraisal*, ed. Susan Schreibman (London: Bloomsbury, 2013)

URCW University of Reading, Chatto & Windus archives

WUL Washington University Libraries, St Louis, Missouri

Unpublished sources

Archives Nationales (ANF), 61 AJ 202: IRLANDE: échange de lecteurs avec le Trinity College Dublin: Affaire Beckett et MacGreevy (1927–29). 'Dénonciation de l'accord avec Trinity College' (26 Mars–Juin 1930)

Beckett to MacGreevy, 3 November 1932, TCD MS 10402/35; 9 October 1933, TCD MS 10402/55; 26 April 1935, TCD MS 10402/81; 29 June 1936, TCD MS 10402/93

Bodkin, Thomas to MacGreevy, 19 March 1952, TCD MS 6962/32

Dáil Debates: Arts Bill 1951 – Second Stage, The Taoiseach, Vol. 125, 24 April 1951

Devlin, Denis to MacGreevy, 31 August 1934, TCD MS 8112/5; 15 February 1937, TCD MS 8112/12

Eliot, T.S. to MacGreevy: TCD MS 8113/4; 8113/6; 8113/55

MacNamara, Brinsley to Thomas Bodkin: TCD MS 6962/120-269

Mangan, Henry, 'Memo on National Portrait Gallery', 14 March 1962, TCD MS 6962/32

MacGreevy, Thomas, 'A Cultural Irish Republic', delivered to the Irish Society at Oxford (November 1934), TCD MS 8003/1–15

——, 'Appearances', TCD MS MF 637/2

——, 'Application for the Curatorship of the Municipal Gallery', TCD MS 8142/1

——, 'Autobiographical Fragments', TCD MS MF 719, 8004/4

——, 'Autobiographical Fragments', TCD MS 8039-8044 and TCD MS 8040A

——, to Babette Deutsch, 5 November 1946, *WUL* MS 034 (Box 1, Folder 3)

——, to Chester Beatty, TCD MS 8133

——, 'Cinema', TCD MS 7989/2/102

——, to Department of Education, 19 August 1955, NGI Admin Box 24

——, 'Epithalamium', TCD MS MF 7989/2, 3

——, 'Evie Hone and Mainie Jellett', TCD MS 8002/4 (*c.* 1942)

——, 'Fifty Years of Irish Painting, 1900–1950', TCD MS 8002/13

——, to George Yeats, NLI MS 30.859

——, 'Gloria de Carlos V', TCD MS 7989/1, 73

——, 'Hill of St Genevieve', TCD MS 7989/2, 40

——, to Lionello Venturi, TCD MS 8132/198–215

——, 'Living with Hester', TCD MS 7989/1, 50

——, 'Local Museums and Galleries', TCD MS 8003/7a

——, to M.E. Barber, 16 April 1947, TCD MS 8097/59

——, 'Municipal Gallery Dublin: Jack Yeats Exhibition Transferred from the Venice Biennial', November 1962, TCD MS 7999-5a/3

——, 'Notes', TCD MS 8002/5

——, 'NOTE. Hieronymus van Aeken', TCD MS 7989/1/28

——, 'Paris Notes – Walking to Mountjoy', TCD MS 7989/1/21

——, to Paul Valéry, TCD MS 7998/94a

——, 'Postscript to Mainie Jellett, Picasso, and Dublin Criticism', TCD MS 8085

——, Preparations for Eileen MacCarvill's volume on Mainie Jellett, TCD MS 8002/6–7

——, 'Recessional', TCD MS 7989/1, 84

——, 'Reminder requested by An Taoiseach Mr de Valera of subjects that came up when he received me on 15/04/1957', TCD MS 8148/250

——, 'The Cultural Dilemma for Irishmen: nationalism or provincialism?', delivered to the NUI Club in London, December 1938, TCD MS 8003-8/9a

——, 'The Rise of a National School of Painting', 1922, TCD MS 8002/19

——, 'Transcript of TCD Tape 106' (recording of his poetry reading in the Widener Library at Harvard), TCD MS 10082/15

——, 'Unpublished notebook', TCD MS MF 8067

——, Unpublished typescripts on Joyce, TCD MS 8114/10; TCD MS 8114/16; and TCD MS 8114/17

——, to Wallace Stevens, 26 May 1946; 10 May 1948; 29 December 1948; 23 March 1949; 21 September 1950; 26 June 1952 [HLMD 152]

Moore, Marianne to MacGreevy, TCD MS 8121/1; TCD MS 8121/9

Murphy, Dónal to MacGreevy: NGIA, MacGreevy (enclosing twenty-four lectures on the history of European painting)

NGI Archives, Chester Beatty file, 13 September 1954

NGIA, Admin Box 24, 'Report by Helmut Ruhemann', 14 July 1951

NGIA, National Gallery of Ireland Director's Report for 1950

NGIA Minutes, 5 July 1950

NGIA Minutes, 5 April 1963

NLI Collection No. 38: Literary Papers of Denis Devlin, MS 33,749/14 (1) and (2)

Pound, Ezra to MacGreevy, c. June 1932, TCD MS 8118/47

Prentice, Charles to MacGreevy, TCD MS 8092/1, TCD MS 8092/3, 11 November 1930, University of Reading, Chatto & Windus archives, MS 2444: 150/541

Yeats, Jack, Metal Dye Sketches, TCD MS 8105/72, 73

——, Sketchbook no. 189 of 204, NGI-Y1 Jack Butler Yeats Archive

——, 'The Future of Painting in Ireland', NLI: Jack B. Yeats Archive / Yeats Museum Y17-1 (four-page typescript)

Historic journal and newspaper articles

Anon., 'Notes and Comments, Bloodshed at Dublin', *New Zealand Herald*, Vol. 60, no. 15,772, 21 (November 1914), p. 6

Beckett, Samuel, 'Censorship in the Saorstát' (1983, though written in 1935), in *Disjecta*, pp. 84–8

——, 'Commentaries: Denis Devlin', *transition* 27, April–May 1938, pp. 289–94

——, 'Dante... Bruno. Vico.. Joyce', *transition* 16/17, pp. 242–53

——, 'Humanistic Quietism', *Dublin Magazine*, July–September 1934, pp. 79–80

——, 'MacGreevy on [Jack] Yeats', *Irish Times*, 4 August 1945

——, 'Peintres de l'empêchement', *Derrière le Miroir*, nos 11–12, Juin 1948 (Paris: Galerie Maeght / Editions Pierre à Feu), pp. 3–7

——, 'Recent Irish Poetry', *Bookman*, 'Irish Number', August 1934

Bodkin, Thomas, 'Hone Exhibition', *Irish Statesman*, 27 September 1924

——, Thomas, 'Letter to the Editor', *Irish Statesman*, 25 October 1924

Colum, Padraic, Stuart Gilbert, Eugene Jolas, Thomas MacGreevy and Philippe Soupault, 'James Joyce at the Half Century', *transition* 21, March 1932, pp. 241–55

Devane, James, 'Nationality and Culture', *Ireland To-Day*, vol. 1, no. 7, December 1936

——, 'Is an Irish Culture Possible?', *Ireland To-Day*, vol. 1, no. 5, October 1936, pp. 21–31

Donnelly, Charles, 'Literature in Ireland', *Comhthrom Féinne*, vol. 5, no. 4, May 1933

Eliot, T.S., 'The Three Provincialities', *Tyro: A review of the arts of painting, sculpture and design*, no. 2, pp. 11–13; reprinted in *Essays in Criticism*, vol. 1, no. 1, January 1951

Fallon, Gabriel, 'The New Drama League Says "Yes"', *Irish Monthly*, vol. 70, no. 824, February 1942

Gilbert, Stuart, 'The Creator Is Not a Public Servant', *transition* 19/20, June 1930, pp. 147–50

Gillet, Louis, 'Mr James Joyce and His New Novel' (translated from the French by Ronald Symond), *transition* 21, pp. 263–72

Gleizes, Albert, 'Le Cubisme et la Tradition', *Montjoie!*, 10 February 1913, p. 4

Hackett, Francis, 'A Muzzle Made in Ireland', *Dublin Magazine* (new series), vol. 11, no. 4, October–December 1936

Higgins, F.R. and Austin Clarke, 'Art and Energy', *Irish Statesman*, vol. 3, no. 8, 11 January 1924

Jellett, Mainie, 'Modern Art and the Dual Ideal of Form Through the Ages', *Motley*, vol. 1, no. 5, October 1932, pp. 7–11

Jolas, Eugene, 'Frontierless Decade', *transition* 27, April–May 1938

——, 'Neologisms', *transition* 21, March 1932, p. 324

——, 'Poetry is Vertical', *transition* 21, pp. 148–9

——, 'Proclamation', *transition* 16/17, June 1929, p. 13

——, 'The New Vocabulary', *transition* 15, pp. 171–4

Joyce, James, 'Fragment from *Work in Progress*' (Part II, Section 3), *transition* 27, pp. 57–78

Leslie, Shane, 'Ulysses', *Quarterly Review*, October 1922, pp. 219–34; reprinted in *James Joyce: The critical heritage, vol. 1, 1902–1927*, ed. Robert H. Deming (London: Routledge & Kegan Paul, 1970)

Leventhal, A.J. (published under the pseudonym Lawrence K. Emery), 'Confessional', *Klaxon: An Irish international quarterly*, vol. 1, no. 1, winter 1923–4

Lou Walton, Eda, 'Review: *Poems* by Thomas MacGreevy', *New York Herald Tribune*, 9 December 1934

Lozowick, Louis, 'El Lissitsky', *transition* 18, pp. 284–6

MacGreevy, Thomas, 'A Lively Exhibition, Water-colour Society', *Irish Times*, 30 March 1943

——, 'Anna Livia Plurabelle', *Irish Statesman*, 16 February 1929, pp. 475–6

——, 'A Note on Work in Progress', *transition* 14, autumn 1928, pp. 216–19

——, 'Art and Nationality: The example of Holland', *Old Ireland*, 8 October 1921, pp. 487–8

——, 'Art from the Continent', *Irish Times*, 12 August 1944

——, 'Artists of Tomorrow: The annual exhibition of students' work at the Westminster School of Art', *Studio*, August 1938, pp. 110–11

——, 'Giorgionismo', *New Review*, vol. 1, no. 2, May–June–July 1931

——, 'How Does She Stand?', *Father Mathew Record*, September 1949

——, *Illustrations of the Paintings* (Dublin: National Gallery of Ireland, 1951)

——, 'Living Art – A New Departure', *Irish Times*, 16 September 1943

——, 'New Dublin Poetry', *Ireland To-Day*, October 1937, pp. 81–2

——, 'Our Picture Collections', *Irish Statesman*, 24 August 1925, pp. 757–60

——, 'Picasso, Mamie [*sic*] Jellett and Dublin Criticism', *Klaxon*, vol. 1, no. 1, winter 1923–24, pp. 23–7; accessed TCD MS 8015/192-4 (Annotated); 8002/8; 10381/205 (Annotated)

——, *Pictures in the Irish National Gallery* (Cork: Mercier Press, 1945)

——, 'Pictures in the National Gallery', *Capuchin Annual*, vol. 22, 1943, pp. 386–443

——, 'Pictures by Nathaniel Hone', *Irish Statesman*, 18 October 1924, pp. 172–3

——, 'Review of Intercessions', *Ireland To-Day*, October 1937, pp. 81–2 (p. 82)

——, *Richard Aldington: An Englishman* (London: Chatto & Windus, 1931)

——, 'Some Italian Pictures in the National Gallery of Ireland: Lecture given at the Italian Institute in Dublin' (Dublin: Italian Institute, 1963)

——, 'Some Statues by John Hogan', *Father Mathew Record*, August 1943, pp. 5–6

——, 'The Ballet', *New Criterion*, October 1926, pp. 741–5

——, 'The Dublin Municipal Gallery', *Father Matthew Record*, January 1946, p. 4

——, 'Three Historical Paintings by Jack B. Yeats', *The Capuchin Annual*, Dublin 1942, pp. 238–51

——, 'To the Editor of T.C.D: A College Miscellany', 27 May 1920

——, 'To the Editor of the Irish Statesman: Anna Livia Plurabelle', *Irish Statesman*, 16 February 1929, pp. 475–6

——, *T.S. Eliot: A study* (London: Chatto & Windus, 1931)

O'Faolain, Sean, 'Almost Music', *Hound and Horn*, vol. 1, January–March 1929, pp. 178–80

——, 'Correspondence: Anna Livia Plurabelle', *Irish Statesman*, vol. 9, 5 January 1929, pp. 354–5

——, 'Daniel Corkery', *Dublin Magazine* (new series), vol. 11, no. 2, April–June 1936, p. 61

——, 'Letter to the Editor', *Irish Statesman*, 2 March 1929, pp. 513–14

——, 'Style and the Limitations of Speech', *Criterion*, vol. 8, no. 30, September 1928, pp. 67–87

——, 'The Irish Shelf', *Ireland To-Day*, vol. 1, no. 4, September 1936

O'Hegarty, Patrick Sarsfield, 'A Review of Daniel Corkery's *Synge and Anglo-Irish Literature*', vol. 7, no. 1, January–March 1932, pp. 51–6

Olden, Anthony, 'A Storm in a Chalice', *Library Review*, vol. 25, no. 7, autumn 1976, pp. 265–9

Oshima, Shotaro, 'An Interview with Jack Butler Yeats', 7 July 1938, in *A Centenary Gathering* (Dublin: Dolmen Press, 1971), pp. 52–3

O'Sullivan, Seumas, 'Editorial', *Dublin Magazine* (new series), vol. 1, no. 2, April–June 1926

Russell, George 'Æ', 'Notes and Comments', *Irish Statesman*, vol. 6, no. 4, 4 March 1926

——, (initialled 'Y.O.' for his art criticism), 'Review', *Irish Statesman*, 27 October 1923

——, 'AE', 'The Censorship in Ireland', *Nation & Athenaeum*, 22 November 1928

Shaw, George Bernard, 'The Censorship', *Irish Stateman*, vol. 11, no. 11, 17 November 1928

Starkie, Walter, 'Literature and Life: The fantastic in literature', *Irish Statesman*, vol. 9, no. 21, 28 January 1928

Stuart, Francis and Cecil Salkeld, 'To All Artists and Writers', *To-Morrow*, vol. 1, no. 1, August 1924

Stewart, William McCausland, 'Mes Souvenirs Personnels sur Paul Valéry', Actes de L'Académie Nationale des Sciences, Belles-Lettres et Arts de Bordeaux 4e série, Vol. xxv, 1970

Thoma, Richard, 'Island Without Serpents', *New Review*, vol. 3, 1931, pp. 119–20

Titus, Edward, 'Editorially: Criticism à l'Irlandaise', *This Quarter*, April–May–June 1931, vol. 3, no. 4, pp. 569–84

Valéry, Paul, 'Discours de Reception: Samedi 23 Juin 1927', reproduced in *Journal Officiel de la République Française* (Cinquante-neuvième année, no. 117)

Yeats, W.B., 'The Need for Audacity of Thought', *Dial*, February 1926

Secondary books and journals

Adams, Michael, *Censorship: The Irish experience* (Dublin: Scepter Books, 1968)

Adams, Bruce, *Rustic Cubism: Anne Dangar and the art colony at Moly-Sabata* (Chicago: Chicago University Press, 2005)

Allen, Nicholas, *Modernism, Ireland and Civil War* (Cambridge: Cambridge University Press, 2009)

Anderson, Jaynie, *Giorgione, the Painter of 'Poetic Brevity'* (New York: Flammarion, 1997)

Anon., *The Late Paintings of Jack B. Yeats* (Whitechapel Art Gallery: Arnolfine, 1991)

Arnold, Bruce, *Jack Yeats* (New Haven, CT: Yale University Press, 1998)

——, *Mainie Jellett and the Modern Movement in Ireland* (New Haven, CT: Yale University Press, 1991)

Arrington, Lauren, *W.B. Yeats, the Abbey Theatre, Censorship, and the Irish State: Adding the half-pence to the pence* (Oxford: Oxford University Press, 2010)

Banta, Melissa and Oscar Silverman (eds), *James Joyce's Letters to Sylvia Beach* (Bloomington, IN: Indiana University Press, 1987)

Beckett, Samuel, *Murphy* (London: George Routledge & Sons, 1938)

——, Marcel Brion, Frank Budgen, Stuart Gilbert, Eugene Jolas, Victor Llona, Robert McAlmon, Thomas MacGreevy, Elliot Paul, John Rodker, Robert Sage and William Carlos Williams, *Our Exagmination Round His Factification for Incamination of Work in Progress* (Paris: Shakespeare & Co., 1929)

Bugayev, Boris Nikolaevich, *Mezdu Dvux Revoljucij* [Between Two Revolutions] (Leningrad: Izdatel'stvo Pisatelej, 1934)

Benstock, Bernard, *Joyce-Again's Wake: An analysis of Finnegans Wake* (Seattle: University of Washington Press, 1965)

Boring, Edwin G., *A History of Experimental Psychology*, 2nd edn. (New York: Appleton-Century-Crofts, 1957)

Bourke, Marie, *The Story of Irish Museums, 1790–2000: Culture, identity and education* (Cork: Cork University Press, 2011 [reprinted 2013])

Boyd, Ernest, *Ireland's Literary Renaissance*, 2nd edn. (London: Grant Richards, 1923)

Brooker, Peter and Andrew Thacker (eds), *The Oxford Critical and Cultural History of Modernist Magazines, Vol 1, Britain and Ireland 1880–1955* (Oxford: Oxford University Press, 2009)

Brown, Karen, *The Yeats Circle, Verbal and Visual Relations in Ireland, 1880–1939* (London: Ashgate, 2010)

Brown, Terence, 'After the Revival: The problem of adequacy and genre', in Ronald Schleifer (ed.), *The Genres of the Irish Literary Revival* (Dublin: Wolfhound Press, 1980), pp. 153–78

——, *Ireland: A social and cultural history, 1922–2002* (London: Harper Perennial, 1981)

——, *The Life of W.B. Yeats: A critical biography* (Oxford: Blackwell, 1999)

——, *The Literature of Ireland: Culture and criticism* (Cambridge: Cambridge University Press, 2010)

Bürger, Peter, *Theory of the Avant-garde* (Minneapolis, MN: University of Minnesota Press, 1984 [first published 1974])

Calinescu, Matei, *Five Faces of Modernity: Modernism, avant-garde, decadence, kitsch, postmodernism* (Durham, NC: Duke University Press, 2003 [first published 1977])

Castle, Gregory, *Modernism and the Celtic Revival* (Cambridge: Cambridge University Press, 2001)

Carlson, Julia (ed.), *Banned in Ireland: Censorship and the Irish writer* (London: Routledge, 1990)

Clarke, Austin, *Pilgrimage and Other Poems* (London: Allen & Unwin, 1929)

Cleary, Arthur E., 'Pearse, MacDonagh and Plunkett: An appreciation', in *Poets of the Insurrection* (Dublin: Maunsel, 1918)

Clyde, Tom, *Irish Literary Magazines: An outline history and descriptive bibliography* (Dublin: Irish Academic Press, 2003)

Chapman, Wayne K., '"The Municipal Gallery Re-visited" and Its Writing', in Warwick Gould (ed.), *Yeats Annual*, no. 10 (London: Macmillan, 1993), pp. 159–87

Conley, Tim (ed.), *Joyce's Disciples Disciplined: A re-exagmination of the exagmination of 'Work in Progress'* (Dublin: UCD Press, 2010)

Correspondance entre Albert Gleizes et Robert et Sonia Delaunay (1926–47), par Association des Amis d'Albert Gleizes c/o Mme Dalban (Ampuis, 1993)

Corkery, Daniel, *Synge and Anglo-Irish Literature* (Cork: Cork University Press, 1931)

——, *The Hidden Ireland: A study of Gaelic Munster in the eighteenth century* (Dublin: Gill & Macmillan, 1924)

Costello, Bonnie, 'Stevens and Painting', in John N. Serio (ed.), *The Cambridge Companion to Wallace Stevens* (Cambridge: Cambridge University Press, 2007), pp. 164–79

Coulter, Riann, 'Translating Modernism: Mainie Jellett, Ireland and the search for a modernist language', *Apollo*, no. 164, September 2006, pp. 56–62

Cronin, Anthony, 'Thomas MacGreevy: Modernism not triumphant', in *Heritage Now: Irish literature in the English language* (Dingle: Brandon Books, 1982), pp. 155–60

Crowley, John, Donal O'Drisceoil, Mike Murphy and John Borgonovo (eds), *Atlas of the Irish Revolution* (Cork: Cork University Press, 2017)

Davis, Alex, *A Broken Line: Denis Devlin and Irish poetic modernism* (Dublin: UCD Press, 2000)

——, '"Foreign and Credible": Denis Devlin's modernism', *Éire-Ireland*, vol. 30, no. 2, summer 1995, pp. 131–48

—— and Lee Jenkins (eds), *Locations of Literary modernism: Region and nation in British and American modernist poetry* (Cambridge: Cambridge University Press, 2000)

—— and Patricia Coughlan (eds), *Modernism and Ireland: The poetry of the 1930s* (Cork: Cork University Press, 1995)

Dawe, Gerald (ed.), *Earth Voices Whispering: An anthology of Irish War Poetry, 1914–45* (Belfast: Blackstaff Press, 2008)

——, (ed.), *The Cambridge Companion to Irish Poets* (Cambridge: Cambridge University Press, 2018)

Dawson, Hugh J., 'Thomas MacGreevy and Joyce', *James Joyce Quarterly*, vol. 25, no. 3, spring 1988, pp. 305–21

Deming, Robert H. (ed.), *James Joyce: The critical heritage, vol. 2: 1928–1941* (London: Routledge & Kegan Paul, 1970)

Eagleton, Terry, 'The Archaic Avant-garde', in *Heathcliff and the Great Hunger: Studies in Irish culture* (London & New York: Verso, 1995)

Eliot, Valerie and John Haffenden (eds), *The Letters of T.S. Eliot, Volume 3: 1926–1927* (London: Faber & Faber, 2012)

Ellmann, Richard (ed.), *Selected Letters of James Joyce* (London: Faber & Faber, 1975)

Fitzpatrick, David, *The Two Irelands, 1912–1939* (Oxford: Oxford University Press, 1998)

Ford, Hugh, *Published in Paris: American and British writers, printers, and publishers in Paris, 1920–1939* (New York: Macmillan, 1975)

Fordham, Finn, *Lots of Fun at Finnegans Wake: Unravelling universals* (Oxford: Oxford University Press, 2007)

Foster, R.F., *Vivid Faces: The revolutionary generation in Ireland, 1890–1923* (London: Allen Lane, 2014)

——, *W.B. Yeats: A life II: The arch-poet, 1915–39* (Oxford: Oxford University Press, 2003)

——, *Words Alone: Yeats and his inheritances* (Oxford: Oxford University Press, 2011)

Frye, Northrop, *The Critical Path: An essay on the social context of literary criticism* (Bloomington & London: Indiana University Press, 1971)

Geertz, Clifford, 'After the Revolution: The fate of nationalism in the new states', in *The Interpretation of Cultures* (New York: Basic Books, 1973 [reprinted London: Fontana Press, 1993]), pp. 234–54

Gerhardus, Maly and Dietfried Gerhardus, *Cubism and Futurism: The evolution of the self-sufficient picture* (Oxford: Phaidon, 1979)

Gibbons, Luke, John Hutchinson and Nigel Rolfe, 'Roundtable Discussion: Avant-garde & popular culture', *CIRCA*, no. 44, March–April 1989, pp. 25–9

Gleizes, Albert, *La Signification Humaine du Cubisme: causerie faite par Albert Gleizes au Petit Palais, 18 Juillet 1938* (Sablons: Moly-Sabata, 1938)

——, *Tradition et Cubisme: vers une conscience plastique, articles et conferences, 1912–24*, ed. Jacques Povolozky (Paris: La Cible, 1927)

Goethe, Johann Wolfgang, *Poems of Goethe*, trans. Edwin H. Zeydel (Chapel Hill, NC: University of North Carolina Press, 1957)

Greenefeld, Liah, *Nationalism: Five roads to modernity* (Cambridge, MA: Harvard University Press, 1993)

Harvey, Lawrence, *Beckett: poet and critic* (Princeton, NJ: Princeton University Press, 1970)

Heller, Erich, *The Disinherited Mind: Essays in modern German literature and thought* (Cambridge: Bowes & Bowes, 1952)

Hoffman, Frederick, Charles Allen and Carolyn Ulrich, *Little Magazine* (Princeton, NJ: Princeton University Press, 1946)

Holroyd, Michael, *Bernard Shaw, Vol. 4: 1950–1991 – The Last Laugh* (London: Chatto & Windus, 1992)

Hutton, Clare and Patrick Walsh, *The Oxford History of the Irish Book, Vol. 5: The Irish Book in English, 1891–2000* (Oxford: Oxford University Press, 2011)

Jellett, Mainie, *The Artist's Vision: Lectures and essays on art, with an introduction by Albert Gleizes*, ed. Eileen MacCarvill (Dundalk: Dundalgan Press, 1958)

Joyce, James, *Finnegans Wake*, eds Robbert-Jan Henkes, Erik Bindervoet and Finn Fordham (Oxford: Oxford University Press, 2012 [first published London: Faber & Faber, 1939])

Kandinsky, Wassily, *Concerning the Spiritual in Art*, trans. Michael T.H. Sadler (London: Tate Modern, 2006 [Munich 1912])

Kearney, Richard (ed.), *The Irish Mind: Exploring intellectual traditions* (Dublin: Wolfhound Press, 1985)

———, *Transitions: Narratives in modern Irish culture* (Manchester: Manchester University Press, 1988)

Kemp, Martin, 'From "Mimesis" to "Fantasia": The quattrocento vocabulary of creation, inspiration and genius in the visual arts', *Viator: Medieval and Renaissance studies*, vol. 8, pp. 347–98

Kennedy, Róisín, 'Transmitting Avant-garde Art: Post-impressionism in a Dublin context', *Visual Resources*, vol. 31, nos. 1–2, 2015, pp. 61–73

Kennedy, S.B., *Irish Art and Modernism: 1880–1950* (Belfast: Queen's University, 1991)

Kernoswki, Frank, 'The Fabulous Reality of Denis Devlin', *Sewanee Review*, winter 1973, pp. 113–22

Lee, J.J., 'Consolidation: 1922–32', in *Ireland 1912–1985: Politics and society* (Cambridge: Cambridge University Press, 1989 [reprinted 2004])

Lloyd, David, *Nationalism and Minor Literature: James Clarence Mangan and the emergence of Irish cultural nationalism* (The New Historicism: Studies in Cultural Poetics) (Berkeley: University of California Press, 1987)

Loizeaux, Elizabeth Bergmann, *Twentieth-century Poetry and the Visual Arts* (Cambridge: Cambridge University Press, 2008)

Longley, Edna, *W.B. Yeats and Modern Poetry* (Cambridge: Cambridge University Press, 2013)

MacCardle, Dorothy, *The Irish Republic: A documented chronicle of the Anglo-Irish conflict and the partitioning of Ireland, with a detailed account of the period 1916–23 with a preface by Éamon de Valera* (London: Gollancz, 1937 [Dublin: Wolfhound Press, 1999])

MacFarlane, James and Malcolm Bradbury (eds), *Modernism: A guide to European literature, 1890–1930* (London: Penguin, 1978)

Mackay, Agnes Ethel, *The Universal Self: A study of Paul Valéry* (Glasgow: William MacLellan, 1961)

Martin, Augustine, 'MacGreevy in the Best Modern Way', *Irish Literary Supplement*, vol. 10, no. 2, autumn 1991, p. 26

Mays, J.C.C., 'How is MacGreevy a Modernist?', in Davis and Coughlan (eds), *Modernism and Ireland*, pp. 103–28

McMillan, Dougald, *transition 1927–1938: The history of a literary era* (London: Calder & Boyars, 1975)

Miller, Liam, *The Dun Emer Press, Later the Cuala Press* (Dublin: The Dolmen Press, 1973)

Moriarty, Dónal, *The Art of Brian Coffey* (Dublin: UCD Press, 2000)

Murphy, Patrick and Homan Potterton (eds), *Irish Women Artists: From the eighteenth century to the present day* (Dublin: National Gallery of Ireland & Douglas Hyde Gallery, 1987)

Nixon, Mark, *Samuel Beckett's German Diaries 1936–1937* (London: Continuum, 2011)

Nolan, Emer, 'Modernism and the Irish Revival', in Joe Cleary and Claire Connolly (eds), *The Cambridge Companion to Modern Irish Culture* (Cambridge: Cambridge University Press, 2005)

O'Byrne, Robert, *Hugh Lane's Legacy to the National Gallery of Ireland* (Dublin: National Gallery of Ireland, 2000)

O'Connor, Ulick (ed.), *The Joyce We Knew* (Cork: Mercier Press, 1967)

O'Driscoll, Dennis, *Stepping Stones: Interviews with Seamus Heaney* (London: Faber & Faber, 2008)

Paulin, Tom, *Writing to the Moment: Selected critical essays, 1980–1996* (London: Faber & Faber, 1996)

Pettit, Philip, *Republicanism: A theory of freedom and government* (Oxford: Oxford University Press, 1997)

Pignatti, Terisio and Filippo Pedrocco, *Giorgione* (New York: Rizzoli, 1999)

Poggioli, Renato, *The Theory of the Avant-garde* (Harvard: Harvard University Press, 1968)

Putnam, Samuel, *Paris Was Our Mistress: Memoirs of a lost and found generation* (London: Platin, 1947)

——, Maida Castelhun Darton, George Reavey and Jacob Bronowski (eds), *The European Caravan: An anthology of the new spirit in European literature – France, Spain, England and Ireland* (New York: Warren & Putnam, 1931)

Pyle, Hilary, *Jack B. Yeats: A biography* (London: Routledge & Kegan Paul, 1970)

——, *Jack B. Yeats: A catalogue raisonné of the oil paintings*, 3 vols (London: Andre Deutsch, 1992)

——, 'Jack B. Yeats, "A Complete Individualist"', *Irish Arts Review Yearbook*, no. 9, 1993, pp. 86–101

——, 'To Be Loved as a Cupboard: The Yeats Museum in the National Gallery of Ireland', *Éire-Ireland*, autumn–winter 2001, pp. 212–25

——, *Yeats: Portrait of an artistic family* (NGI in association with London: Merrell Holberton, 1997)

Quadflieg, Roswitha, *Tagebuch Samuel Becketts von 1936* (Hamburg: Hoffman und Campe Verlag, 2006)

Radek, Karl, 'James Joyce or Socialist Realism?', delivered to the Soviet Writers' Congress, *Contemporary World Literature and the Tasks of Proletarian Art*, August 1934, pp. 151–4

Saddlemyer, Ann, *Becoming George: The life of Mrs W.B. Yeats* (Oxford: Oxford University Press, 2002)

Schneider, Norbert, *Still Life* (Köln: Taschen, 2003)

Schreibman, Susan, 'Letters from Nice: Chester Beatty's friendship with Thomas MacGreevy', Chester Beatty Library, 21 November 2013

Scott, David, *Pictorialist Poetics: Poetry and the visual arts in nineteenth century France* (Cambridge: Cambridge University Press, 1988)

Setz, Cathryn, '*transition*'s Anachronistic Zeitgeists', *Everydayness and the Event*, MSA 15 Annual Conference, University of Sussex, 31 August 2013

Shovlin, Frank, *The Irish Literary Periodical, 1923–1958* (Oxford: Oxford University Press, 2004)

Sisson, Elaine, 'A Note on What Happened': Experimental influences on the Irish stage, 1919–29', *Kritika Kultura*, no. 15, 2010, pp. 132–48

Smith, Gerry, 'Culture, Criticism and Decolonisation', in *Decolonisation and Criticism: The construction of Irish literature* (London: Pluto Press, 1998), pp. 35–53

Smith, Michael, 'Irish Poetry Since Yeats: Notes towards a corrected history', *Denver Quarterly V*, winter 1971, pp. 1–26

——, 'Michael Smith Asks Mervyn Wall Some Questions About the Thirties', *Lace Curtain*, no. 4, summer 1971

Smith, Stan, 'From a Great Distance: Thomas MacGreevy's frames of reference', *Lace Curtain*, no. 6, autumn 1978, pp. 47–55

——, *Irish Poetry and the Construction of Modern Identity: Ireland between fantasy and history* (Dublin: Irish Academic Press, 2005)

——, 'Precarious Guest: The poetry of Denis Devlin', *Irish University Review*, vol. 8, no. 1, 1987, pp. 51–67

Somerville-Large, Peter, *1854–2004: The story of the National Gallery of Ireland* (Dublin: National Gallery of Ireland, 2004)

Stevens, Holly (ed.), *Letters of Wallace Stevens* (London: Faber & Faber, 1966)

Stevens, Wallace, *The Necessary Angel: Essays on reality and the imagination* (London: Faber & Faber, 1951)

Tóibín, Colm, 'Who To Be', Review of Martha Dow Fehsenfeld and Lois More Overbeck (eds), *The Letters of Samuel Beckett 1929–40*, *London Review of Books*, vol. 31, no. 15, August 2009, pp. 14–20

Toksvig, Signe, *Irish Diaries* (Dublin: The Lilliput Press, 1994)

Valéry, Paul, *Introduction to the Method of Leonardo da Vinci*, translated from the French of Paul Valéry of the Académie Française by Thomas MacGreevy (London: John Rodker, 1929)

Venturi, Lionello, *Four Steps Toward Modern Art: Bampton lectures in America*, FTMA Giorgione, Caravaggio, Manet, Cézanne, delivered at Columbia University (New York: Cambridge University Press, 1956)

Vico, Giambattista, *The New Science of Giambattista Vico*, trans. Thomas Bergin and Max Fisch (Ithaca, NY: Cornell University Press, 1970 [first published 1725])

Walker, Tom, '"Even a Still Life Is Alive": Visual art and Bloomsbury aesthetics in the early poetry of Louis MacNeice', *Cambridge Quarterly*, vol. 38, no. 3, 2009, pp. 196–213

Wheatley, David, 'Slippery Sam and Tomtinker Tim: Beckett and MacGreevy's urban poetics', *Irish Studies Review*, vol. 13, no. 2, May 2005, pp. 189–202

White, James, 'Introduction', in *National Gallery of Ireland* (with thirty-two colour plates and 191 monochrome plates) (London: Thames & Hudson, 1968)

Yeats, W.B., *Essays and Introductions, 1865–1939* (London & New York: Macmillan, 1961)

—— and Douglas Hyde (eds), *Fairy and Folk Tales of the Irish Peasantry* (London: Walter Scott, 1888)

——, *The Poems*, ed. Daniel Albright (London: Everyman's Library, 1992)

Digital sources

The Thomas MacGreevy Archive

In 1993, Susan Schreibman created a digital research project entitled *The Thomas MacGreevy Archive* that pioneered his recovery in Irish studies and in accounts of European modernism. Over 400 hypertexts by or about MacGreevy can be accessed via this website at http://www.macgreevy.org [accessed 14 January 2019]. The archive includes online versions of MacGreevy's monographs, articles and essays; a versioning engine that allows readers to trace the compositional development of draft poems; and a database that provides authority files for the names of people and organisations found in the texts. Its intelligent search-and-navigation tools offer access to a large proportion of MacGreevy's work by individual, theme and topic.

The *Book of Kells*

The *Book of Kells* (IE TCD MS 58) is now available in digital format (MS58_335v) thanks to DRIS Trinity College Library, Dublin. It can be accessed online and zoomed into at will as part of the Medieval and Renaissance Latin Manuscripts collection at the following extension: https://digitalcollections.tcd.ie/home/#folder_id=14&pidtopage=MS58& entry_point=1 [accessed 14 January 2019]

Anthologies

MacGreevy's poems have been widely anthologised across the English-speaking world. They feature in Samuel Putnam's *The European Caravan: An anthology of the new spirit in European literature – France, Spain, England and Ireland* (New York: Warren & Putnam, 1931); in W.B. Yeats' *The Oxford Book of Modern Verse, 1892–1935* (Oxford: Clarendon Press, 1936); in Padraic Colum's *Anthology of Irish Verse: The poetry of Ireland from mythological times to the present* (New York: Liveright, 1948); in Donagh MacDonagh and Lennox Robinson's *The Oxford Book of Irish Verse: XVIIth century – xxth century* (Oxford: Clarendon Press, 1958); in Derek Mahon's *Modern Irish Poetry* (London: Sphere Books, 1972); in John Montague's *The Faber Book of Irish Verse* (London: Faber & Faber, 1974); in Edward Germain's *Surrealist Poetry in English* (London: Penguin, 1979); in Anthony Bradley's *Contemporary Irish Poetry* (Berkeley: University of California Press, 1980) and *Contemporary Irish Poetry: New and revised edition* (Berkeley: University of California Press, 1988); in Patrick Crotty's *Modern Irish Poetry: An anthology* (Belfast: Blackstaff Press, 1995); and in Gerald Dawe's *Earth Voices Whispering: An anthology of Irish war poetry, 1914–45* (Belfast: Blackstaff Press, 2008), the title of which is derived from the final line of MacGreevy's 'Nocturne of St Eloi, 1918'.

Audio recordings

'A Conversation Between Jack Butler Yeats and Thomas MacGreevy', broadcast on the BBC Third Programme, 17 May 1948, the British Library (BL), 11783, 84 + 85 (78rpm)

MacGreevy, Poetry Reading in the Widener Library at Harvard 'TCD Tape 106', TCD MS 10082/15

Exhibitions

Exhibition at the New Galleries, First Floor Royal Hospital, Gordon Lambert Galleries, IMMA, *The Moderns: The arts in Ireland from the 1900s to the 1970s* (20 October 2010 – 13 February 2011)

Exhibition at the New Galleries, IMMA, *Analysing Cubism: Mainie Jellett, Evie Hone, Mary Swanzy and masters of European modernism* (20 February – 19 May 2013)

Exhibition samples from the 1950 Chester Beatty bequest to the National Gallery of Ireland, Chester Beatty Library, Dublin Castle (7 September 2012 – 24 March 2013)

Exhibition samples from the Jack Yeats sketchbooks at the Beit Wing (Room 13), NGI (2 February – 3 June 2013)

Jellett, Mainie, catalogue of *A Retrospective Exhibition of Paintings and Drawings at the Municipal Gallery of Modern Art, Dublin* (26 July – 7 October 1962)

Koerner, Joseph, 'Hieronymus Bosch: Enemy painting', delivered to the Edgar Wind Society, New Seminar Room, St John's College, Oxford (7 February 2013)

INDEX